Thracian Treasures from Bulgaria

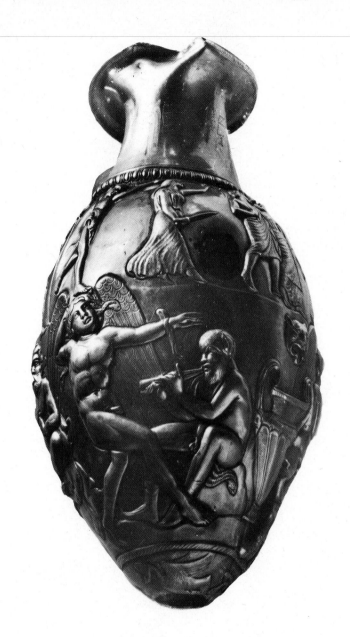

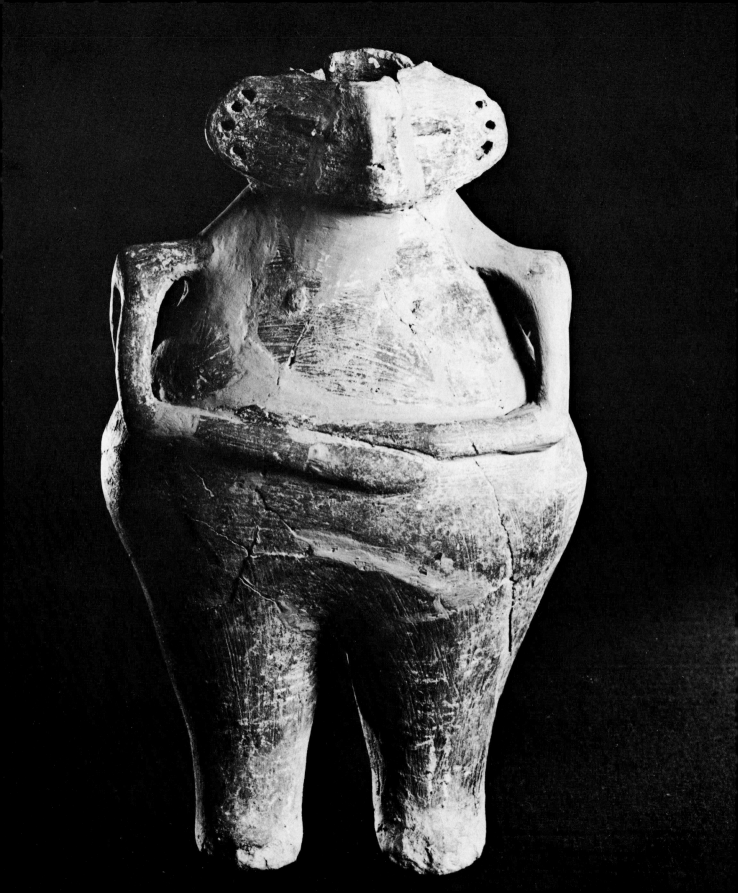

Thracian Treasures

FROM BULGARIA

A SPECIAL EXHIBITION
HELD AT THE BRITISH MUSEUM
JANUARY–MARCH 1976

Published for THE TRUSTEES OF THE BRITISH MUSEUM
by British Museum Publications Limited

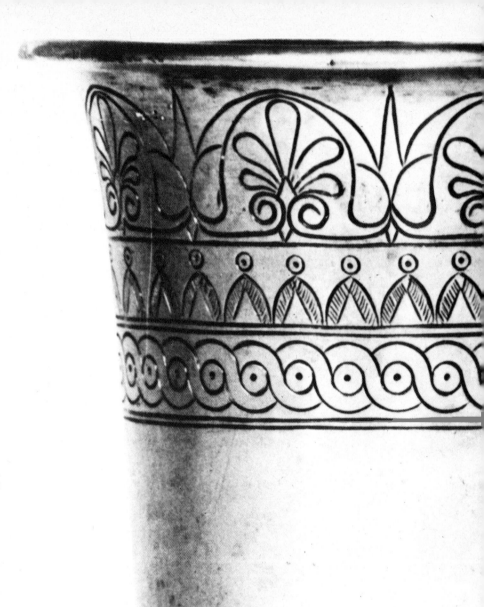

The text of the Catalogue, by I. Venedikov,
was supplied in English by the Bulgarian
Committee for Art and Culture. It has been
co-ordinated and adapted by R.A. Higgins.
The plates of nos. 548–51 are reproduced
by courtesy of the Ashmolean Museum,
Oxford. The rest are made from material
supplied by the Austrian Ministry of
of Culture (photos by Udo Otto) and from
official Bulgarian negatives.
Map of Bulgaria in Antiquity drawn by
Miss Carey Miller

Designed by Roger Davies
Set in Times New Roman
Printed in Great Britain by
Balding and Mansell Ltd,
Wisbech and London

ISBN 0 7141 1256 9 *paper*

ISBN 0 7141 1257 7 *cased*

Published by British Museum Publications Ltd,
6 Bedford Square, London WC1B 3RA

Contents

Preface

The Trustees of the British Museum are honoured to present this exhibition. The material it contains is of the highest archaeological and artistic interest. Conceived by the Committee for Art and Culture of the Bulgarian People's Republic, it has been shown in Paris, Moscow, Leningrad and Vienna. For the London showing additional objects have been made available by the Ashmolean Museum, Oxford. In connection with it special gratitude is due to Dr L. Zhivkova, Chairman, and Professor A. Fol, Deputy Chairman, of the Committee for Art and Culture; to Dr A. Minchev, Commissioner of the exhibition, and to Professor I. Venedikov, who has composed the catalogue. We are also greatly indebted to the Bulgarian Ambassador in London, Dr Alexander Yankov, to the Bulgarian Cultural Attaché, Mr S. Baev, and to the British Ambassador in Sofia for much valuable assistance in the preparation of the exhibition. Dr Reynold Higgins, Deputy Keeper of Greek and Roman Antiquities in the British Museum, has been responsible for organizing the exhibition on the British side. The project has been helped forward at every stage by the British Council and by the Great Britain/East Europe Centre. The exhibition forms part of an agreed programme of cultural exchanges between Bulgaria and Great Britain.

TREVELYAN

Lending institutions

BOURGAS, District Museum of History.
KAZANLUK, Museum of History.
LOM, Museum of History.
LOVECH, District Museum of History.
MIHAILOVGRAD, Museum.
NESSEBUR, Museum.
NOVA ZAGORA, Museum of History.
PLEVEN, District Museum.
PLOVDIV, Archaeological Museum.
RAZGRAD, District Museum of History.
ROUSSE, District Museum of History.
SHOUMEN, District Museum of History.
SILISTRA, District Museum of History.
SOFIA, Archaeological Museum.
SOFIA, Collections of the University.
SOFIA, Ecclesiastical Museum of History and Archaeology.
SOFIA, Museum of History of Sofia.
SOFIA, National Museum of Military History.
STARA ZAGORA, District Museum of History.
TETEVEN, Museum of History.
TURGOVISHTE, District Museum of History.
TURNOVO, District Museum of History.
VARNA, Archaeological Museum.
VIDIN, District Museum of History.
VRATSA, District Museum of History.

OXFORD, Ashmolean Museum.

Introduction

This display, which can be seen in the Special Exhibitions Gallery of the British Museum from 8 January to 28 March 1976, is a landmark in the history of our loan exhibitions. The antiquities of Romania were made known to us in a splendid exhibition in 1971, and those of Yugoslavia in an equally splendid one in 1975. Our horizons are now further enlarged with this superb collection of national treasures from Bulgaria, the ancient Thrace; masterpieces of the art of the goldsmith, the silversmith and other craftsmen over thousands of years. Twenty-five Bulgarian museums have contributed to this magnificent display, and additional material has been lent by the Ashmolean Museum, Oxford.

None of these objects has been seen before in this country. Many are unpublished, and some have only been excavated in the last two or three years. We are indeed grateful for the privilege of exhibiting such things.

The Exhibition is arranged as far as possible in the order of this Catalogue, which is in essentials a chronological order. The visitor will thus start at the main entrance to the Gallery with the Early Neolithic, about 6000 BC, and will end with the Roman Empire, about AD 300.

REYNOLD HIGGINS
Deputy Keeper of Greek and Roman Antiquities

Exhibition Plan

Major Treasures from:

Varna, cases 4 and 5

Vulchitrun, case 10

Douvanli, cases 14 and 15

Vratsa, case 25

Panagyurishté, cases 30 and 31

Roussé, case 41

Stara Zagora, case 42

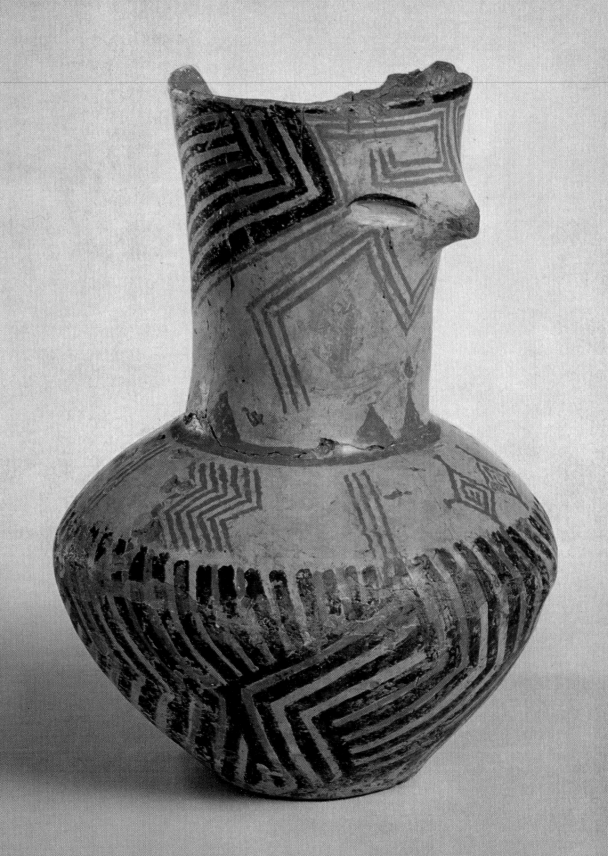

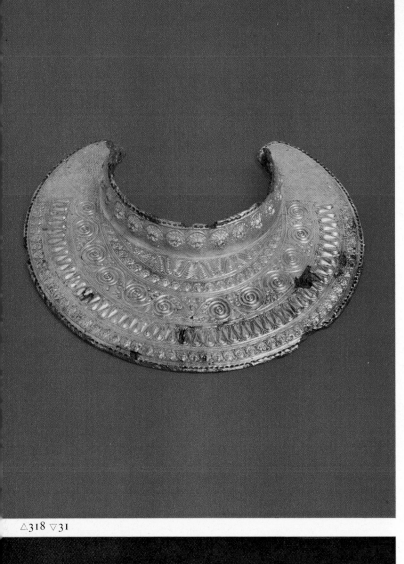

△318 ▽31

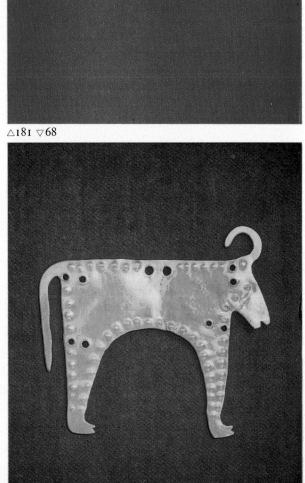

△181 ▽68

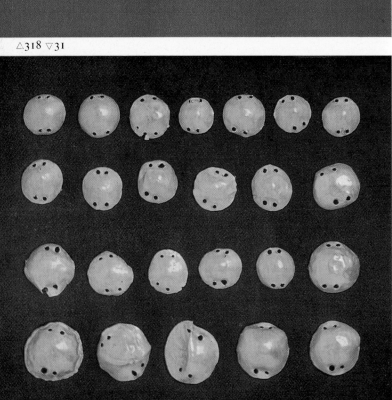

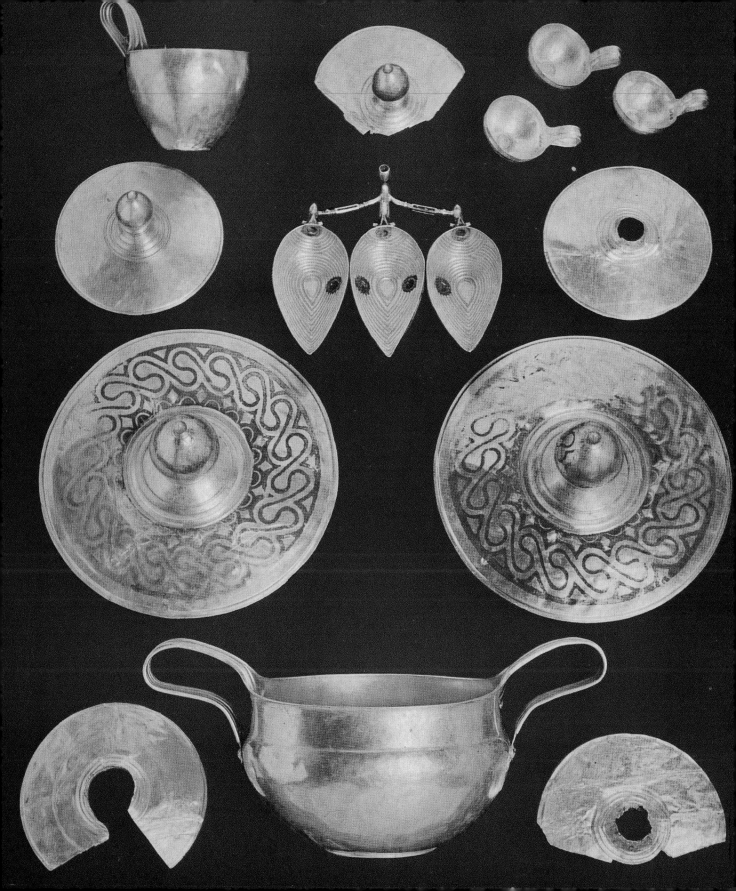

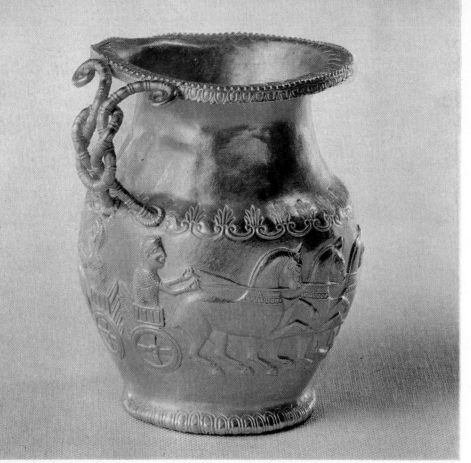

△294 ▽425

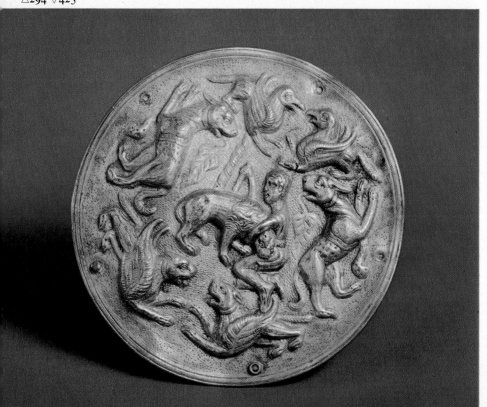

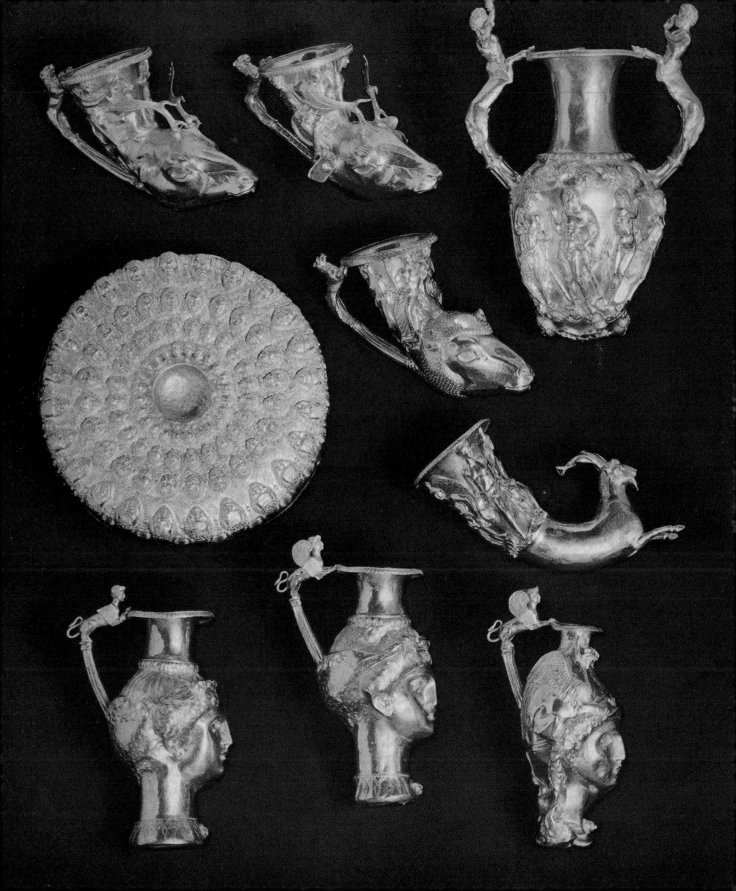

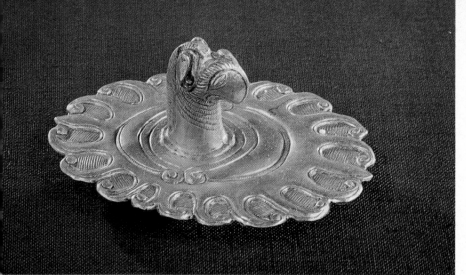

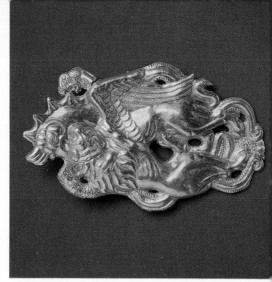

△325 ▽266

△287 ▽327

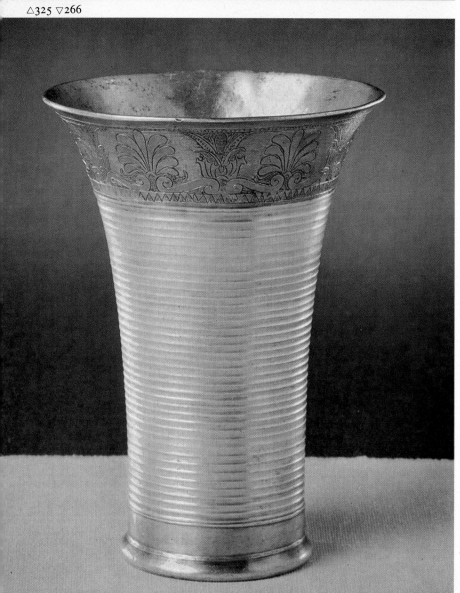

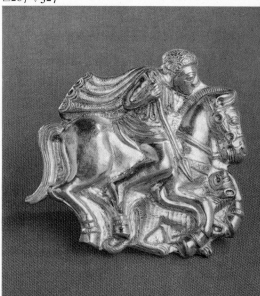

▽279

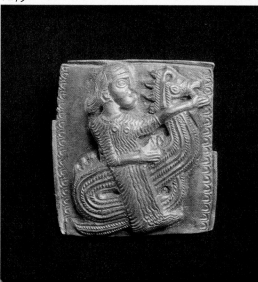

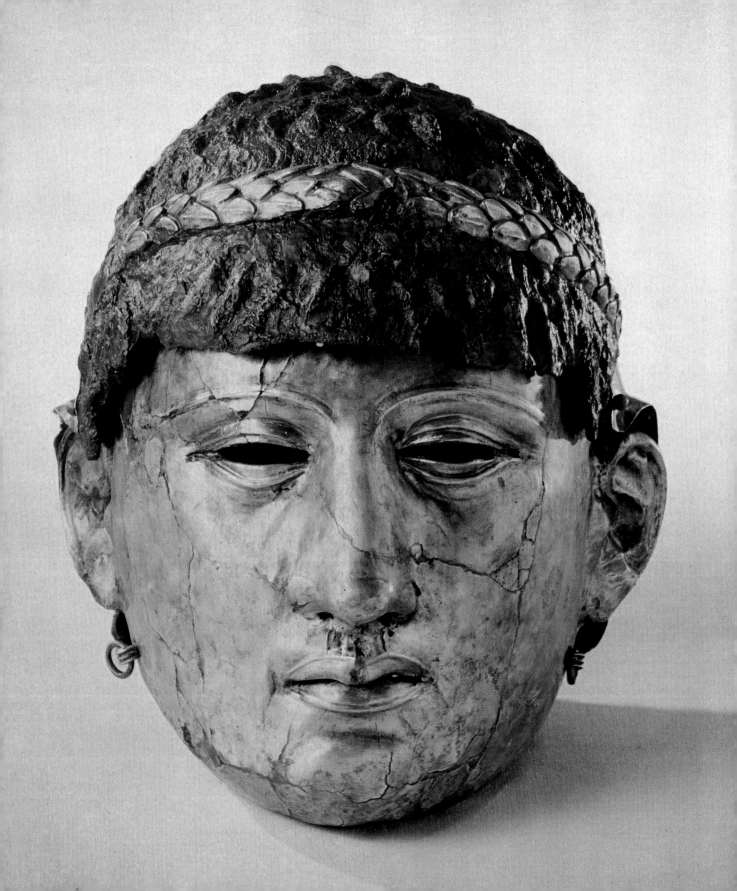

Thrace

For many a long year Thrace was an unknown country associated with all kinds of mysteries and legends, which students of ancient Greece were unable to explain through Greek history, culture, philosophy and religion. This was quite natural, because the complex study of Thracian antiquity, known as Thracology, was undertaken in Bulgaria only after the Second World War, and has recently developed in many countries.

One of the strangest and most mysterious figures in the history of Europe came from Thrace: Orpheus. Anyone can find his own interests reflected in this mystical personage: the historian sees the earliest Thracian king, who united Thrace and Macedonia under his rule; the archaeologist sees one of the ancient high priests who built the temple at Libethra; the musician sees the legendary singer who charmed not only men and beasts with his voice, but also the deities of the Underworld; the philosopher sees the ancient thinker who reformed the Thracian religion. It is therefore no accident that Orpheus should be the first person linked with the most strategic spot in Thrace, the Hellespont (Dardanelles), where he reigned by the will of none other than the god of wine and fertility, Dionysus. For, according to Diodorus, when this god, accompanied by his retinue of Sileni, Satyrs and Maenads, wished to pass from Asia into Europe at the head of his army, he had to obtain the consent of the ruler of these straits, the Thracian King Lycurgus. The king tried to deceive the god. When Dionysus passed into Europe with the Maenads, Lycurgus ordered his troops to slay the divine settlers. However, a certain Charops betrayed the secret to Dionysus. The god then returned to Asia in secret, led his army out from there, captured Lycurgus and tortured and crucified him. He then gave the Hellespont to Charops, who was the father of Oeagrus and grandfather of Orpheus.

The earliest mention of Thrace is to be found in these strange legends about Orpheus and the Thracians. The Thracian King Rhesus is another personality in Thrace who is mentioned in the Homeric epics and Greek legends. Greek legends place him sometimes around the mouth of the Strymon (the Strouma), sometimes in the Pangaeus Mountains, sometimes in Rhodope, along the shores of the Aegean from where he set out to help Troy in the war against the Achaeans. We know, of course, that the Trojan War was waged by Mycenae and the whole Achaean world for mastery over the Hellespont, that narrow sea route which led from the Aegean to the broad Pontus and the riches of Colchis. That was the country for which Jason set out in his ship the *Argo*, and Orpheus joined him at the Hellespont.

However, the Achaeans first set foot on Thracian land only after the victory over Troy. Returning with his ships, and pursued by the gods, Odysseus passed through Ismaros (Smyrna) on the shores of the Aegean, and turned aside to the land of the Cicones. Here he spared the life of Maron, King of the Cicones and High Priest of Apollo. In gratitude Maron richly rewarded him, giving Odysseus and his companions seven talents of gold, exquisitely worked, a silver crater and eleven amphoras of wine. The wine was so wonderful that

even when it was mixed with twenty times the amount of water, it still preserved its strength and flavour.

All these tales belong to an epoch in which Thrace was not yet a reality for the Greek writers. However, even later this country was to remain just as mysterious, because the Greeks were not accustomed to seeing people who differed so greatly and sharply from them in their way of thinking. It was the strange religion of the Thracians, above all, which impressed the ancient Greek historians. What was told them about the Trausi, a Thracian tribe of Southern Rhodope, seemed improbable to them. Herodotus was astonished that they should welcome death and accompany the dead to their resting place with songs and merrymaking, while they lamented over the newborn because of the hard life which awaited them. What this historian had to say about the Thracians who lived north of Belassitsa and Macedonia also seemed strange to them. The following custom was found among them: since they were polygamous, when a man died, his relatives tried to discover which of his wives he had loved the most; they then decked her out in all her finery, took her to the tomb and there her closest relative sacrificed her to the dead man. Thus she went into the other world to accompany her husband. The Thracians believed that they could associate with the gods and sending a messenger to a deity was something quite usual among them. This was also recorded of the Getae, who inhabited both sides of the lower reaches of the Danube. Herodotus described it thus: 'Every five years they choose by lot one among them, whom they send as an emissary to Salmoxis to tell him of their needs at the moment. They send him thus: several of them, selected to this end, hold three spears; others seize the messenger by the arms and legs, rock him in the air and cast him onto the spears. If he died, they believed that the god was favourable to them; if he did not die, they said that he was an evil man, casting the blame on the messenger. After which they sent another man!'

The god Salmoxis was also strange to the Greeks. According to legend he had once been King of the Getae, and taught them that no one really died, but that all went to a place where men lived eternally, enjoying all benefits. When Salmoxis himself died, he was resurrected three years later and, returning from the world of the dead, he proved to the Getae through his resurrection that he had spoken the truth. Herodotus gives a more rational explanation of the death of Salmoxis, accusing him of having hidden in an underground dwelling, which had been built beforehand, but he had doubts himself about this explanation, and gave up the attempt to find out if Salmoxis was man or god. In any case, it is obvious that the ideas of the Thracians about the other world, in which Salmoxis had offered them a paradise, were quite different from those of the Greeks, with their gloomy life of shades beyond the grave. Moreover, Herodotus asserts that besides Salmoxis the Thracians honoured only Dionysus, Ares and Artemis among the gods, and that when it thundered, the Getae shot arrows into the sky, believing that there was no other god but theirs, i.e. Salmoxis. Thus Herodotus himself sometimes

presents the Getae as followers of a primitive monotheism and sometimes presents the Thracians as worshippers of many gods.

These legends made Thrace seem quite different from Greece. Indeed, the ancient Greeks knew amazingly little about Thrace despite their geographical proximity to that country. For a long time they saw in it the home of Ares, the bloodthirsty god of war, and of the North Wind, Boreas, who dragged their ships down into the deeps of the sea. Even the sea which washed the eastern shores of Thrace was an inhospitable sea, the Pontus Axeinos.

The legends about Orpheus, about Rhesus and about Maron, and probably even about Salmoxis, should be referred to very great Antiquity, to the time about the Trojan War, i.e. to the Mycenaean period. Therefore, according to the Greek legends, the Thracians were already in Thrace at that time, i.e. between 1600 and 1200 BC. Of course, this conclusion, although confirmed by archaeology, is far from solving the great problem of the origin of the Thracians, which has recently exercised historians and is being considered in connection with their possible autochthonous tribal development and the great migrations in the Balkans.

Troubled times set in for the whole peninsula at the end of the Bronze Age. In Greece the Dorian Migration put an end to the Achaean kingdoms. A legend preserved by the Greek historians tells us that this was an even harder age for the northern part of the Balkan Peninsula, where the Phrygians migrated from Macedonia, around the mouths of the Rivers Vardar and Strouma, passing through the Dardanelles to settle in the lands of the Hittites, whose kingdom they destroyed. In the same period the Carians migrated from the lands along the lower reaches of the Danube. In Antiquity many names are mentioned which are common to Thrace and Asia Minor, a fact which ancient authors explain by the migration of part of the population of the Balkan Peninsula. Thus, for instance, the Mysians inhabited the lands along the Danube, but were also to be found in north-western Asia Minor; the Dardanians inhabited the upper reaches of the Vardar, and also gave their name to the inhabitants of Troy in the *Iliad;* the Mygdonians are mentioned in Macedonia and also in north-western Asia. References to the passing of the Thracians, known under the name of Bithynians, from the valley of the Strouma to the lands south of the Bosphorus are still more persistent. Finally, there is talk of a later migration of the Trerians and the Cimmerians through Thrace.

After all these migrations, some certain, others more conjectural, calm set in once more in both Greece and in Thrace. There is no information in this epoch either about Greece or about Thrace. However, somewhat later, when the Greeks settled along the Thracian coast and colonized it, we hear individual names, also legendary. Just as Maroneia bore the name of legendary Maron, whom Odysseus visited, so, according to Strabo, Messembria (modern Nessebur) was earlier called Menebria (i.e. the city of Mena) because its founder was called Mena, while *bria* meant 'city' in Thracian; thus the city of

Selya was called Selymbria (on the northern shore of the Propontis), while Aenus was once called Poltymbria. It is debatable how far these statements can be believed, although they are repeated in the works of several authors, going back to Herodotus, and some of them are supported by inscriptions. In any case, if we accept them as the truth, they give us a little information about persons who lived in the period after the ruin of the Achaean kingdoms and after the migrations. Trustworthy information about Thrace begins to appear much later when, thanks to colonization, the Greeks began to come into direct contact with the Thracians. From that time on we are well informed about Thracian society, Thracian political history and the Thracian way of life.

The Greek colonists were able to settle along the Thracian coast because they found the Thracians divided up into many tribes, although Herodotus noted that they were the most numerous people after the Indians. The king headed the tribe, and the tribal aristocracy was grouped around him. The numerous small tribes of south-western Thrace earlier joined in a tribal state, although its territory was small. For a long time the king was also the high priest, and in the days of Orpheus and Maron possessed both religious and political power. At first the Thracians had no cities. Life was lived in the villages and in the fortified residences of the chieftains. The population was organized in village communities chiefly engaged in stockbreeding, and to a limited extent in farming, living a rather isolated life for centuries in certain regions of Thrace.

The polygamous Thracian family was the basis of the community. A man had many wives, described by Greek authors as living a hard life. Women did the work in Thrace, both at home and in the fields. They reared children and, besides this, according to almost all Greek and Roman writers, were the servants of their menfolk. A man usually bought his wife from her parents. Before marriage young women had free intercourse with the men of their choice, but after marriage they were strictly guarded. According to Herodotus, Thracian men considered it shameful to till the land, and their noblest occupation was to go to war and to be tattooed, a custom which clearly indicates the contrast between the aristocracy and the peasantry. Parents often sold their children as slaves. Herodotus gives the same information to an even greater extent about the Lydians and the Carians, inhabitants of Asia Minor. It is hard to say how far the negative traits of a way of life, so different from that of the Greeks, were over-emphasized in the Greek sources. In any case, Thracian society resembled that of the tribes and peoples of Asia Minor rather than that of the Greeks in many respects, particularly in its distinctive features.

The Thracians did indeed inhabit a vast territory. Part of them had made their way into the islands of the Aegean Sea, while others inhabited present-day southern and eastern Macedonia, and also Pieria, a region of Thessaly. North of the Danube the population up to the Carpathians was Thracian, or

akin to the Thracians, while there were Thracians living in the lands as far as the Dnieper to the north-east. Finally, in Asia Minor to the south-east, Bithynia was also a Thracian region. That is why Greek colonization along the Thracian coast and in Asia Minor resulted not only in a breaking of ties between Asia Minor and Thrace, but also in detaching the Thracians of Asia Minor from those of Europe. More than fifty names of various tribes are known in Europe, among whom the Thyni on the Strandja Mountain; the Odrysae in the valley of the River Maritsa where Edirné (Adrianople) now stands, and in Eastern Rhodope; the Bessi in the southern regions of Rhodope; the Edoni, Bisaltae and Maedi along the River Strouma. There is less information about the tribes north of the Balkan range, where the Getae had settled on both banks of the lower reaches of the Danube, while the Mysians lived between them and the Triballi, who settled in the Valley of the Morava, north-western Thrace.

The important events which set in in the life of the Thracian tribes from the end of the seventh to the last decades of the fifth century BC were caused by the advance of the southern peoples to the north. The Greeks first began colonizing the Thracian coast in the second half of the seventh century BC. The shores of Aegean Thrace were occupied chiefly by colonists from Naxos and Chalcidice, after they had taken the islands of Thasos and Samothrace, while the Greek metropolises of Asia Minor were more active in colonizing the coast of the Propontis and the Pontus. Miletus was the most active of the cities of Asia Minor. In the light of the information we have regarding this colonization, the Greeks rarely settled in Thrace by peaceful means, the colonies they founded being several times destroyed and rebuilt.

Cities appeared along the Aegean coast: Amphipolis, Maroneia, Abdera, Aenus and the little towns in Thracian Chersonese (the Gallipoli Peninsula). Along the Propontis (the Sea of Marmara), Perinthus, Selymbria and Byzantium, and along the Pontus (Black Sea), Apollonia, Messembria, Odessus, Dionysopolis, Callatis, Istria, and many other smaller colonies, more than thirty of the latter, which played a more insignificant role. Colonization was still expanding when another misfortune befell Thrace. The Persians, who had gradually conquered the kingdoms of the Lydians, Carians and Phrygians in Asia Minor, struck at the Greek cities in this area and in 512 BC crossed over into Europe. The campaign which Darius undertook against the Scythians was aimed at placing Persian troops in their rear. The huge army of Darius crossed eastern Thrace and the Danube and made for Scythia. Here, after the defeat of the Persians, the Thracians followed at their heels, reaching as far as Thracian Chersonese. Somewhat later, while Darius was still on the Persian throne, the Persians made for Aegean Thrace. They reached the River Maritsa, at the mouth of which they had earlier built Doriscus, a large fort; they then crossed the river and captured the lands as far as the Mesta. From here, in the reign of Xerxes they made for the Strouma, crossed the river, conquered the Thracians of that region and, taking all the conquered

tribes with them, they made for Greece through southern Macedonia. Thus, in the course of more than thirty years the southern regions of Thrace were occupied by the Persians, who placed their military administration in the cities of Doriscus and Aenus, which remained there until 476 BC.

After their defeat the Persians withdrew to Asia, but the Greek colonists remained along the Thracian coast. We do not know whether it was before the withdrawal of the Persians or immediately after it that in the reign of Teres the Odrysae made for the regions inhabited by the Thyni and the small tribes in their neighbourhood, and conquered them. The Getae along the Lower Danube also joined his kingdom after this, but no one knows how they and the Bessi, the western neighbours of the Odrysae, came to be included in the Odrysaean kingdom. We do know that Teres improved his relations with the Scythian ruler Ariapites by giving him one of his daughters as his wife. Athens, which headed the Greek world after the Graeco-Persian Wars, appears to have been favourable to the founding of the Odrysaean Kingdom, in which she saw a strong ally, should the Persians try to cross into Europe again. The kingdom lay along the shores of the Propontis and the Black Sea up to the Lower Danube. In the last years of the reign of Teres many of the Greek cities between the mouth of the Mesta and the Maritsa, which had paid tribute to the Athenian Naval League as allies of the Athenians, reduced or absolutely stopped payment of their tribute. It is thought that this occurred because they now depended on Teres, to whom they had to pay a tax. For these reasons, and so as not to antagonize Teres, Athens consented to these payments being reduced or stopped.

Sitalces, the son of Teres, extended the lands of the Odrysaean kingdom to the west, as far as the upper reaches of the River Strouma. From here, after signing an alliance with Athens, he made for Macedonia but, receiving no aid from Athens, he was forced to put an end to his campaign.

The Odrysaean kingdom achieved great prosperity and from the mention by Thucydides it is apparent that in the reign of Seuthes I, who followed Sitalces on the throne, the annual revenue reached the sum of 400 talents, paid in gold and silver, at a time when taxes were the highest. Thucydides adds, moreover, that as much again was received in the form of gifts, not counting among them coloured and plain fabrics and other articles. For, according to the same author, gifts were offered not only to the king, but also to the governors and the Odrysaean nobles. In general this was a Thracian custom, but in contrast to the Persians, the Odrysae made full use of it. It appears that in the reign of Seuthes, who came to the throne in 424 BC, a change was made for the first time in the policy of friendship with Athens, followed until then. Information, of doubtful reliability, indicates that Seuthes I made war on the Athenian colonies in the Thracian Chersonese. On the other hand, it is also known that in the reign of Seuthes the Greek cities along the Aegean coast continued to pay taxes to the Odrysaean king. In the last years of the reign of Seuthes the Odrysaean kingdom began to decline rapidly.

The reigns of the three kings Teres, Sitalces and Seuthes I were a comparatively calm period of progress. In this period, alongside the kings who ruled the Odrysaean kingdom, sons and grandsons of Teres were appointed as governors of various parts of the kingdom. One of them was Sparatokos, the elder brother of Sitalces. Another grandson of Teres, a certain Maisades, ruled the Thynians and the neighbouring tribes between the Maritsa, the Black Sea and Propontis. At that time the Odrysaean kingdom began to disintegrate. The Greek historian Xenophon, arriving at the head of his army in Propontis on his return from the campaign against the Persians in 400 BC, was summoned by Seuthes II, the son of Maisades, to try and regain the land formerly ruled over by his father. Seuthes explained that he had grown up in the palace of Metokos, therefore the rebellion of the Thyni occurred in the reign of Metokos and after the death of Seuthes I. With the aid of Xenophon's army, Seuthes II dealt with the Thyni and the other rebellious tribes and re-established his rule. It therefore soon became necessary for Athens, and particularly for Thrasybulos, who was sent to Thracian Chersonese in 389 at the head of the Athenian fleet on the way to Byzantium, to reconcile Metokos and Seuthes II.

In 383 BC an energetic ruler, Kotys I, probably the son of Seuthes II, seems to have restored the unity of the Odrysean kingdom. In the course of his reign, which lasted until 359 BC, he tried to seize the Thracian Chersonese, and had some measure of success, but was unable to accomplish his plan, being killed by two inhabitants of Aenus. The death of Kotys, about whom ancient authors tell many anecdotes, describing him as a very artful and at the same time irascible and hysterical man, did not put an end to the war with Athens for the Thracian Chersonese. Kotys had availed himself of the services of two Greek generals and their mercenary armies, Iphicrates and Charidemos, whom he had married to his daughters. One of them, Charidemos, continued his operations under Kersobleptes, who followed Kotys on the throne. However, the disagreements with Amatokos, the heir of Metokos, led once more to the disintegration of the Odrysaean kingdom at a most critical moment, when an extremely enterprising ruler, Philip II, had come to the throne in Macedonia. He at once seized Amphipolis, crossed the Strouma and settled at the spot known as Crenides. Here the inhabitants of Thasos had just founded a colony, which Philip reorganized as a Macedonian city, calling it Philippi. Philip II took advantage of the strife which had broken out in the kingdom of the Odrysae and advanced eastwards, first into the lands of the independent Thracian tribes, and then into the lands of the Odrysae. In the middle of the fourth century BC Amatokos was forced to recognize the rule of the Macedonians and after him Kersobleptes was defeated.

The Triballi, who took advantage of the fighting between the Odrysaeans and the Macedonians, expanded to the east between the Danube and the Balkan Range, seizing the lands of the Odrysae and conquering all southern Thrace almost as far as the Balkan range. One of the kings of the Getae, a

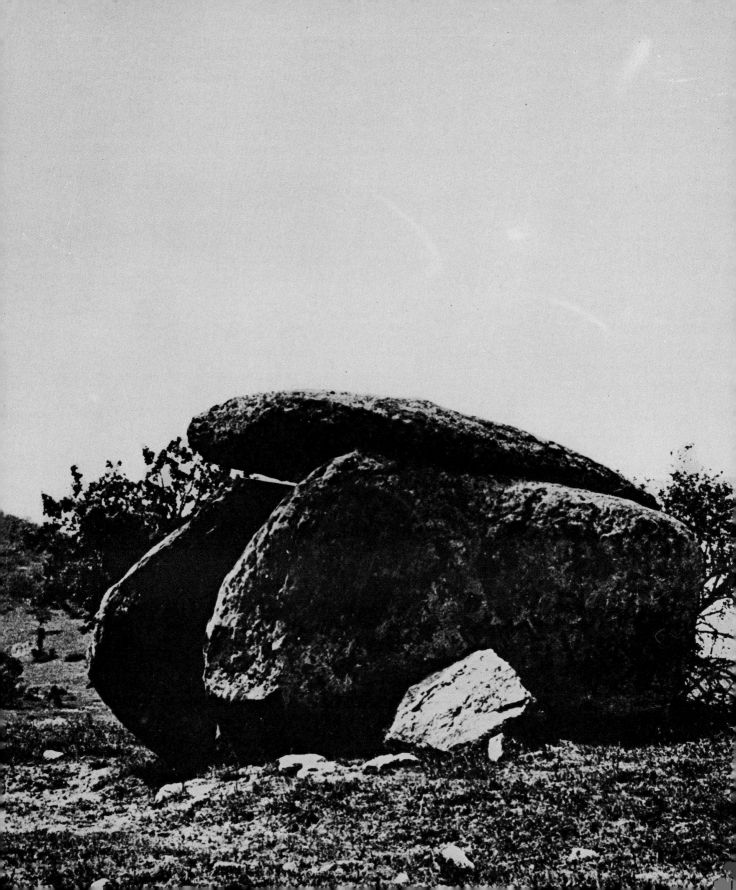

certain Kotylas, gave his daughter to Philip as his wife, as a hostage of peace. However, it was the son of Philip, Alexander the Great, who dealt with the Triballi, who had remained free. After the reign of Alexander, when the Kingdom of Macedonia, which had been extended to an extraordinary degree, was divided up and disintegrated, Thrace remained under the rule of his general Lysimachus, and a period in the development of the country came to an end.

We have a large amount of information on this period, but it sheds light only on part of the events in Thrace, since they concern those of the country's southern regions in which the Greeks had great political and economic interests. For the Greek authors, events which directly or indirectly affected the Greeks and their colonies in Thrace were of interest; that is why the internal relations in Thrace were insufficiently elucidated. It is hard to say what the relations between the individual Thracian tribes within the Odrysaean kingdom were and how they changed during the period of its power and when it declined.

It would appear that the Odrysaean kings were in the habit of placing their own trusted chieftains at the head of the individual Thracian tribes, while the Macedonians tried to depend on the lesser dynasts. Because of this, rulers on both sides of the Balkan Range formed alliances in the time of Lysimachus. Seuthes III, who ruled the Valley of Roses, was one of them, while Dromichaites, ruler of the Getae, headed another. There were big clashes between the alliances and Lysimachus in which neither he nor the Thracians got the upper hand. Lysimachus's further struggles to master Macedonia, and after that Asia Minor, where he died, reduced the powers of resistance of all the peoples of the Balkan Peninsula and opened the gates to the invasions of the Celts from Central Europe.

After invading Macedonia and Thessaly the Celts made for Thrace, where a considerable number of their groups settled and founded a kingdom. While some of them were busy plundering and looting Thrace, without sparing the Greek colonies, another group of them crossed the whole of Thrace and settled in Asia Minor, where Galatia was founded on the former territory of Phrygia. In Thrace the kingdom of the Celts only lasted from 279 to 216 BC when it was finally swept away by a rebellion of the Thracians, who received help from Macedonia. However, liberation from Celtic rule did not lead to union, but to the complete splitting up of Thrace. Just when the Celtic rule was overthrown in Thrace, a new conqueror appeared in the westernmost regions of the Balkan Peninsula, slowly making his way from the shores of Albania to the interior.

In 168 BC the Romans were already masters of both Macedonia and Greece, and were gradually imposing their rule on the Greek colonies in Thrace and on Thrace herself. They found the Odrysaean kingdom weakened and ruined, and in the course of the first century BC Rome exploited this situation in order to impose her rule on the neighbouring tribes. Actually, however, this whole

period was spent, above all, in fighting with Macedonia and afterwards, when the kingdom had become a Roman province, in fighting between the Bessi and the Odrysaeans. At the end of this period, around 56–54 BC the Getae organized a powerful military and political alliance under Burebista. It was, however, shortlived and Rome subjected the north-western regions of Thrace. The province of Moesia was formed there, while the south-eastern parts of the country became a Roman Protectorate, ruled by the Odrysaean kings. The complicated internecine strife which Rome created in Thrace paved the way for the gradual and imperceptible turning of the Odrysaean kingdom into a new province — Thrace.

From the first century AD the fate of the numerous Thracian people was decided. The Roman Empire built cities in the provinces it had founded, cities in which the crafts flourished, in which there was a rich citizen class, possessing considerable estates, and in which there were paved roads and temples. In most cases the Roman rulers organized life in those centres which had formerly had a more or less urban character. We know, for instance, that as early as the oldest Thracian kings certain settlements had developed in size to the level of cities. Demosthenes mentions several of them, such as Kabyle, near Yambol, Masteyra (near the village of Mladenovo, Haskovo district) and Drongilion. On the other hand, we also know the name of a city which was the residence of the rulers of the Getae, Helis. The most important Thracian city of the Hellenistic period discovered and excavated so far is Seuthopolis near Kazanluk, on the River Toundzha. The conquest of Thrace by the Macedonian kings also resulted in the building of many cities in the country, such as Philippi in the southern regions; Philippopolis, which in their language the Thracians called Poulpoudeva (modern Plovdiv), the Thracian name being a translation of the Greek name and meaning Philip's City. There was also Beroë (now Stara Zagora). It is probable that many more settlements like Serdica (modern Sofia) appeared still earlier, and that the Romans found an already fairly well-developed city life in them. In any case, the building of roads, and turning the cities into important trade, administrative, military and cultural centres, led to a considerable part of the peasant population of Thrace becoming urbanized. The officers, the army and the military officials brought from other countries, or from Italy, the veterans who colonized Moesia and Thrace, the officials, merchants and craftsmen who were brought here, played a big part in creating this urban life. As everywhere else, this rapid transformation of life in the provinces created stability for the Roman rule and respect for its government. The Roman legionaries who manned the frontiers, the First Italian, the Fifth Macedonian and the Seventh Claudian legions, as well as the numerous auxiliary troops organized in various squadrons and cohorts, provided a strong defence for Thrace and a peaceful life, which it had not known in earlier times. There were, of couse, many invasions, but the Roman Empire was strong enough to overcome them and turn them into brief and temporary misfortunes. It was this which provided all the neces-

sary conditions for the prosperity of the two provinces, which reached its zenith in the period from the middle of the second to the middle of the third centuries AD. By that time Moesia was no longer a frontier region. Divided into two parts, Upper and Lower Moesia, it had become an inner region of the Roman Empire after the conquest of Dacia by the Emperor Trajan. The Severan period (the turn of the second and third centuries AD) was one of the greatest prosperity for Roman Thrace.

The Roman way of life transplanted in Thrace did much for the gradual Romanization of its people; however, Greek was still the official language in the greater part of the country. Greek had a long history in Thrace, since as early as the time of the Macedonians, and even earlier it had come to the fore as an international language. The few official inscriptions of the Thracian kings were written in Greek. The oldest of them is the inscription settling the relations between the followers of Seuthes III, who ruled at Seuthopolis, and the ruler of Kabyle. Far more inscriptions of the last Thracian kings have come down to us, however, and they too are written in Greek, even at a time when Thrace was already a Roman protectorate. The coins of the Thracian kings also had Greek inscriptions.

In the fourth century AD Thrace fell under the rule of the emperors of the Eastern Roman Empire, the capital of which was actually one of the cities of Thrace, Byzantium (Constantinople). However, when the Roman Empire disintegrated a new period set in, a period which our exhibition does not touch upon.

The archaeological wealth of ancient Thrace

Whoever travels in Bulgaria today has noticed the countless Thracian grass-covered burial mounds which dot the plains and hilly regions. Here, as all over Europe, they are the most important sources for the study of ancient cultures. Besides the rich and interesting finds there are stone tombs within these mounds which reveal something of the history of Thracian architecture. These burial mounds have produced jewellery worn by women, arms borne by men and the trappings of their horses, the ornaments of their cuirasses and shields, vessels made of clay, bronze, glass, silver and gold, and countless other articles used in daily life.

The treasures hidden in the earth are of no less importance. Composed of wonderful gold and silver vases, of the coins in circulation in Thrace, and sometimes of jewels and ornaments made of precious metals, they all complete the picture of the development of Thracian culture. The Thracian settlements are being carefully studied. However, in this country, as in the eastern kingdoms, it is the palaces of the kings which would provide a fuller picture of the achievements of Thracian architecture. The greater number of them still escape the archaeologist's eye; the only residence of Thracian rulers

discovered so far is Seuthopolis, capital of one of the more outstanding Thracian kings, Seuthes III, who reigned in the period of Alexander the Great and Lysimachus.

In offering a selection of Thracian wealth it should be borne in mind that it does not come from the whole of ancient Thrace, but only that part which is now within the present boundaries of Bulgaria. It originates therefore from an area of only 110,000 sq. km., yet shows a variety not to be found in any other country, and which is largely due to the proximity of Thrace to the great cultures of the first millennium BC. This wealth was the fruit of the inner development of Thrace which, lying as it did between several cultures totally different in character from one another, adopted elements from them all. For Thrace, which is a European country, has a culture which is not very different from those of the neighbouring countries of Central and Western Europe. However, Thrace was very near Greece and was divided from Asia Minor by two straits alone, neither of them wider than a big river. Persia, the most highly cultured country of the East, which had absorbed the culture of almost all the peoples she had conquered: Assyrians, Babylonians, Urartians, Phrygians, Lydians and Carians, and even the Bithynian Thracians, lay beyond those two narrow straits. On the other hand, the Greeks surrounded her on all sides. Their colonies sprang up along the whole coast of Asia Minor, of Southern Russia and of Thrace herself. Lastly we should not forget the Scythians of Southern Russia, to whom research workers assign a considerable contribution to the development of Thracian culture. Situated on the outskirts of four very different cultures Thrace could most easily pass from the range of one into the range of another of them, accepting elements from all these cultures. Moreover, when it is borne in mind that in the last three centuries of the first millennium BC the Celts, and after them the Romans, penetrated deep into the Balkan Peninsula, we cannot well expect a steady and calm development in Thrace, such as is to be observed in Western or Central Europe.

The Thracian material and spiritual culture, highly original and richly coloured by fruitful interrelations, is the result of many centuries of dramatic historical development, and can be considered one of the most beautiful and brilliant stones in the mosaic of civilizations in the period of the slave-owning society.

IVAN VENEDIKOV

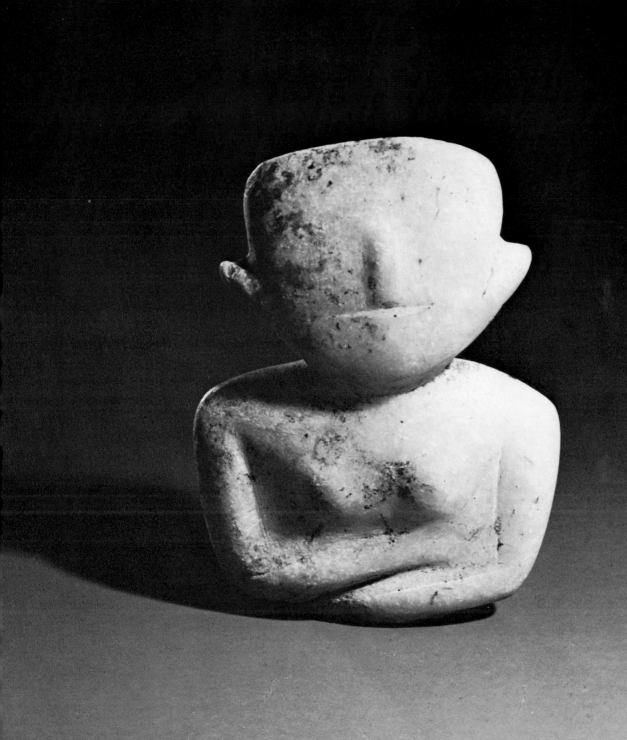

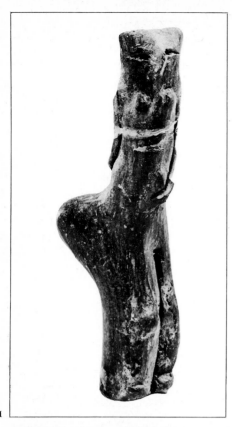

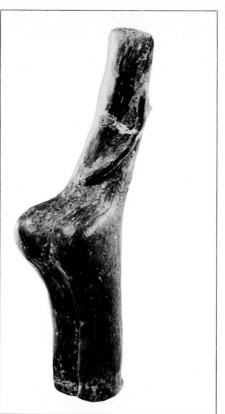

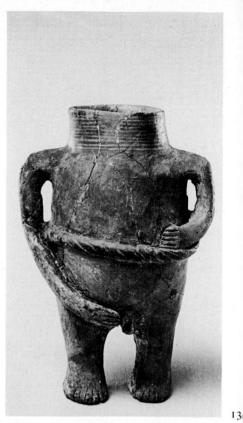

1

13

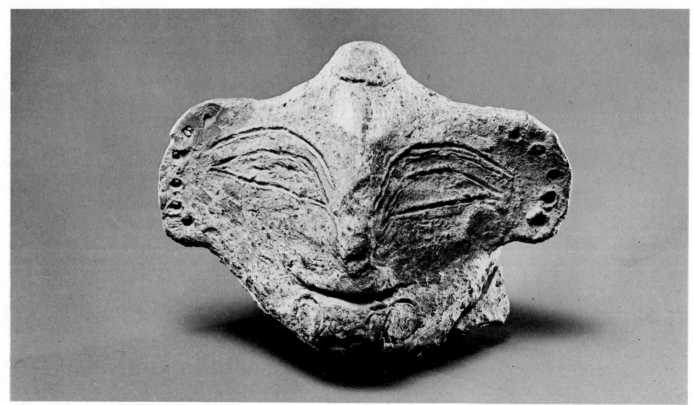

9

Thrace before the Thracians

NEOLITHIC TO THE LATE BRONZE AGE

The first rich culture in Thrace came into being in the sixth, fifth and fourth millennia BC. The forms of its artefacts were original and they appeared spontaneously without there having been any earlier developments in the country. This culture belonged to an unknown and mysterious people. Scholars cannot explain it, but ascribe to it a slow and regular development. It appeared over almost all the country at the same time.

It is, however, possible to find certain similarities between Thrace and Asia Minor. In Asia Minor the walls of forts were made of stone, those of houses of lath and plaster, whereas in Thrace both types of walls were made of lath and plaster. The burial mounds are similar in both regions; local pottery, gracefully made from its very beginnings, was often brightly coloured and richly ornamented. In Thrace, as in Asia Minor, it is images of the mother-goddess which predominate in the idols made of clay or bone, whether as a pregnant woman, a woman in labour or a mother.

About the end of the fourth millennium this culture reached its zenith. Models of houses were made of pottery, and the first examples of stone sculpture, and sickles made of antlers, whose cutting edges were of flint (No.7) made their appearance. These examples have close parallels in Asia Minor.

It often happens that accepted opinions about a given society (primitive and backward) are seriously upset by the discovery of a necropolis such as the one near Varna, dating back to the end of the fourth millennium BC. The richness of the treasures discovered here, especially the considerable quantity of gold jewellery indicates that these were the tombs of rulers.

At a later date, about 2800 BC, far-reaching changes took place throughout the Bronze Age, changes which contributed to the disappearance of all traces of this culture and which were connected with a strongly centralized rule.

The decline which followed does not allow us to present any considerable examples of works of the Early and Middle Bronze Age. Here the Bronze Age is restricted to the Late Bronze Age, which already belongs to the Thracian culture.

1 IDOL
Pottery, height 11·5 cm.
Karanovo, near Nova Zagora.
Early Neolithic, about 5500 BC.
Archaeological Museum, Sofia.
Inv.No.4033.
Brown surface, undecorated.
Bibl. G. Georgiev, *Kulturgruppen der Jungstein— und der Kupferzeit in der Ebene von Thrazien.* Prague, 1961, 64, Fig.1.

2 ANTHROPOMORPHIC VESSEL
Pottery, height 25·5 cm., breadth 19 cm.
Gradeshnitsa, Vratsa district.
Early Neolithic, about 5500 BC
Vratsa, District Museum of History.
Inv.No.A-2022.
A vessel with a high neck on which a human face is schematically depicted. The vessel is covered with a beige slip and has geometrical ornaments painted on it in black.
Unpublished.

3 IDOL
Pottery, height 13·5 cm.
Karanovo, near Nova Zagora.
Late Neolithic, about 4000 BC.
Archaeological Museum, Sofia.
Inv.No.4035.
Pale brown. Painted in dark brown. An elongated head.
Bibl. G. Georgiev, *op. cit.*, Plate XXXII, Fig.1.

4 IDOL
Marble, height 7 cm., breadth 5 cm.
Karanovo, near Nova Zagora.
Late Neolithic, about 4000 BC.
Nova Zagora, Museum of History.
Inv.No.3395.
Figure of a woman, preserved to the waist. Trapezium-shaped head. The nose, ears, breasts and arms crossed on the abdomen are depicted in relief.
Bibl. M. Kunchev, *Praistoricheski i antichni materiali ot mouzeya v gr. Nova Zagora*, Nova Zagora, 1973, No.15, A.

5 VESSEL
Pottery, height 18·5 cm.
Karanovo, near Nova Zagora.
Late Neolithic, about 4000 BC.
Archaeological Museum, Sofia.
Inv.No.3406.
Brown surface ornamented with cone-shaped buds. The handle and small legs are cylindrical.
Bibl. G. Georgiev, *op. cit.*, Plate XXXI, Fig.4.

6 DISH
Pottery, height 11 cm., diam. 21 cm.
Karanovo, near Nova Zagora.
Early Neolithic, about 5500 BC.
Archaeological Museum, Sofia.
Inv.No.3550.
Ornamented on the outside in black (graphite) on a brown background.
Unpublished.

7 RITUAL SCENE
Pottery.
Ovcharovo, Turgovishté district.
Late Chalcolithic, about 3000 BC.
Turgovishté District Museum of History.
Inv.No.1459 — from A to XI, 2, 3.
Model of an open-air shrine with small figures of priests, altars, cult tables, small chairs and large and small cult vessels in it. All painted in black and decorated with spirals, meanders, triangles and other geometric designs.
Bibl. H. Todorova, *Eneolitna koultova Stsena. Sp . . . Mouzei i pametnitsi na koultourata,* XIII, 1973, No.4.

8 SEAL
Pottery, diam. 6 cm.
Karanovo, near Nova Zagora.
Late Neolithic, 3800–3600 BC.
Archaeological Museum, Sofia.
Inv.No.4031.
In the form of a disc divided into four parts in which letter-like signs are incised. A cone-shaped handle on the reverse

9 HEAD OF AN IDOL
Pottery, height 7·2 cm.
Karanovo, near Nova Zagora.
Late Chalcolithic, about 3000 BC.
Archaeological Museum, Sofia.
Inv.No.4034.
Light brown surface. Eyes green; wrinkles around the eyes, lips and forehead in red.
Bibl. V. Mikov, *IBAI,* VIII, 1934 and 198, Fig. 132.

10 FLAT IDOL
Bone, height 15 cm., breadth 5·1 cm.
Lovets, Stara Zagora district.
Late Chalcolithic, about 3000 BC.
Stara Zagora. District Museum of History.
Inv.No.1-C3-135.
Schematic figure of a woman, the individual parts of the body indicated by grooves and incised lines. Small copper plates wound under the knees.
Bibl. M. Dimitrov, *Archaeologia,* IV, 1962, No.1, c.65–67.

11 SICKLE
Antler, with flint teeth, height 21 cm.
Karanovo, near Nova Zagora.
Late Chalcolithic, about 3000 BC.
Archaeological Museum, Sofia.
Inv.No.3143.
Unpublished.

12 DISH
Pottery, height 16 cm.
Karanovo, near Nova Zagora.
Late Chalcolithic, about 3000 BC.
Painting on a red background with incisions and encrustations in white.
Unpublished.

13 ANTHROPOMORPHIC RHYTON
(drinking vessel)
Pottery, height 15 cm.

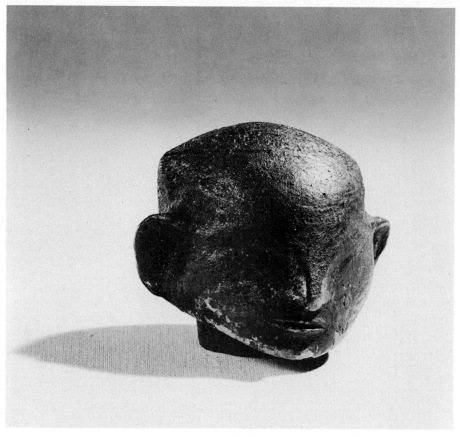

14

Gabarevo, near Kazanluk.
Late Chalcolithic, about 3000 BC.
Archaeological Museum, Sofia.
Inv.No.2957.
Figure of a man, dark brown polished surface.

14 HEAD OF AN IDOL
Pottery, height 7 cm.
Gabarevo, near Kazanluk.
Late Chalcolithic, about 3000 BC.
Archaeological Museum, Sofia.
Inv.No.2958.
Black surface, may have had ornaments of red ochre, now vanished.
Bibl. V. Mikov, *IBAI,* VIII, 1934, Fig.132.

15 IDOL
Marble, height 33 cm.
Blagoevo, Razgrad district.
Late Chalcolithic, about 3000 BC.
District Museum of History, Razgrad.
Inv.No.770.
Bibl. G. Georgiev, *INI,* XIX, 1955, 1–13.

16 TWO-FACED IDOL
Pottery, height 41 cm., breadth 25 cm.
Stara Zagora Mineral Baths, near Stara Zagora.
Late Chalcolithic, about 3000 BC.
Stara Zagora, District Museum of History.
Temporary Inv.No.St.Z.B.-665.
A hollow figure of a woman with arms crossed on her abdomen. The front and back of the

body are almost exactly the same. The faces have incised eyes and mouth, ears and nose in relief. An opening on the back of the head.
Restored.
Unpublished.

17 MODEL OF A SHRINE
Pottery, height 13·5 cm., breadth 14·5 cm.
Stara Zagora Mineral Baths, near Stara Zagora.
Late Chalcolithic, about 3000 BC.
Stara Zagora, District Museum of History.
Temporary Inv.No.St.Z.B.-1258.
Model of a building with a saddle roof and two 'chimneys' with wide openings beside it, placed on a base shaped like a four-sided prism.
Unpublished.

18 MODEL OF A HOUSE
Pottery, height 20 cm.
Kodzhadermen, Shoumen district.
Late Chalcolithic, about 3000 BC.
Archaeological Museum, Sofia.
Inv.No.1367.
Light brown surface with incised ornaments.

19 MODEL OF A HOUSE
Pottery, height 6·5 cm.
Vinitsa, near Preslav.
Late Chalcolithic, about 3000 BC.
Archaeological Museum, Sofia.
Inv.No.4037
Incised decoration. Unpublished.

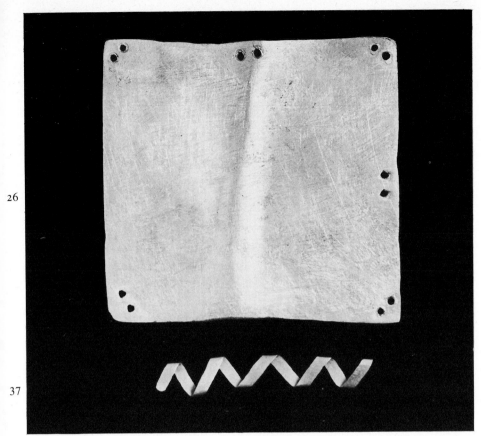

26

37

20–72
The Varna Treasures
ARCHAEOLOGICAL MUSEUM, VARNA.

These treasures belong to the Late Chalcolithic Age (3200–3000 BC) and are part of the finds from the necropolis of that date near Varna. They were discovered in tombs 1 and 36 of the necropolis, where digging has been in progress since 1972, and are shown to the public for the first time in this Exhibition. We are most grateful to the director of the excavation, Research Fellow Ivan S. Ivanov, for permission to show part of this unique find, as yet unpublished. Digging is still in progress at the necropolis, and 44 tombs have so far been brought to light, in many of which there are similar articles. Some of the tombs have no skeletons in them and were probably symbolic burials or cenotaphs. This necropolis offers us surprising information about a highly organized society with the beginnings of social differentiation existing at the end of the Chalcolithic Age in the Balkan Peninsula.

Bibl. Iv. Ivanov, *Eneolitniyat necropol pri*

Varna — 'Mousei i pametnitsi na koultourata', 1974, 44–47.

Tomb No.1

20 BRACELET
Gold, diam. 9·6 cm., thickness 4 cm., weight 268 gr.
Inv.No.I-1512.

21 BRACELET
Gold, diam. 9·6 cm., thickness 5 cm., weight 194·32 gr.
Inv.No.I-1513.

22 BRACELET
Gold, diam. 7·8 cm., thickness 0·7 cm., weight 139 gr.
Inv.No.I-1515.

23 BICONICAL BEAD
Gold, diam. 0·9 cm., weight 0·54 gr.
Inv.No.I-1554.

24 NECKLACE WITH 162 BEADS
Gold, diam. 0·3 to 0·5 cm., weight 30·96 gr.
Inv.No.I-1555.
All the beads are cylindrical.

25 SEASHELLS FROM A NECKLACE
Inv.No.I-1558.
Seashell (*ventalium*)

26 PECTORAL
Gold, width 11·3 cm., length 10·3 cm., weight 189 gr.
Inv.No.I-1514.
Quadrangular in form with rounded corners. There are holes by which it was attached at each end.

27 HEAD OF A SCEPTRE (Fragment)
Gold, height 7·2 cm., diam. 2·4 cm., weight 50·74 gr.
Inv.No.I-1516.
Cylindrical in form.

28 TWO RINGS
Gold, diam. 3·5 cm., 3·7 cm., weight 43·96 gr.
Inv.Nos.I-1520 and 1521.

29 FOUR RINGS
Gold, diam. 1·6 to 2·17 cm., weight 8·16 gr.
Inv.Nos.I-1522, I-1526, I-1539, I-1553.

30 THREE CYLINDERS
Gold, height 1·5 to 1·9 cm., weight 26·07 gr.
Inv.Nos.1523 to 1525.

31 TWENTY-FOUR PLAQUES
Gold, diam. 1·3 to 2·2 cm., weight 29·79 gr.
Inv.Nos.1531 to 1538, I-1559 to 1562, I-1566 to 1573, I-1576, I-1577, I-1582 and I-1585.
Round, concave, on one of them there are five holes by which it was attached, on the twenty-three others there are only four holes.

32 SIX PLAQUES
Gold, height 1·2 to 1·5 cm., weight 4·88 gr.
Inv.Nos.I-1530, I-1578 and I-1581.
They are shaped like a trapeze and have one or two holes by which they were attached.

33 FOUR PLAQUES
Gold, width 3·5 to 3·7 cm., weight 10·76 gr.
Inv.Nos.I-1527, I-1528, I-1551, I-1552.
Shaped like a half moon with a hole at each end by which they were attached.

34 HEAD OF A SCEPTRE
Gold, height 7·4 cm., diam. 2·2 cm., weight 68·78 gr.
Inv.No.I-1517.
Cylindrical and hollow.

35 SPHEROID
Gold, diam. 2 cm., weight 25·09 gr.
Inv.No.I-1518.
Has a round opening. Function not established.

36 NAIL
Gold, height 1·7 cm., weight 8·16 gr.
Inv.No.I-1519.

37 OBJECT IN THE FORM OF A SPIRAL
Gold, height 8·1 cm., width 1·2 cm., weight 3·20 gr.
Inv.No.I-1550.
Use unknown.

38 UNIDENTIFIED OBJECT
Copper, length 14·9 cm., width 0·8 cm.
Inv.No.I-1544.
Wider in the middle, one end pointed and bent.

39 AXE
Copper, length 19·2 cm., width 3·2 cm.
Inv.No.1540.
Rounded, with triangular edge and elliptical opening.

40 AXE
Copper, height 14·1 cm., width 3·2 cm.
Inv.No.I-1542.

41 WEDGE
Copper, height 14·3 cm., breadth 2·9 cm.
Inv.No.I-1542.

42 CHISEL
Copper, height 14·6 cm., width 1·1 cm.
Inv.No.I-1543.

43 THREE AWLS
Copper, length from 5·4 to 8·2 cm., width 0·3 to 0·4 cm.
Inv.Nos.I-1545, I-1546, I-1547.

44 KNIFE
Flint, length 6·5 cm.
Inv.No.I-1548.
Broken in three pieces, light brown.

45 KNIFE
Flint, length 11·2 cm.
Inv.No.I-1548.
In two pieces.

46 TWO KNIVES BROKEN IN TWO PIECES
Flint, lengths 43 cm. and 24·5 cm.
Inv.Nos.I-1547 and I-1565.

47 KNIFE
Flint, length 11·6 cm.
Inv.No.I-1546.

Tomb No.36

48 SCEPTRE
Gold, total length 22·5 cm., maximum width 5·3 cm., weight 85·47 gr.
Inv.Nos.I-1641 to I-1649.
Consists of seven parts: Cylindrical tip, cross-section with intricate profile (broken in two), three cylindrical handles, a ring-like cover and an oblong profiled part (broken in two).

49 BRACELET
Gold, diam. 6·7 cm., height 2·6 cm., weight 47·30 gr.
Inv.No.I-1631.
The bracelet has a double arc-shaped profile, without ornament.

50 BRACELET
Gold, diam. 6·9 cm., height 2·7 cm., weight 55·21 gr.

Inv.No.I-1632.
Similar to 49.

51 DIADEM
Gold, length 3·4 cm., height 3·4 cm., weight 11·72 gr.
Inv.No.I-1635.
The diadem is an arc-shaped rectangular plaque with a higher triangular piece in the centre. There are holes by which it was attached at each end.

52 HEMISPHERE
Gold, diam. 3·5 cm., height 1·9 cm., weight 16·68 gr.
Inv.No.I-1639.

53 PLAQUE
Gold, diam. 3·3 cm., height 0·7 cm., weight 5·60 gr.
Inv.No.I-1640.
A small round concave plaque with beading in relief along the edge and four holes by which it was sewn on.

54 THIRTY-THREE PLAQUES
Gold, diam. from 1·8 to 2·6 cm., height from 0·6 to 1 cm., total weight 99·18 gr.
Inv.Nos.I-1637 to I-1719.
Round unornamented concave plaques with four holes each by which they were sewn on.

55 ARC-SHAPED OBJECT
Gold, length 8·8 cm., width 5·6 cm., weight 17·05 gr.
Inv.No.I-1637.
Use unknown.

56 MODEL BOOMERANG(?)
Gold, length 4·1 cm., width 1·2 cm., weight 5·47 gr.
Inv.No.I-1638.

57 SIXTEEN RINGS
Gold, diam. from 1·6 to 3·5 cm., total weight 27·71 gr.
Inv.No.I-1720 to I-1735.
Made of round wire, with overlapping ends.

58 STRING OF TWO HUNDRED AND FIFTY-SEVEN CYLINDRICAL BEADS
Gold, diam. from 0·2 to 1 cm., total weight 125·10 gr.
Inv.No.I-1737.

59 STRING OF ONE HUNDRED AND SIXTY-EIGHT CYLINDRICAL BEADS
Gold, diam. from 0·2 to 0·8 cm., total weight 97·82 gr.
Inv.No.I-1738.

60 STRING OF ONE HUNDRED AND THIRTY-SIX CYLINDRICAL BEADS
Gold, diam. from 0·2 to 0·8 cm., total weight 45·33 gr.
Inv.No.I-1741.

61 STRING OF FIFTY-FOUR CYLINDRICAL BEADS
Gold, diam. 0·4 to 0·8 cm., total weight 15·69 gr.
Inv.No.I-1743.

62 FORTY-FOUR BEADS FROM A STRING
Gold, diam. from 0·4 to 0·8 cm., total weight 16·64 gr.
Inv.No.I-1736.
Identical with the above.

63 STRING OF FIFTY-SEVEN SPHERICAL BEADS
Gold, diam. 0·2 cm., total weight 2·90 gr.
Inv.No.I-1740.

64 TWENTY-TWO BEADS FROM A STRING
Gold, diam. from 0·4 to 0·8 cm., total weight 4·94 gr.
Inv.No.I-1739.

65 FOURTEEN BICONICAL BEADS FROM A STRING
Gold, diam. from 0·4 to 0·8 cm., total weight 2·85 gr.
Inv.No.I-1742.

66 SEVEN SMALL ANTHROPO-MORPHIC PLAQUES
Gold, length from 1·8 to 2·1 cm., diam. 1·5 to 2·0 cm., total weight 13·34 gr.
Inv.Nos.I-1650 to I-1656.
Four of the plaques are concave with two holes each on a trapezium-shaped projection, two are concave with an opening in the middle and two holes each in the projecting piece, and one is flat with an opening in the middle and one hole in the projecting piece.

67 THIRTY SMALL ZOOMORPHIC PLAQUES, FROM A STRING(?)
Gold, length from 2·8 to 4 cm., height from 1·2 to 2·1 cm., total weight 50·37 gr.
Inv.Nos.I-1657 to I-1686.
Flat schematic images of a horned animal head with two holes each on the lower part.

68 FIGURINE OF AN ANIMAL
Gold, length 6·5 cm., height 5·8 cm., weight 11·70 gr.
Inv.No.I-1633.
A flat figure in profile of a horned animal. Ornamented with beading in relief around the edges, with two holes at the upper end by which it was attached.

69 FIGURINE OF AN ANIMAL
Gold, length 3·9 cm., height 3·7 cm., weight 6·74 gr.
Inv.No.I-1634.
Identical with the preceding figure, but smaller in size.

70 MODEL OF A KNUCKLEBONE
Gold, length 1·9 cm., width 1·2 cm., thickness
0·8 cm., weight 33·17 gr.
Inv.No.I-1636.

71 SMALL DISH
Marble, diam. 15·9 cm., height 4·5 cm.
Inv.No.I-1749.
Shaped like a truncated cone, with a small
bottom and a rounded edge to the mouth.

72 KNIFE
Flint, length 29·5 cm., width 2·1 cm.
Inv.No.I-1755.
The knife is curved like an arc, its cross-section
is shaped like a trapeze.

73

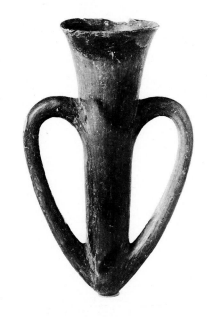

73 TWO-HANDLED VESSEL
Pottery, height 20 cm.
Mihalich, Kurdjali district.
Early Bronze Age, 2750–2000 BC.
Archaeological Museum, Sofia
Inv.No.3190.
Grey, polished.
Bibl. V. Mikov, *RP*, I, 1948, 57–25.

74 CUP
Pottery, height 9·5 cm., diam. of mouth 3 cm.
Village of Ezero, near Nova Zagora.
Middle Bronze Age, 2000–1500 BC.
Nova Zagora Museum of History.
Inv.No.2247.
The cup has a spherical body, a cylindrical
neck with raised mouth and a small flat
bottom. The handle is high above the body and
ends in a knob.
Bibl. M. Kunchev, *Preistoricheski i antichni
materiali ot mouzeya v gr Nova Zagora*, Nova
Zagora, 1973, No.57-B.

Thracian Art
in the era of the
legendary kings

LATE BRONZE AGE: 1600–1200 BC

In Greek legends the history of the Achaean
kings of Mycenae is interwoven with that of
the Thracian kings and this has led many
scholars, who consider the *Iliad* and the
Odyssey as a source for the earliest history
of the peoples of the Aegean, to explain the
culture which is discovered in Thrace as
belonging to the Thracians mentioned in
these legends.

In the age of Orpheus, of Maron or Dio-
medes, whose horses tore strangers to
pieces, Troy dominated the Hellespont; to
the east of that city lay the kingdom of the
Hittites, to the west, in the southern part of
Macedonia, lay the land of the Phrygians,
while the Scythians and the Paeonians had
not yet settled in Central Russia and in
Macedonia.

In this period, as yet only slightly known,
the life of the Thracian tribes did not differ
greatly from that of the other peoples in the
northern part of the Balkan Peninsula.

Pottery was the most widespread art, and
the distant influence of Mycenae was to be
felt in it, but Thracian pottery differed from
Mycenaean both in form and in ornamen-
tation. The proportions of the vessels were
rather heavy, they were ornamented with
incisions and encrustations of a white paste
(Nos.95 to 101); this also applies to vessels
shaped like birds and to the idols, depicted
in the form of a woman, wearing a long
dress, as at Mycenae (Nos.91 to 94). We
once more find these clear and ornamental
features of both countries in the Western
Balkan Range and in the Carpathians, and
also in certain regions of the Danube along
its middle and lower reaches. The pottery
of southern and western Thrace is similar
in character, but it is more primitive, as in
general the entire culture of these regions is
calmer in the north-west than in the south
and the east — a fact which may be due to
the way of life.

In this period the bronze weapons of the
Thracians are found all over the Danubian
Plain, where two-edged swords, with a very
lengthened point, were used. The rapier
with a cross-shaped handle, which made
thrusting possible, was also known.

The rapiers found in Thrace are of the
same quality as those discovered in Greece,
and it was thought for a long time that they
had been imported from Mycenae. How-
ever, aside from articles which were com-
mon to Thracians and Greeks in Homer's

epoch, Thracian art was often of a local character, as can be seen from the matrices for the casting of bronze weapons discovered at Pobit Kamuk, near Razgrad (Nos.81 to 87). Improved ornamentation proves that they were intended for Thracian chieftains, and shows what perfection the technique of the master bronze workers had reached to satisfy their wishes. On the other hand, the discovery of these matrices, which were probably deliberately buried, is evidence of the incursion into Thrace of a population which surely did not possess such highly perfected articles.

The bronze work such as we see here is the zenith of an already highly advanced technique. Some articles cast in similar matrices are to be found in Romania and therefore provide evidence of a local art. Another treasure, that of Vulchitrun, demonstrates the skill of the craftsmen better still, not only in casting metal, but also in wrought metalwork.

75 SWORD
Bronze, length 63 cm.
Oryahovo, Late Bronze Age, 1500 to 1200 BC.
Archaeological Museum, Sofia.
Inv.No.3020-0.
Northern type.
Unpublished.

76 SWORD
Bronze, length 63·5 cm.
Baikal, near Pleven.
Late Bronze Age, 1500 to 1200 BC.
Archaeological Museum, Sofia.
Inv.No.20.
Northern type.
Bibl. R. Popov, *Edinichni nahodki ot bronzovata i Hallstattskata epoha*, III, 292.

77 SWORD
Bronze, length 80 cm.
Dolno-Levski, near Panagyurishté.
Late Bronze Age, 1500 to 1200 BC.
Archaeological Museum, Sofia.
Inv.No.616.
Mycenaean type.
Bibl. V. Mikov, *Predistoricheski selishta i nahodki v Bulgaria*, Sofia, 1933, 107, No.9, Fig.66.

78 SWORD
Bronze, length 45 cm.
Yossifovo, Mihailovgrad district.
Late Bronze Age, 1500–1200 BC.
Archaeological Museum, Sofia.
Inv.No.3960.
Mycenaean type.
Unpublished.

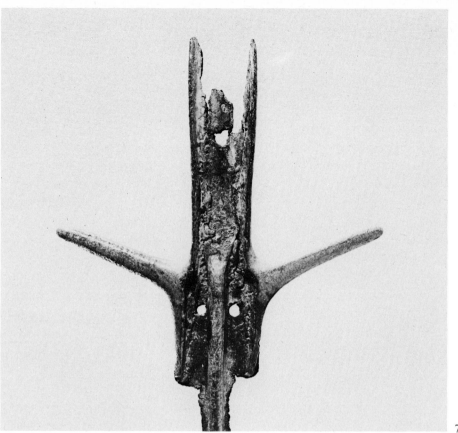

78

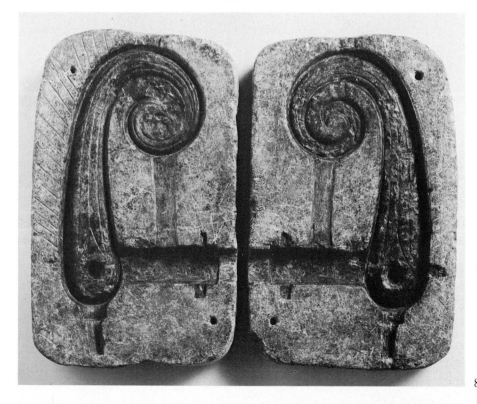

81

79 SPEAR HEAD
Bronze, length 19·2 cm.
Dolno-Levski, near Panagyurishté.
Late Bronze Age, 1500–1200 BC.
Archaeological Museum, Sofia.
Inv.No.617.
Bibl. V. Mikov, *Predistoricheski selishta i nahodki v Bulgaria*, Sofia, 1933, 143, No.50.

80 SPEAR HEAD
Bronze, length 19·2 cm.
Sarantsi, Sofia district.
Late Bronze Age, 1500–1200 BC.
Archaeological Museum, Sofia.
Inv.No.2755.
Bibl. R. Popov, *Novootkriti predistoricheski starini*, VII-1932–33, 358, Fig.109.

81 TWO MATRICES
Stone.
Pobit Kamuk, Razgrad district.
Late Bronze Age, 1500–1200 BC.
Archaeological Museum, Sofia.
Inv.No.5086.
These matrices were for casting a sceptre:
a) a matrix for casting the back part of a
 sceptre in the form of a spiral.
Height 25 cm. length 17 cm. for both parts.
b) matrix for casting the front part of the
 sceptre.
Length 8 cm., width 4 cm.
Consisting of six elements.
Unpublished.

83–87
Group of five matrices
Stone.
Pobit Kamuk near Razgrad.
Late Bronze Age, 1500–1200 BC.
District Museum of History, Razgrad.

83 MATRIX
Width 27 cm., height 18 cm.
Inv.No.1194.
In two parts, intended for casting the upper
part of a sceptre in the form of a spiral.
Unpublished.

84 MATRIX
Width 16 cm., height 11 cm.
Inv.No.1193.
In two parts: for casting hollow rectangular
axes, ornamented with concentric circles.
Unpublished.

85 MATRIX
Width 17·7 cm., height 8 cm.
Inv.No.1197.
In two parts: for casting an axe.
Unpublished.

86 MATRIX
Width 18 cm., height 8 cm.
Inv.No.1195.
In two parts: for casting axes.
One part missing.
Unpublished.

87 MATRIX
Width 19 cm., height 9 cm.
Inv.No.1201.
Like the above mould.
Unpublished.

88–106
Pottery from Orsoya, near Lom

LATE BRONZE AGE, 1500–1200 BC

LOM MUSEUM OF HISTORY

88 VESSEL IN THE SHAPE OF A BIRD
Pottery, height 9·5 cm.
Inv.No.20189.
Vessel and lid are ornamented with incised
ornamentation encrusted with white. There are
spirals, triangles and dots on the vessel, and a
hollow handle with deep furrows, forming
horizontal grooves on the top of the lid.
Unpublished.

89 VESSEL IN THE SHAPE OF A BIRD
Pottery, height 8·2 cm.
Inv.No.20190.
Cone-shaped lid, with incised ornamentation
encrusted in white, an interwoven design
between small parallel lines, triangles and
wavy lines.
Unpublished.

90 VESSEL IN THE SHAPE OF A BIRD
Pottery, height 8 cm.
Inv.No.20180.
Cone-shaped lid ornamented with incised
meanders.
Unpublished.

91 IDOL
Pottery, height 15·1 cm.
Inv.No.20182.
The lower part is cylindrical and hollow; the
upper part rounded and flattened, incised
ornamentation encrusted in white, consisting of
little circles, spirals and small dots; the head is
missing.
Unpublished.

92 IDOL
Pottery, height 11·9 cm.
Inv.No.20181.
The lower part cylindrical, the upper part
spiral-shaped, incised decoration with white
encrustation.
Unpublished.

93 IDOL
Pottery, height 9·9 cm.
Inv.No.20184.
The lower part cylindrical, the upper part
round and flattened.
Ornamentation: incised spirals.
Unpublished.

94 TWO IDOLS
Pottery, height 11·5 and 3·3 cm.
Inv.No.20183.
The smaller idol was found inside the larger.
Both have incised ornamentation. The head is
missing.
Unpublished.

95 VESSEL IN TWO SECTIONS
Pottery, width 14·2 cm.
Inv.No.20179.
No ornamentation; a handle joins the two
parts of the vessel.
Unpublished.

96 TWO-HANDLED VESSEL
Pottery, height 7·8 cm.
Inv.No.20187.
A square vessel with a cylindrical mouth. It has
incised ornamentation with white encrustation:
spirals and wavy lines on the widest part, a
band of small lines on the mouth and handles.
Unpublished.

97 TWO-HANDLED VESSEL
Pottery, height 5·3 cm.
Inv.No.20180.
Incised ornamentation: zig-zag lines on the
body and a band of lines around the neck.
Unpublished.

98 VESSEL WITH A HANDLE
Pottery, height 7·7 cm.
Inv.No.20178.
Incised ornamentation: a row of dots around
the mouth and along the handle. Regularly
placed rosettes on the body, one of which
ornaments the lower part of the handle.
Unpublished.

99 TWO-HANDLED VESSEL
Pottery, height 6·1 cm.
Inv.No.20186.
Square shape with cylindrical mouth, incised
ornamentation, with grooves on the broad
part and a wavy line around the mouth.
Unpublished.

100 TWO-HANDLED VESSEL
Pottery, height 8·3 cm.
Inv.No.20188.
Square shape with cylindrical mouth, incised
wave-like ornamentation, indented line, band
of small lines.
Unpublished.

101 VESSEL WITH ONE HANDLE
Pottery, height 8·3 cm.
Inv.No.20191.
Incised ornamentation on the body of the
vessel and the handle: parallel lines on the
neck and handle, spirals on the body. Three
protuberances on the body.
Unpublished.

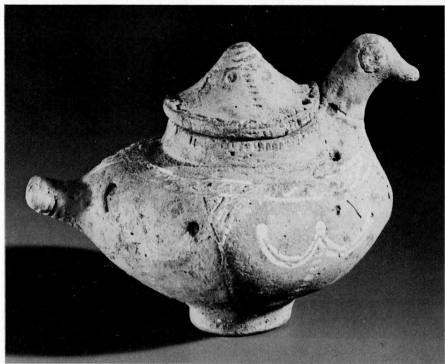

89

92

102 URN
Pottery, height 31 cm., diam. of broad part
30 cm.
Inv.No.20185.
Cone-shaped with two handles, incised
ornamentation over the entire surface of the
vessel.
Unpublished.

103 URN
Pottery, height 37 cm., diameter of the wide
part 30 cm.
Inv.No.20192.
Cone-shaped. Lid in the form of a bowl with
four ring-shaped handles (two on the body and
two on the lid). Incised ornamentation of
meanders and half-circles.
Unpublished.

104 TWO URNS
Pottery, heights 37.5 and 36 cm.
Inv.Nos.20195 and 20194.
Biconical in shape, with four ring-shaped
handles on the body.
Unpublished.

105 URN
Pottery, height 27 cm.
Inv.No.20196.
Like the preceding urns, but a large part of the
mouth is missing.
Unpublished.

106 URN
Pottery, height 35 cm.
Inv.No.20193.
Biconical in shape. There are four ring-like
handles on the body, incised ornamentation
on the lower and upper part of the mouth.
Unpublished.

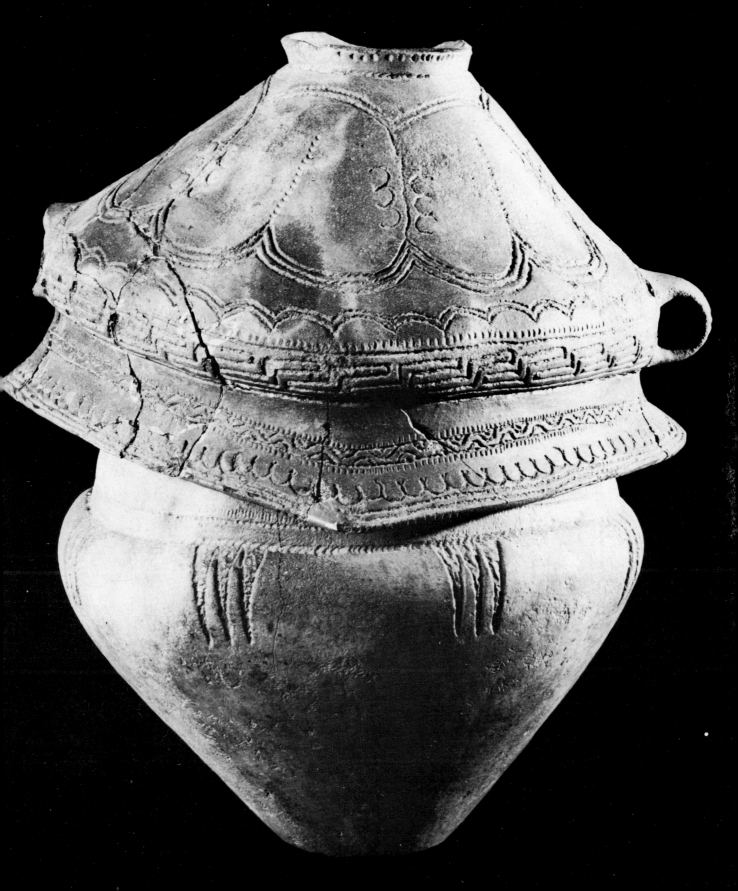

The Vulchitrun treasure (Pleven district)

LATE BRONZE AGE, THIRTEENTH TO
TWELFTH CENTURIES BC

ARCHAEOLOGICAL MUSEUM, SOFIA.

Bibl. V. Mikov, *Zlatnoto sukrovishté ot Vulchitrun*, Sophia, 1958. N. Popovich, RA, 1959, ii, 106.

This treasure is a masterpiece of the Thracian goldsmith's art. It is composed of a large vessel, a triple vessel, four cups, and seven lids, making a total weight of 12·5kg. of gold. It is the most important find of gold articles to come to light in Thrace.

Some archaeologists date it to the end of the Early Iron Age, others date it to the Bronze Age. More recent discoveries of the Iron Age, as well as the two finds in Sofia and Belogradets near Provadia prove that metal was not so finely worked in the Iron Age; on the other hand, the gold nails with conical heads, which rivet the handles of the large vessel and those of the cups are reminiscent of those to be found on the Cretan-Mycenaean swords. Finally, the silver inlays in the lids also offer evidence in support of the Late Bronze Age.

The most characteristic feature of this treasure, besides the simplicity of its forms, is the sparing use of ornament, which is limited to the grooved handles. This shows a sense of proportion not to be found in later articles. However, the Thracian master goldsmiths were quite able to make intricate articles, as is apparent from the triple vessel. The electrum handle in the form of a trident, and the little silver tubes which connect the elements prove that the master who cast them worked with the same precision as the goldsmith. The craftsmanship of the large lid reveals the same skill: a bronze pad, which continues in a bronze circle, is found under the handle and provides a firm hold. An open-work cross strengthens the handle.

The difference in quality between the pottery and the metalwork in this period is proof of the power of the aristocracy, which had craftsmen at its disposal who were well able to satisfy their requirements

and their refined taste. Buried in the walls of the palace of a Thracian chieftain, this treasure also indicates that political power was linked with religious power; such a find was, indeed, intended for ritual use. This treasure must originally have been far larger. The gold lids must have belonged to seven vessels, all of them larger than the single two-handled lidless vessel.

The number of large vessels was probably considerably greater than that of the small vessels, whose form is more like that of a vessel used for pouring than for drinking. The cups were used to pour liquid into the big vessels, to be poured afterwards into the cups of each individual, a ceremony which accompanied the mystical rites of the Thracians. As to the triple vessel, which must have been used to mix three different liquids, the strangeness of its form proves the ritual nature of the find.

In composition the Vulchitrun treasure may be compared to another treasure bearing an inscription, a consecration to a Thracian deity Pyurmerula. However, this latter treasure is of a much later date, since it belongs to the period of the Roman Empire.

107 TRIPLE VESSEL
Gold, height 5·3 cm., width 23·9 cm., weight 1190 gr.
Inv.No.3203.
It consists of three small vessels joined by two curved electrum tubes along which the liquid passed from one vessel into the remaining two; they are covered with horizontal grooves. The rounded backs are connected with an electrum handle in the form of a trident. The handle is ornamented with niello.

108 TWO-HANDLED VESSEL
Gold, height 22·4 cm., weight 4395 gr.
Inv.No.3192.
The vessel is made of two parts soldered with silver. Its handles are drawn out of the mouth welded and riveted to the body with small nails with cone-shaped heads.

109 LID
Gold, height 12·6 cm., diam. 27 cm., weight 1755 gr.
Inv.No.3197.
The handle is spherical with horizontal grooves around its base and a conical knob at the top. The top of the cover has geometrical ornaments formed by a thin silver band. A border of dots has been placed all along the length of the band.

110 LID
Gold, height 12·6 cm., diam. 37 cm., weight 1850 gr.
Inv.No.3196.
Similar to the above.

111 LID
Gold, height 11·5 cm., diam. 21·5 cm., weight 558 gr.
Inv.No.3198.
There are three concentric circles of beading at the base of the handle.

112 LID
Gold, height 3·4 cm., diam. 21·5 cm., weight 374 gr.
Inv.No.3200.
Similar to the above. The handle is missing.

113 LID
Gold, height 11·6 cm., diam. 21·6 cm., weight 462 gr.
Inv.No.3199.
Similar to the preceding lid. A large part is missing.

114 LID
Gold, height 3·1 cm., diam. 21·6 cm., weight 207 gr.
Inv.No.3202.
Crushed; part of the handle and the lid are missing.

115 LID
Gold, height 4·8 cm., diam. 21·6 cm., weight 300 gr.
Inv.No.3201.
Crushed; a large part of the lid is missing.

116 CUP
Gold, height (with handle) 18·3 cm., diam. (of mouth) 16·2 cm., weight 919 gr.
Inv.No.3193.
Flat handle, drawn out of the mouth and riveted with three rivets below, the rivets having heads on the inside and outside. Four grooves along the handle, ending in three scallops.

117 CUP
Gold, height (with handle) 8·9 cm., diam. (of mouth) 8·8 cm., weight 123 gr.
Inv.No.3204.
Similar to the preceding cup; three horizontal grooves around the mouth.

118 CUP
Gold, height 8·9 cm., diam. (of mouth) 4·9 cm., weight 132 gr.
Inv.No.3195.
Like the preceding cup.

119 CUP
Gold, height 8·2 cm., diam. (of mouth) 4·5 cm., weight 130 gr.
Inv.No.3194.
Like the preceding cup.

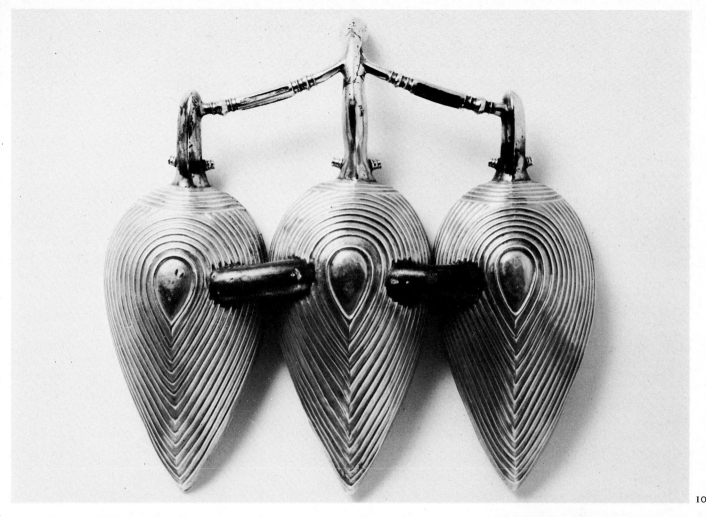

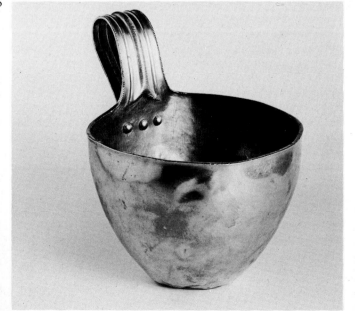

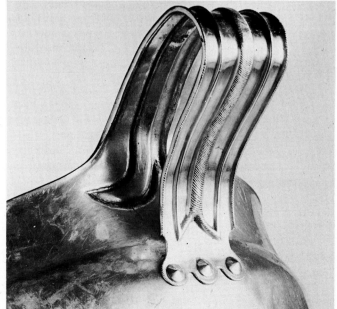

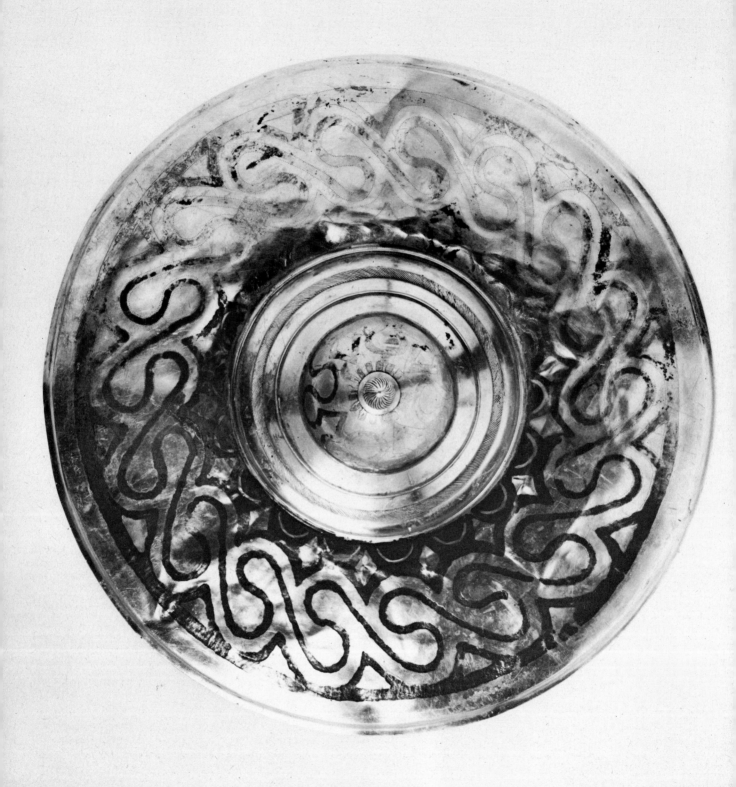

Thrace in the Early Iron Age

GEOMETRIC ART

Little is known about Thrace in this period. No name of a king or a chieftain, no exact records of any events have come down to us in myths and legends. Only a large number of burial mounds have been left, for in this period they were very widespread. The archaeological name for this period is the Early Iron Age. We can also define it as the period of Megaliths, or of geometric art.

No matter how the invasions may have taken place in the twelfth century BC, it is obvious that the further to the south-east we go, the more important they become. These movements from Europe into Asia passed through Thrace in great waves. The Thracian population experienced periods of hardship, and part of it had to flee from the broad plains and take refuge in the mountainous regions of Sakar and Strandja, in Rhodope to the east and in the eastern sections of the Balkan Range.

Huge stone tombs appeared when these invasions came to an end in the south-eastern regions. They were dolmens made of very large slabs. The walls of these tombs, made of one or two slabs, surrounded the burial chamber which could be 2 to 2·5 m. in length and have only one slab as a cover. Sometimes a passage (*dromos*) and an ante-chamber led to the burial chamber, which was often covered with a false vault and a mound. In the south-east, rock-cut tombs are also found. All these tombs were intended solely for the aristocracy of the tribe. They were robbed in Antiquity and in the Middle Ages, and in still more recent times, so that today only pottery is to be found in the dolmens and the rock tombs. Moreover, the richest archaeological discoveries were made in north-western Thrace, where the work of craftsmen was also intended for the aristocracy. Let us note that it is chiefly fibulae which are found in the women's tombs, while in the men's there are weapons and horse-trappings.

As in Greece, so in Thrace in this period pottery returned to old techniques and the old decorative designs. However, the execution was simpler, sometimes even clumsy. The principal ornament was composed of circles with a dot in the middle, connected by triangles and other geometrical motifs, loops or spiral lines. These designs were usually painted and often had white paint encrusted in them, but they were sometimes worked in relief. Metalwork did not reach the perfection of former ages. In eastern Thrace the fibulae went back to the model from the Ionian Islands, while in western Thrace those in vogue came from Greece and Macedonia. The small bronze figures of animals made in this period are characteristic, and also imitate models from Greece and Macedonia in the west, while in the east they have elements very reminiscent of forms from Asia Minor. Certain royal insignia, known in Asia Minor, also appeared among the Thracians under the influence of the east. Let us note, above all, the iron sceptre, whose upper part is made of bronze in the form of an axe, ornamented with beads or animal figures. However, whilst in the east all the axes had wooden handles, in Thrace some of them were in the nature of amulets and are simply synthesized geometrical figures. As to the animals which we come across in Thrace, they are rams, bulls, he-goats, stags, horses, birds, etc. This type of axe spread very far to the north-west and is found in the cemeteries at Hallstatt.

Other royal insignia of this period, also mentioned by Homer in connection with Caria and Lydia, are the headstalls ornamented with appliqués and known all over the northern part of the Balkan Peninsula. These appliqués, cast from bronze, sometimes took the form of little crosses, circles or rosettes. The only headstall with animal ornamentation is the one from Sophronievo, No.155. The statuette of a stag from Sevlievo should be mentioned among the animal figurines; its symmetrical antlers end in a stylized animal head, a superficially made figure of a bird, a motif which was later to pass into Thracian art, and from there to the Scythians.

Goldwork of this period is represented by several pairs of earrings in the form of open rings, and also by bracelets, which are either open or broad in the middle, e.g. No.140.

Few examples of metalwork have survived, but what has come down to us is particularly important: a gold bowl from Kazichané, a suburb of Sofia, No.122, dated about 700 BC. Its simple ornamentation is reminiscent of that on pottery, but both form and ornamentation (deep, irregular ribs at a distance from one another) are heavy and clumsy. This is a curious

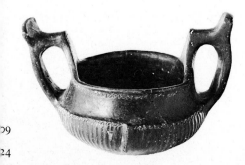

09

24

phenomenon, when it is borne in mind that a large number of pottery vessels are thought to be imitations of metalwork.

120–123

The Sofia treasure
About 700 BC

Museum of History, Sofia,
Bibl. M.Stancheva, MPK, 1973, pt.iii, 3

120 CAULDRON
Copper, height 24 cm., diam. (of mouth) 34 cm., diam. (of body) 43 cm.
Inv.No.3012.
A cauldron of the so-called Urartian type, of the eighth or seventh century BC. The foreparts of creatures, real or mythological, were formerly riveted to the rim in four places. This cauldron dates the treasure.

121 BOWL
Pottery, height 22·6 cm., diam. (of mouth) 29 cm., diam. (of body) 32·6 cm.
Inv.No.3013.

122 BOWL
Gold, height 14·5 cm., diam. (of mouth) 24 cm.
Inv.No.3014.
There are horizontal grooves around the neck, ornamented with hatching and under them a band of semi-circles. The body is ornamented with vertical ribbing. On the bottom of the bowl are roundels in relief, surrounded by dots and joined by tangents of dots.

123 ỴASE
Pottery, height 33 cm.
Shiroko Polé, near Momchilgrad.
Beginning of the Early Iron Age (eleventh to eighth centuries BC).
Archaeological Museum, Sofia.
Inv.No.2952.
Conical form with three legs. Bands around the mouth and legs are ornamented with small incised triangles, encrusted with white paint. At the bottom end the legs end in roughly worked feet.
Bibl. V. Mikov, *IAI*, XIX, 1955, 29, Fig.6.

124 CANTHARUS (drinking vessel)
Pottery, height 12 cm.
Krivodol, Vratsa district.
Beginning of the Early Iron Age.
Archaeological Museum, Sofia.
Inv.No.3258.
The body covered with vertical grooves; there are wavy lines around the mouth. The handles have the imprint of a thumb and a protuberance at the upper end.
Bibl. V. Mikov, *IAI*, XXI, 1957, 5295, Fig.I.

125 RITUAL AXE
Bronze, height 12·5 cm.
Teteven (tenth to eighth centuries BC).
Archaeological Museum, Sofia.
Inv.No.745.
The neck is ornamented with the heads of a bull, a he-goat and a ram.
Bibl. At. Milchev, *IAI*, XIX, 1955, 359, No.1, Fig.2.

126 RITUAL AXE
Bronze, height 4 cm.
Karloukovo (tenth to seventh centuries BC).
Archaeological Museum, Sofia.
Inv.No.746.
The neck is ornamented with two animals in relief, only one of which (a ram) is complete, the head of the second one is missing.
Bibl. At. Milchev, *IAI*, XIX, 1955, 360, No.3, Fig.I.

127 RITUAL AXE
Bronze, height 10·6 cm.
Origin unknown (tenth to seventh centuries BC).
Archaeological Museum, Sofia.
Inv.No.744.
The axe has a semi-circular blade and there are two small round holes in it. The neck is ornamented with three animal heads: a he-goat, a bull and a ram.
Bibl. At. Milchev, *IAI*, XIX, 1955, 359, No.1, Fig.1.

128 RITUAL AXE
Bronze, height 7·7 cm.
Stara Zagora (tenth to seventh centuries BC).
District Museum of History, Stara Zagora.
Inv.No.225.
The neck is ornamented with the heads of a bull, a griffin, a stag and a he-goat.
Bibl. D. Nikolov, *Istoricheski okruzhen mouzei, Stara Zagora*, Sofia, 1965, 132, Fig.24.

129 RITUAL AXE
Bronze, height 3·5 cm.
Kameno Polé, Vratsa district (tenth to seventh centuries BC).
District Museum of History, Vratsa.
Inv.No.A 732.
The edge is rounded and has holes at the upper end (see No.94), there are two holes; the neck ornamented with two animal heads of a horse and a ram.
Bibl. B. Nikolov, *IAI*, XVIII, 1965, 170, Fig.10-B.

130 AMULET
Bronze, height 9.9 cm.
From the Rila Monastery (eighth to seventh centuries BC).
Ecclesiastical Museum of History and Archaeology, Sofia.
Inv.No.6929.
This axe has a small square blade, the neck is in the form of a two-headed bird with a short beak, protuberant eyes and a crest twisted like a hor. Between the two heads there is a ring by which it was suspended at the back.
Bibl. Iv. Venedikov, *IVAD*, XIV, 1963, 22, Fig. 8.

131 AMULET
Bronze, height 6 cm., width 8·6 cm.
Gorna Lyubota, near Bossilegrad (eighth to seventh centuries BC).
Archaeological Museum, Sofia.
Inv.No.3958.
In the form of a bird with a triangular tail; the legs form the edge; on the upper part a ring by which it was suspended.
Bibl. V. Mikov, *IAI*, XIX, 295, Fig.2.

132 FIGURINE OF A STAG
Bronze, height 3·5 cm., width 4·3 cm.
From Oryahovo (eighth to seventh centuries BC).
Collection of Sofia University.
Inv.No.M-1.
The modelling is very summary. There is a ring for suspension.
Bibl. At. Milchev, *IAI*, XIX, 1955, 364, Fig.8.

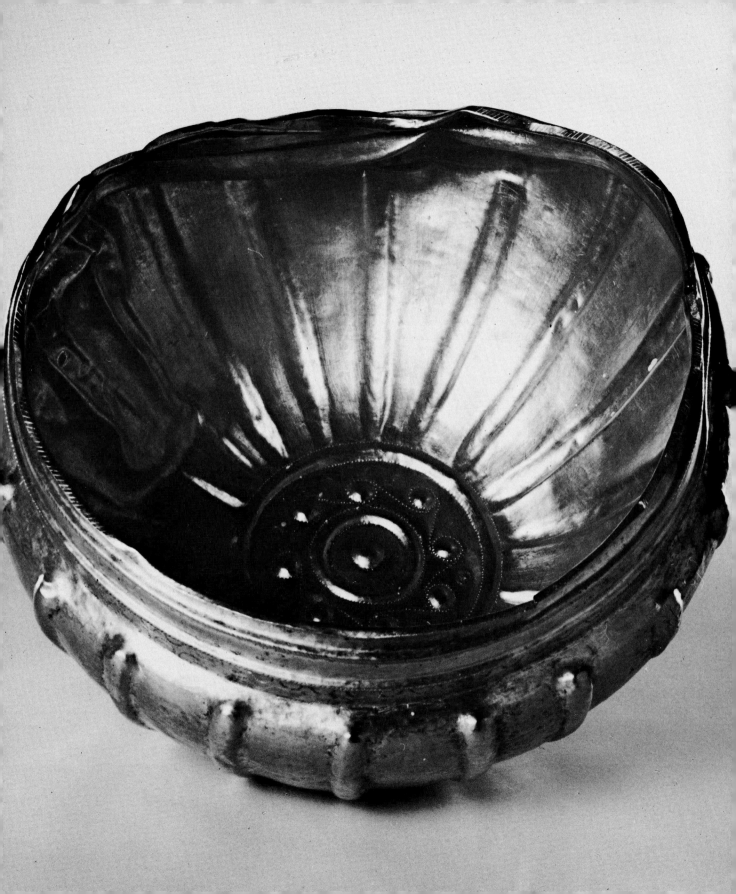

133 FIGURINE OF A STAG
Bronze, height 16 cm.
From the region of Sevlievo (tenth to seventh centuries BC).
Its forelegs and part of the right hindleg are missing. The shoulder and thigh are freely treated, the other parts of the body reduced to geometrical forms: the head is triangular, the eye a circle, the neck and body in the shape of a prism, and the antlers symmetrical ending in the stylized heads of birds.
Bibl. At. Milchev, *IAI*, XIX, 1955, 364, Fig.9.

134 FIGURINE OF A HORSE
Bronze, height 6 cm.
From the area of Philippi in south-eastern Macedonia (seventh century BC).
Archaeological Museum, Sofia.
Inv.No.1578.
The tail of the horse reaches the ground; the four legs and the long tail are joined to a stand.
Unpublished.

135 BELT BUCKLE
Bronze, width 9 cm.
From the region of Vidin (eighth to seventh centuries BC).
Archaeological Museum, Sofia.
Inv.No.125.
The buckle ends in a big ring and has an openwork plaque, ending in a ring; diamond-shapes and triangles are ornamented with circles, their centre is marked and there are zig-zags; the back part is an empty rectangular space.
Bibl. R. Popov. *BAN*, XVI, 1918, 108, No.7, table.III. Fig.1.

136 BELT BUCKLE
Bronze, width 6 cm.
Moravitsa, Vidin district (eighth to seventh centuries BC).
Archaeological Museum, Sofia.
Inv.No.657.
In three parts, like the preceding buckle.
Bible. R. Popov, *BAN*, XVI, 1918, 109, No.2, Plate IV, I-A-C.

137 BELT BUCKLE
Bronze, width 4·5 cm.
From Sozopol (eighth to seventh centuries BC).
Archaeological Museum, Sofia.
Inv.No.2565.
Like the preceding buckle.
Bibl. V. Mikov, *Prehistoricheski selichta i nahodki v Bulgaria*, Sofia, 1933, 143, No.50.

138 EARRINGS
Gold, diam. 1·8 cm., height 4·9 cm.
Chomakovtsi, Vratsa district (seventh to sixth centuries BC).
Archaeological Museum, Sofia.
Inv.No.6093.
Triangular in cross-section; intended to be attached to the ears by small rings.
Unpublished.

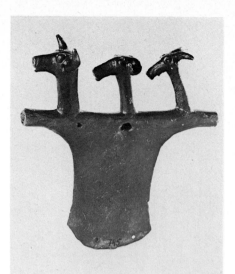
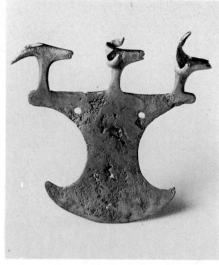
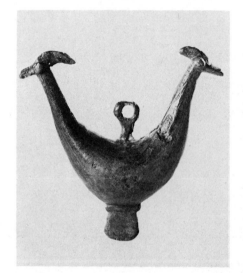
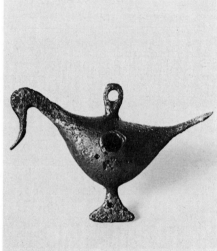
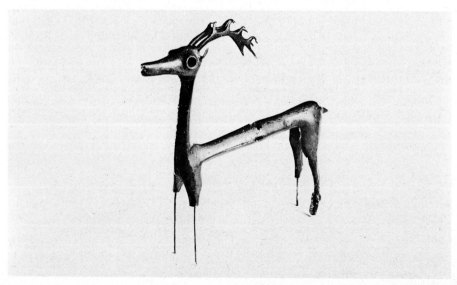

139 EARRINGS
Gold, diam. 2·5 cm., weight 26·13 gr.
From Vidin (seventh to sixth centuries BC).
District Museum of History, Vidin.
Inv.No.102.
Like the preceding pair.
Unpublished.

140 BRACELET
Bronze, diam. 9 cm.
Rouska Byala, Vratsa district (eighth to seventh centuries BC).
Archaeological Museum, Sofia.
Inv.No.737.
The bracelet has overlapping ends, which are slightly thicker and have geometrical figures engraved on them.
Bibl. R. Popov, *BAN*, XVI, 1918, 109, No.3, table.IV,2.

141 ORNAMENTAL SHEATH
Gold, length 20·1 cm.
Belogradets, Varna district (eighth to seventh centuries BC).
Archaeological Museum, Sofia.
Inv.No.2865.
Decorated with a plastic ornament encrusted with amber, which has now fallen out in the middle. Bands of semi-circles made with a punch, with their centres marked, ornament the top and bottom.
Bibl. G. Toncheva, *Izkoustvo*, 1974, 4, 26 sl.

142 KNIFE
Iron, length 42 cm.
Belogradets, Varna district (eighth to seventh centuries BC).
Archaeological Museum, Sofia.
Inv.No.2866.
The edge has a gilt horizontal border in relief.
Unpublished.

143 TWENTY-TWO BUTTONS
Bronze, diam. 1·5 cm.
Provenance unknown (eighth to seventh centuries BC).
Archaeological Museum, Sofia.
Inv.No.1958.

144 FIBULA (SPECTACLE-SHAPED)
Bronze, length 14·5 cm.
Vidin (eighth to seventh centuries BC).
Archaeological Museum, Sofia.
Inv.No.120.
Bibl. R. Popov, *BAN*, XVI, 1118, 106, No.2, Plate I, 2.

145 BOAT-SHAPED FIBULA
Bronze, length 6·7 cm.
Svoboda, Pazardjik district (eighth to seventh centuries BC).
Archaeological Museum, Sofia.
Inv.No.2790.
A thick bow. The front part ornamented with three vertical lines. The back flat, the foot ornamented with concentric circles with a dot in the middle.
Bibl. R. Popov, *IAI*, VII, 1932/33, 357, Fig.108.

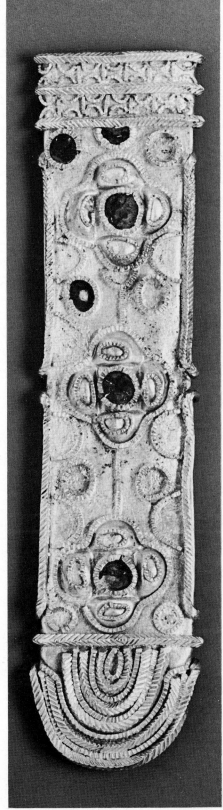

142

146 BOAT-SHAPED FIBULA

Bronze, length 7 cm.
From Hvoyna, Smolyan district (eighth to seventh centuries BC).
Archaeological Museum, Sofia.
Inv.No.274.
A flanged bead on the pin. The bow thick, ornamented with vertical lines, flat at the back; with a rectangular plaque.
Bibl. R. Popov, *BAN*, VI, 1913, 148, No.7, Fig.7.

147 FIBULA

Bronze, length 5·6 cm.
Bednyakovo, near Chirpan (seventh to sixth centuries BC).
Archaeological Museum, Sofia.
Inv.No.643.
The bow ornamented with a central ball and three small rings.
Bibl. R. Popov, *BAN*, VI, 1913, 150, No.10.

148 FIBULA

Bronze, length 10 cm.
Zelenigrad, near Trun (seventh to sixth centuries BC).
Archaeological Museum, Sofia.
Inv.No.711.
A slightly bulging bow. The plaque ornamented with vertical lines.
Bibl. R. Popov, *IAI*, III, 1912, 297, No.8, Fig. 223.

149 FIBULA

Bronze, length 13·1 cm.
Tsarevets, Vratsa district (seventh to sixth centuries BC).
Archaeological Museum, Sofia.
Inv.No.1942.
Like the above.
Bibl. R. Popov, *IAI*, II, 1923, 1924, 118, Fig.53A.

150 FIBULA

Bronze, length 5·4 cm.
Durzhanitsa, Vidin district (seventh to sixth centuries BC).
Archaeological Museum, Sofia.
Inv.No.1903.
Long plaque with a horizontal strip in relief. The bow ornamented with grooves.
Bibl. V. Mikov, *IAI*, XII, 1933, 342, Fig.150.

151 TWO PLAQUES FROM HORSE-TRAPPING

Bronze, height 8·9 cm.
From Gevgeli, Macedonia (eighth to seventh centuries BC).
Archaeological Museum, Sofia.
Inv.Nos.794 and 795.
Cross-shaped with boss in the middle and rings at the four ends on the back.

152 THREE PLAQUES FROM HORSE-TRAPPING

Bronze, height 3 and 2·7 cm.
Provenance unknown (eighth to seventh centuries BC).
Archaeological Museum, Sofia.
Inv.Nos.1953, 1954, 1957.
In the form of a cross with triangular branches. Around the boss decoration of incised concentric circles. A ring at the back.
Unpublished.

153 REIN

Bronze, length 14·3 cm.
Provenance unknown (seventh century BC).
Bibl. Iv. Venedikov. *IAI*, XXI, 1957, 156, No.5, Fig.5.

154 PARTS OF A HALTER: THIRTY-TWO RINGS

Bronze, diam. 5 cm.
Archar, Vidin district (seventh to sixth centuries BC).
Archaeological Museum, Sofia.
Inv.No.1825.
Unpublished.

155 HEADSTALL

Bronze, height 7 cm.
Sophronievo, Vratsa district (sixth century BC).
District Museum of History, Vratsa.
Inv.No.757.
An open-work plaque in the shape of an ellipse with three pairs of spirals at the side: with a big boss covered with incised ornaments and a three-dimensional horned animal's head, around them small incised circles with a marked centre and spirals. A ring at the back for suspension.
Bibl. B. Nikolov, *IAI*, XXVIII, 1965.

156 PHIALE

Bronze, height 4 cm., diam. 17 cm.
Sophronievo, Vratsa district (sixth century BC).
District Museum of History, Vratsa.
Inv.No.747.
Ornamented with two concentric circles around the boss.
Bibl. B. Nikolov, *IAI*, XXVIII, 167, No.24, Fig.5, A-B.

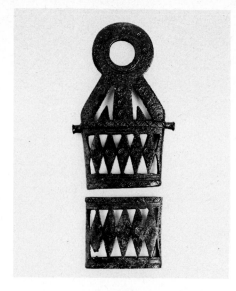

13

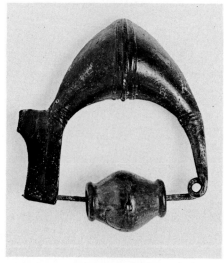

14

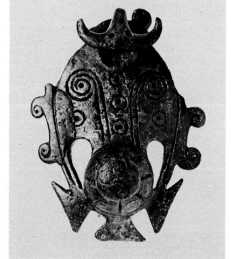

15

Development of Thracian Art in the Middle Iron Age

525 TO 280 BC

In the mid-sixth century BC Thrace reached a degree of development which is evidenced by the finds from many burial mounds. Her culture reached its zenith, but at the same time underwent far-reaching changes.

The Greeks founded a large number of colonies, until the whole Thracian coast was in their hands. Here they built forts, temples, theatres and rich houses; they made statues and reliefs and produced vessels of bronze, gold and silver. They also wore garments made of expensive fabrics and gold jewellery, and introduced filigree work, under the influence of the Orient.

A rich inhabitant of Thrace could easily buy works of Greek art, either in the cities of the coast, or in the big centres of Continental Greece. Greek coins also made their appearance on the Thracian markets together with these objects.

On the other hand, the shores of Asia Minor were in the hands of the Persian Achaemenids, who ruled these territories until Alexander the Great conquered them. Everything was adapted to the Persian monetary system. Thrace could not fail to be influenced by this Eastern Power, and the Greek colonies on her shores extended their contacts with the east.

In the fifth and fourth centuries BC trade flourished between the interior of Thrace and the town of Cyzicus on the Propontis in Asia Minor, Apollonia on the European shores of the Black Sea, Parium and the Thracian Chersonese on the Hellespont. All the fifth and fourth century treasures found in Thrace contain coins of these cities.

In general, at that time Thrace emerged from the isolation in which she had found herself in the previous period, through her trade with the Persians and the Greeks. The Thracian burials are a good illustration of this change. In them we find much gold jewellery, alabaster vessels, glass and classical pottery.

At the end of the fourth century BC imports from Greece increased greatly and at the same time many works by Thracian master craftsmen, made under the influence of the Orient, also appeared.

The mounds of Douvanli

About fifty of the numerous mounds lying near the village of Douvanli, Plovdiv district, southern Bulgaria, have been excavated to date. They belong to various periods from the sixth to the first century BC. Five of the mounds excavated at Douvanli proved to be the greatest discoveries in Thracian archaeology; the articles found in them could well fill a large museum. They were the richest mounds, and also the oldest, since they date back to the end of the sixth and to the fifth century BC.

In all three women's burials (in the Moushovitsa, Arabadjiyska and Koukova Mounds) were found wonderful gold ornaments made by Greek workshops in Thrace, together with pectorals of rare forms, necklaces and massive bracelets which make a great impression with their luxury and their rich ornamentation. They are proof of the great wealth and taste for luxury of their owners. Two other mounds, later ones, brought to light the burials of men. They are the Golyamata and the Bashova Mounds. Helmets and cuirasses were found with the men's burials, while all the mounds contained a large number of vases.

The tribe of the Bessi inhabited the territory of the present-day village of Douvanli in antiquity. The oldest finds were discovered in the Moushovitsa Mound.
Bibl. Duvanlij, passim; Strong, 77–79; Hoddinott, 58–64.

157–163
The treasure from the Moushovitsa mound, Douvanli

END OF THE SIXTH CENTURY BC

ARCHAEOLOGICAL MUSEUM, PLOVDIV

This mound is almost contemporary with Darius's campaign against the Thracians. There is not the slightest doubt that Mou-

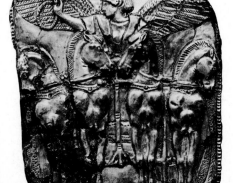

78

shovitsa marks the beginning of the rich Thracian burials. All the artefacts found here were made either of silver or of gold. Pectoral No.157, fibula No.158 and cup No.163 – the latter influenced by a Persian model of the same period – can be classed as local ware. Jewellery, however, such as earrings Nos.159 and 160 are the work of Greek jewellers working in Thrace.

157 PECTORAL
Gold, length 25·9 cm , weight 65·5 gr.
Inv.No.1531.
Hexagonal in form: there is a hole at each end through which fibulae which pinned the pectoral to the garment were passed. Three small chains hung from each fibula, ending in acorn-shaped pendants. Ornamented with a border of sixteen stylized birds.
Bibl. Duvanlij, 84–85, No.3, Fig.106; No.4, Fig.107. Plate 2,3.

158 FIBULA OF A THRACIAN TYPE
Gold, height 4·9 cm., weight 13·10 gr.
Inv.No.1532.
Bibl. Duvanlij, 88, No.7, Fig.109.

159 TWO EARRINGS
Gold, heights 2·7 and 3·2 cm., weight from 7·30 to 9·90 gr.
Inv.No.1537.
In the form of an open ring, the broader part ornamented with rosettes and diamonds of granules.
Bibl. Duvanlij, 88, No.6, Fig.109.

160 EARRINGS
Gold, height 3·6 cm., weight 26·05 gr. and 26·40 gr.
Inv.No.1538.
Rounded cross section, in the form of cylinders, ending in a pyramid with a bead at the top, the ends ornamented with granules. They were attached to the ears by means of small rings.
Bibl. Duvanlij, 84, No.2, Fig.107.

161 NECKLACE
Gold, weight 11·5 gr.
Inv.No.1535.
Composed of sixteen grooved beads.
Bibl. Duvanlij, 85, No.5, Fig.109.

162 NECKLACE
Gold, weight 79·60 gr.
Inv.Nos.1534 and 1536.
Composed of nineteen cylindrical grooved beads. There is a disc ornamented with a rosette below each one.
Bibl. Duvanlij, 85, No.4, Fig.108.

163 PHIALE
Silver, height 4·6 cm., diam. 11·7 cm.
Inv.No.1539.
Small protuberances in the form of olives at the bottom, arranged in the form of a rosette.
Bibl. Duvanlij, 88, No.8, Fig.110.

164–177

The treasure from Koukova mound, Douvanli

EARLY FIFTH CENTURY BC

The treasure from this burial mound dates back to the first decade of the fifth century BC, a time when the Thracian regions between Rhodope and the Aegean Sea were under Persian rule. Here the Persians were preparing a new campaign against the Greeks. Undoubtedly a royal gift accompanied the women buried in this tomb: a silver amphora (No.171) made by an Achaemenid craftsman. Possibly she was a hostage for peace between the Bessi and the Persian troops occupying the neighbouring regions. In any case necklaces and earrings Nos.166 and 168, like those of Moushovitsa, were found in this tomb, also two bracelets and a torque, Nos.167 and 165, whose massive weight and barbarous style indicate the existence of relations between local goldsmiths and those of Chalcidice in Macedonia. Pectoral No.164 and the silver phiale No.170 can be included in the series of local products. This mixture of local Greek, Macedonian and Persian forms is only possible in Thrace.

164 PECTORAL
Gold, length 23·4 cm., weight 50·10 gr.
Archaeological Museum, Plovdiv,
Inv.No.1266.
In the shape of an ellipse with a small hole at each end for the fibulae which pinned it to the garment. The whole surface ornamented with dots, crescents and semi-circles.
Bibl. Duvanlij, 40, Fig.1.

165 TORQUE
Gold, diam. 13·3 cm., weight 350 gr.
Archaeological Museum, Plovdiv.

Inv.No.1271.
Twisted wire with ends in the form of a ring.
Bibl. Duvanlij, 44, No.8, Fig.50.

166 NECKLACE
Gold.
Archaeological Museum, Sofia.
Inv.Nos.6136 and 6192.
Lens-shaped beads with filigree rosettes hanging by a vertical bar from melon beads. In the centre, a bud-shaped bead hanging from a rose etc.
Bibl. Duvanlij, 42, No.3, Fig.47.

167 TWO BRACELETS
Gold, diam. 9 cm., weight 257·10 gr. and 298·25 gr.
Archaeological Museum, Sofia.
Inv.Nos.6128 and 6189.
The ends shaped like a snake. The lips and the circles around the eyes in the form of a cord-like ornament, while the scales on the body are formed of rows of big beads.
Bibl. Duvanlij, 44, No.9.

168 EARRINGS
Gold, height 4·5 cm., weight 20·10 gr. and 18·25 gr.
Archaeological Museum, Sofia.
Inv.Nos.6134 and 6190.
Pyramids ornamented with granules at each end.
Bibl. Duvanlij 44, No.7, Fig.49, 1–2.

169 SEVEN EARRINGS
Gold, diam. 2·5 cm, weight 5·60 to 6·20 gr.
Archaeological Museum, Sofia.
Inv.Nos.6130, 6131, 6191.
Archaeological Museum, Plovdiv.
Inv.No.1270.
In the form of rings tapering at the ends, with gold wire wound around them, the wider part ornamented with rows of beading.
Bibl. Duvanlij, 43, No.5, Figs.48 and 50.

170 PHIALE
Silver, height 6·6 cm., diam. 26 cm., weight 120 gr.
Archaeological Museum, Plovdiv.
Inv.No.1255.
With a central boss.
Bibl. Duvanlij, 50, No.15, Fig.66.

171 AMPHORA
Silver, partly gilt, height 27 cm., diam. (of mouth) 13·4 cm.
Archaeological Museum, Sofia.
Inv.No.6137.
Ornamented with palmettes alternating with lotus blossom on the shoulders and the upper part of the body. The lower part of the vessel is grooved; between neck and shoulder there is a row of ovulae; between the shoulder and the broader part there is an intertwined motif. The handles are in the shape of horned lions, their heads turned back; one of the handles has a beak placed below the lion's neck.
Bibl. Duvanlij, 46, No.14, Plate III.

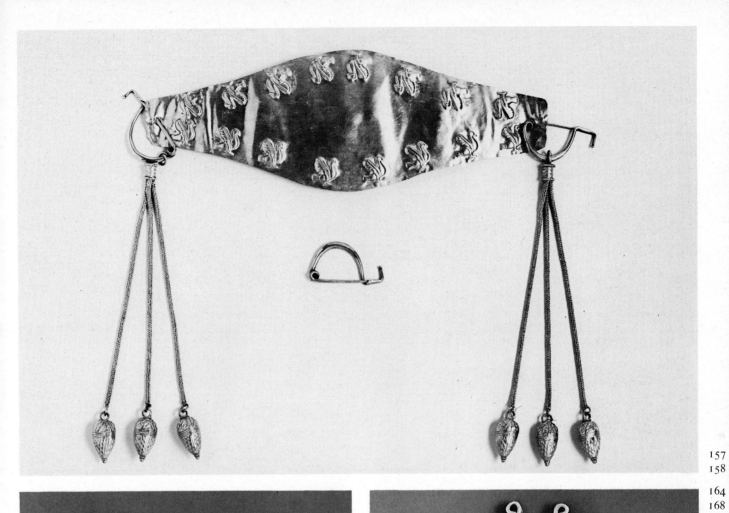

157
158

164
168
169

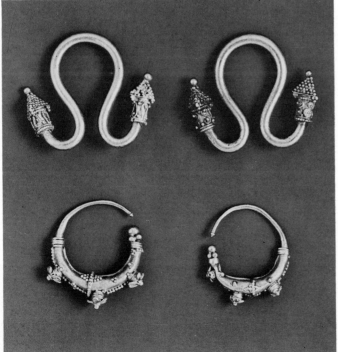

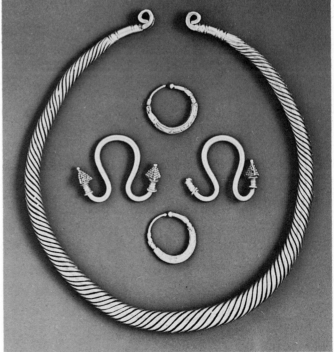

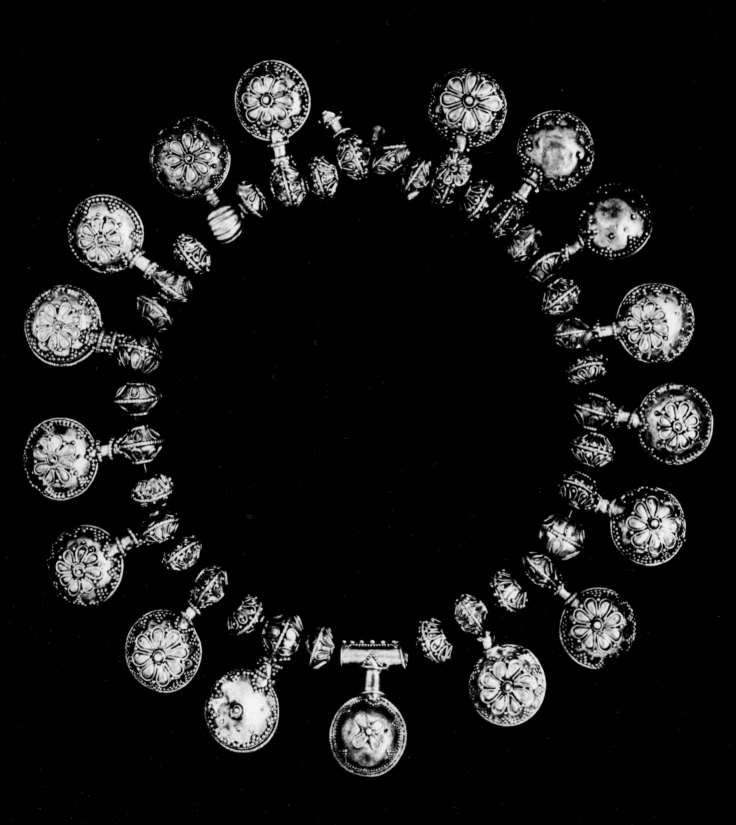

The treasure from the Arabadzhiyska mound, Douvanli

460–450 BC

ARCHAEOLOGICAL MUSEUM, PLOVDIV

This treasure consists of a locally made pectoral (No.172) accompanied by Greek jewellery (Nos.173 and 175) similar to that found in the older burial mounds of Douvanli.

172 PECTORAL

Gold, width 16·5 cm., weight 16·75 gr.
Inv.No.1645.
Hexagonal, with holes at each end by which it was attached. Ornamentation: dots, circles and a stylized Tree of Life.
Bibl. Duvanlij, 131, No.2, Fig.153.

173 NECKLACE

Gold, weight 54·7 gr.
Inv.No.1646.
Composed of filigree beads from which hang seventeen small spheres ornamented with rosettes and granules.
Bibl. Duvanlij, 132, No.4, Fig.154.

174 FIVE EARRINGS

Gold, width 2·4 to 2·5 cm., weight 31·35 gr.
Inv.No.1647.
In the form of small wineskins ornamented with spirals and triangles with indented edges.
Bibl. Duvanlij, 233, No.5–6, Fig.155.

175 TWO EARRINGS

Gold, length 2·8 and 3 cm., weight 12·90 gr. and 12·75 gr.
Inv.No.1641, 1642.
Spiral-shaped, ending in pyramids, indented along the edges.

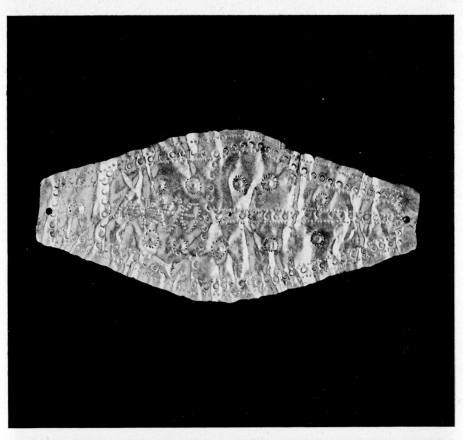

172

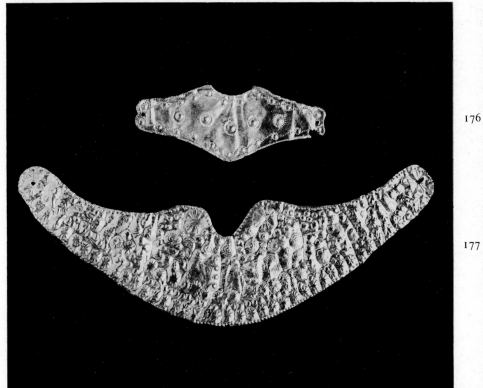

176

177

The treasure from the Golyamata Mound, Douvanli

MID-FIFTH CENTURY BC

ARCHAEOLOGICAL MUSEUM, PLOVDIV

This mound contains the earliest tomb of a man found in Douvanli. Two gold pectorals (Nos.176 and 177) and plaques ornamenting a cuirass (Nos.178 and 180) were made in local workshops. Only the two plaques (No.179) showing Nikè, the Goddess of Victory, driving a chariot with four horses, can be ascribed to a Greek workshop. The furniture of the grave reveals a large number of Greek artefacts, among which two wonderful silver canthari (not exhibited) should be mentioned.

176 PECTORAL
Gold, width 17·5 cm., weight 28 gr.
Inv.No.1644.
Bordered by hatching and rosettes surrounded by circlets connected with little dots. Rosettes, surrounded with hatching, are symmetrically placed in the centre. There are holes at each end by which the pectoral was attached.
Bibl. Duvanlij, 105, No.2, Fig.131.

177 PECTORAL
Gold, width 38·5 cm., weight 86·95 gr.
Inv.No.1643.
Bordered by dots and rosettes; the whole surface is ornamented with rosettes of different sizes. There is a square surrounded by dots in the centre. Holes at each end to attach the pectoral to the garment.
Bibl. Duvanlij, 106, No.3, Fig.131.

178 FIVE PLAQUES FOR A CUIRASS
Silver gilt, height 5·5 cm.
Inv.No.1652.
In the form of a lion's head seen from above. The mane stylized in tufts; folds below the cheeks, the lower jaw not indicated. The five plaques come from the same matrix.

179 TWO PLAQUES FOR A CUIRASS
Silver gilt, height 6·5 cm.
Inv.No.1562.
An image of Nikè, Goddess of Victory, with wings, wearing a long *chiton* and mantle, standing in a chariot holding a wreath in her right hand and the reins in her left. The head of Nikè is shown in profile, but the eye is rendered frontally. A ribbon binds her hair.
Bibl. Duvanlij, 112, No.6-B, Plate VIII, 1,2.

180 PLAQUE FOR A CUIRASS
Silver gilt, width 9 cm.
Inv.No.1653.
In the form of a Gorgon (mask of Medusa) with open mouth and protruding tongue.
Bibl. Duvanlij, 112, No.6, Plate IX.

The treasure from the Bashova mound, Douvanli

TURN OF THE FIFTH AND FOURTH CENTURIES BC

ARCHAEOLOGICAL MUSEUM, PLOVDIV

The gold pectoral (No.181) of this find, on which a lion is depicted, was made by a local craftsman. He borrowed from Achaemenid models, but adapted them to his own taste. The pitcher and rhyton, (Nos.182 and 183) are Greek work from the Propontis, strongly influenced by Persian art. The tomb dates from the Peloponnesian War.

181 PECTORAL
Gold, width 13·8 cm., weight 19·60 gr.
Inv.No.1514.
Crescent-shaped, with a border of shields (*peltas*) surrounding the image of a highly stylized lion (the mane is depicted in the form of diamonds, and there are wrinkles on the cheeks). There are holes at each end by which it was attached.
Bibl. Duvanlij, 62, Plate II, 1.

182 MUG
Silver, height 8·6 cm., diam. 8·3 cm., weight 236 gr.
Inv.No.1518.
The body grooved. The upper part of the handle above the mouth ornamented with two volutes. An inscription in Greek letters around the neck: ΔΑΔΑΛΕΜΕ
Bibl. Duvanlij, 67, No.5, Fig.84.

183 RHYTON (drinking vessel)
Silver, height 20·6 cm.
A border of beading and ovulae around the mouth; below it a band of palmettes and alternating lotus blossoms. Below them a row of small engraved circles. The body of the vessel is grooved, with a row of beading at the end, separating it from the protome of a horse. The hooves, mane and trappings of the horse are gilt, and there is a hole between its legs through which the liquid flowed. At the lower end of the rhyton there is an inscription in Greek letters: ΔΑΔΑΛΕΜΕ.
Bibl. Duvanlij, 67, No.4, Plate VI, Fig.83.

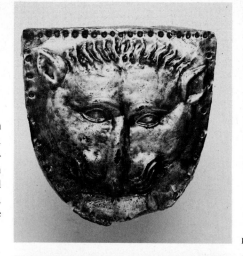

17

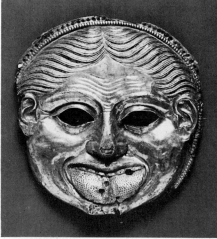

18

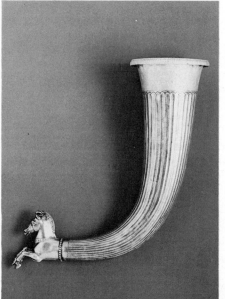

18

Chance and isolated discoveries

END OF THE SIXTH AND THE FIFTH
CENTURY BC

Numerous articles found in different mounds in the course of chance discoveries reveal the splendour which surrounded the Thracian aristocracy at the end of the sixth and in the course of the fifth century BC. Such are the finds at Tatarevo, Turnichené, Svetlen, Rouvets, Pastousha, Pesnopoi, Sadovets, Staro Selo, Chervenkova Mogila (mound) near Brezovo, Mazrachevo, Daskal Athanassovo, Ezerovo and Skrebetno. We also see how the military equipment (helmets and cuirasses) and the jewellery (rings, torques, bracelets and earrings) found at Douvanli were also widespread all over the Thracian area.

The presence of the same elements in the grave furniture is a characteristic feature of all these tombs. Changes only appeared at the turn of the fifth and fourth centuries BC: more particularly hydrias (water-jars) and helmets disappear, being replaced by other vases and another type of defensive arms.

Two objects of particular importance among the chance finds, and those which are difficult to date with any certainty, should be mentioned here: a belt from Lovets and a matrix from Gurchinovo (No. 203), which was used in ornamenting beakers. Beakers of this kind have not been found in Bulgaria, but did come to light in another part of Thrace, now Romania, where a treasure was found at Agighiol. It contains a silver beaker, whose ornamentation can be compared to that of the Gurchinovo matrix. The principal motif of this ornamentation is a stag, the ends of whose antlers are in the shape of animal heads and which is connected with other animal motifs.

As to the belt from Lovets (No.204) it has a type of ornamentation which is often found on the gold pectorals of Anatolia. It is a composition of hunting scenes, symmetrically disposed on both sides of a plant motif. This motif is influenced by an oriental model and symbolizes the Tree of Life.

184 HELMET
Bronze, height 20·9 cm.
Chelopechené, Sofia district (end of the sixth century BC).
National Museum of Military History, Sofia.
Inv.No.547/63.
Corinthian type.

185 HELMET
Bronze, height 17 cm.
Pastousha, Plovdiv district (early fifth century BC).
Archaeological Museum, Sofia.
Inv.No.2445.
Bibl. BCN, IX, 1925, 436, No.90, Fig.11.

186 HELMET
Bronze, height 30 cm.
Sadovets, (fifth century BC).
Archaeological Museum, Sofia.
Inv.No.6756.
With round cheek-pieces, one of which is missing.
Bibl. Iv. Velkov and Hr. Danov, *IAI*, XII, 1938, 440, Fig.232.

187 HELMET
Bronze, height 21 cm.
Sborishté, near Nova Zagora (fifth century BC).
Nova Zagora Museum of History.
Inv.No.1152.
Eyebrows are indicated, with a small tongue between them. Hinged cheek-pieces on both sides.
Bibl. N. Koychev, *IAI*, XIX, 1955, 56, No.3, Fig.4-A-B.

188 HELMET
Bronze, height 21 cm.
Provenance unknown. Second half of the fifth century BC.
Archaeological Museum, Sofia.
Inv.No.4013.
Part of the helmet and cheek-pieces missing.
A griffin on both sides.
Unpublished.

189 HELMET
Bronze, height 19·5 cm.
Pesnopoi, near Chirpan (end of the fifth century BC).
Archaeological Museum, Plovdiv.
Inv.No.3395.
From Pesnopoi Mound; a terracotta sarcophagus contained, besides the helmet, many Attic vases.
Bibl. L. Botousharova, *Pogrebenié v glinen sarkofag — Pesnopoi. Godishnik na museité, Plovdivski Okrug*, I, 1954, 265, No.I, Fig.8.

190 CUIRASS
Bronze, height 32 cm.
Turnichané, near Kazanluk (fifth century BC).
Kazanluk Museum of History.
Inv.No.497.
The pectoral muscles are indicated in the form

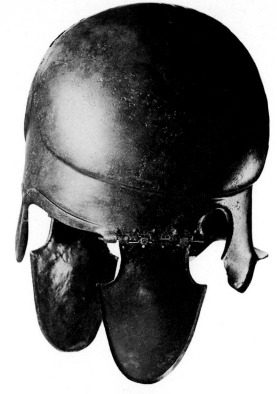

187

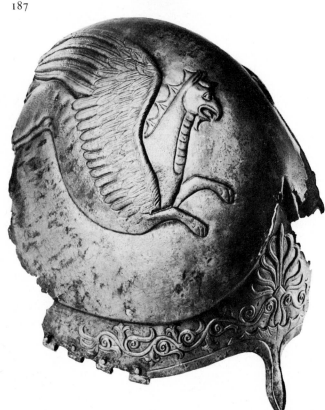

188

of dragons ornamented with engraved palmettes.
Bibl. L. Ognyanova, *BCH*, 1961, 2, 512–516, Figs.7–8. G. Tabakova-Tsanova and Getov, *Gradski Muzei, Kazanluk*, Sofia, 1967, 140, No.34.

191 CUIRASS
Bronze, height 39 cm.
Tatarevo, near Chirpan (first half of fifth century BC).
Archaeological Museum, Sofia.
Inv.No.3364.
Like No.190.
Bibl. L.Ognyanova, *BCH*, 1961, 2, 504–509, Fig.I-3.

192 CUIRASS
Bronze, height 35 cm.
Svetlen (Ayazlar), near Popovo (450–400 BC).
Archaeological Museum, Sofia.
Inv.No.48B.
The mound at Svetlen contained a wealth of burial finds consisting of a large number of bronze vessels and iron articles. Although damaged, the cuirass showed the same motif as that on Nos.190 and 191; the pectoral muscles depicted in the form of dragons. There are traces of gilding.
Bibl. I. Velkov, *IAI*, v 1928, 29, 52, Fig.78. L. Ognyanova, *BCH*, 1961, 2, 509–512, Fig.4–6.

193 CUIRASS
Bronze, height preserved 25 cm.
Rouyets, near Turgovishté (450–400 BC).
Archaeological Museum, Sofia.
Inv.No.6168.
A stone tomb found under the mound at Rouyets contained very interesting burial finds. Besides the cuirass a bronze hydria and a fragment of Greek red-figured pottery was found. The cuirass had a decorative motif similar to the preceding ones: stylized muscles on front and back. It also contained a semi-circular part which covered the abdomen.
Bibl. Iv. Velkov, *IAI*, v, 1928–1929, 39, Figs. 53–54. L. Ognyanova, *BCH*, 1961, 2, 519–522, Fig.14.

194 PECTORAL
Gold, height 13·5 cm., width 3·7 cm., weight 30·7 gr.
From an unknown find-spot in north-eastern Bulgaria (fifth century BC).
Archaeological Museum, Sofia.
Inv.No.8156.
Hexagonal in form ornamented with a network of dots.
Unpublished.

195 PECTORAL
Gold, width 17 cm., weight 40·48 gr.
Staro Selo, near Sliven (second quarter of the fifth century BC).
Archaeological Museum, Sofia.
Inv.No.8123.
Besides the pectoral a water-jar and a foot-bath both made of bronze, a silver beaker, a large number of vessels and the oldest *situla*

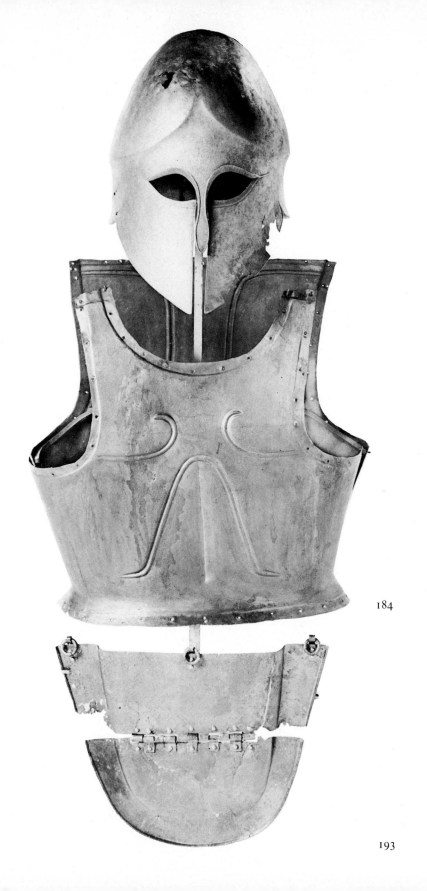

184

193

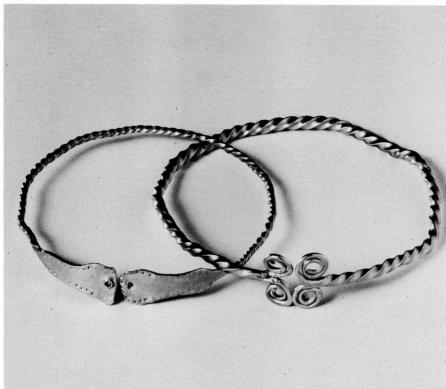

199
200

202

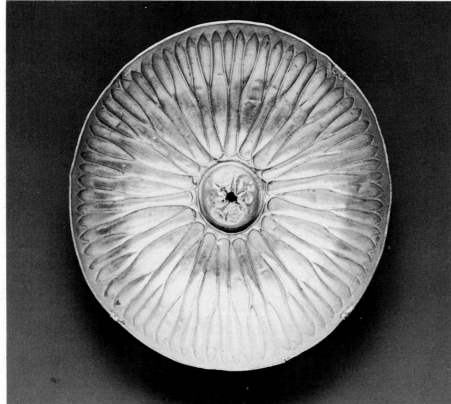

(pail) found in Thrace so far were discovered in the Staro Selo Mound. The pectoral is in the form of an ellipse, has a smooth border and is ornamented with lotus blossoms, alternating with earrings of the Thracian type. There is a stylized Tree of Life in the centre and a hole at each end by which it was attached with next to it a summarily worked palmette.
Bibl. I. Venedikov, *IAI*, XXVII, 1964, 77, No.1, Fig.1.

196 PECTORAL
Gold, width 17·5 cm., weight 19·8 gr.
The Chervenkova Mogila, near Brezovo, Plovdiv district (second half of the fifth century BC).
Archaeological Museum, Plovdiv.
Inv.No.1809.
This mound was particularly rich in burial finds. Besides the pectoral, there were fifth century BC Attic vases. The pectoral is in the form of an ellipse with a border of scales, forming triangles at regular intervals.
Bibl. Iv. Velkov, *IAI*, VIII, 1934, 5, Fig.2.

197 PECTORAL
Gold, width 16·8 cm., weight 28·10 gr.
Ezerovo, near Purvomai (end of the fifth century BC).
Archaeological Museum, Sofia.
Inv.No.5218.
Besides this pectoral and a ring No.198 the finds of Ezerovo included a large number of articles made of pottery, and bronze vessels. The pectoral is shaped like an irregular hexagon, the lower part is longer than the upper part. It is surrounded by a border of dots in relief, and ornamented with small circles. There are holes at each end for attachment.
Bibl. B. Filov, *op. cit.*, No.167, 206, No.2, Plate III, 1.

198 RING
Gold, diam. 2·7 cm., weight 31·3 gr.
Ezerovo, near Purvomai (end of fifth century BC).
Archaeological Museum, Sofia.
Inv.No.5217.
The hoop is fitted with a movable bezel on which is engraved a Thracian inscription in Greek letters:
ΡΟΛΙΣΤΕΝΕΑΣΝ
ΕΡΕΝΕΑΤΙΛ
ΤΕΑΝΗΣΚΟΑ
ΡΑΖΕΑΔΟΜ
ΕΑΝΤΙΛΕΖΥ
ΠΤΑΜΙΗΕ
ΡΑΖ
At the side:
ΗΛΤΑ
Bibl. B. Filov, *IAI*, III, 1911, 203, Plate III-4, V.206.

199 BRACELET
Gold, diam. 8·4 cm., weight 17·65 gr.
Skrebatno, near Gotsé Delchev (fifth century BC).
Archaeological Museum, Sofia.

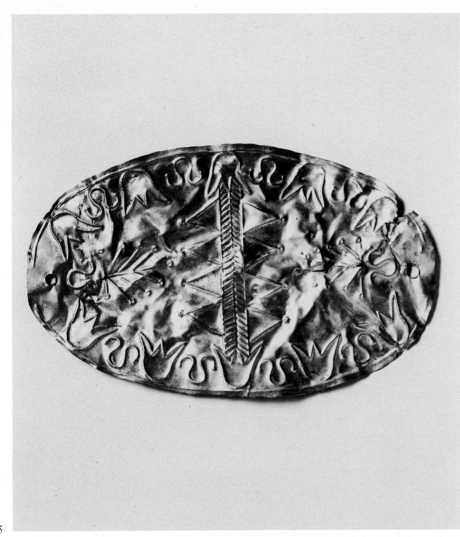

Inv.No.3168.
Made of twisted wire with flat widened ends ornamented with a border of dots, a hole in the middle of each end.
Bibl. V. Mikov, *IAI,* XVII, 1950, 151, Fig.89.

200 BRACELET
Gold, diam. 10 cm., weight 41·5 gr.
Skrebatno, near Gotsé Delchev (fifth century BC).
Archaeological Museum, Sofia.
Inv.No.3167.
Made of twisted wire ending in spirals.
Bibl. See No.199.

201 EARRINGS
Gold, length 3·4 cm., weight 11·72 gr.
Mazrachevo, Kyustendil district (fifth century BC).
Ending in the protome of a snake. Ornamented with granules grouped in triangles, like scales.
Unpublished.

202 PHIALE
Gold, height 3 cm., diam. 14·5 cm., weight 809·5 gr.
Daskal Athanassovo, Stara Zagora district (fifth century BC).
District Museum of History, Stara Zagora.
Inv.No.IICz 1132.
Bibl. D. Nikolov, *Zlatni fiali ot s. Daskal Athanassovo, St. Zagorsko* (*Studies in memory of K. Shkorpil*), Sofia, 1961, 367–368, Fig.1.

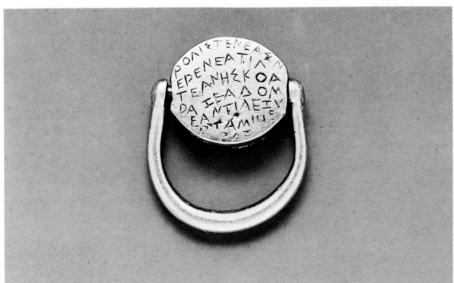

203 MATRIX
Bronze, length 29 cm.
Gurchinovo, Shoumen district (fifth century
BC).
District Museum of History, Shoumen.
Inv.No.23.
This matrix was used in ornamenting beakers.
It depicts a stag with its head turned back and
its legs folded under its body. The shoulder is
stylized in the shape of a bird, the tips of the
antlers are heads of birds. Behind the stag there
is a winged griffin with only one horn. In front
of the stag there is a bird with a curved beak,
its claws also depicted as birds' heads. The stag
is being attacked by a small lion. On the left of
the lower frieze there are a lion, a griffin and a
horned griffin, all turned to the left; on the
right there are two lions, a stag and a lion.
Bibl. I. Venedikov, *Izkoustvo*, XIV, 1966,
20–22, No.4.

204 BELT
Silver gilt, length 31 cm.
Lovets, Stara Zagora district (fifth to fourth
centuries BC).
Archaeological Museum, Sofia.
Inv.No.6617.
A small rectangular plaque with a hook at both
ends, attached to a silver base by nails, framed
by a band of little squares with a bead in the
centre. In the centre three plant ornaments of
lotus blossoms between two boars enclosed in a
frame. A horseman behind them with a dog
under him on one side, and a helmet on the
other. At both ends a kneeling archer shooting
his bow.
Bibl. I. Velkov, *IAI*, VIII, 1934, 18–33.

204

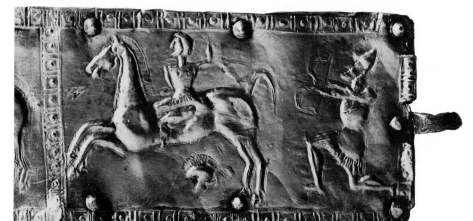

203

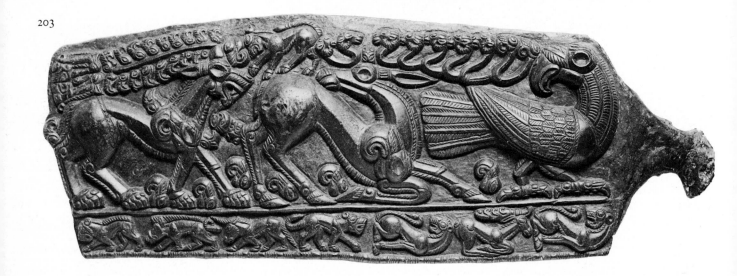

Mounds from the end of the fifth to the third century BC

The only group of mounds of this period to have been discovered and systematically studied is that at Mezek. In other cases, the objects were obtained from chance finds, which it was not possible to study in their archaeological context. It should, moreover, be noted that despite the existence of the Odrysaean kingdom, the really rich finds were discovered in the north on both sides of the Balkan Range. The splendour of Douvanli should therefore be attributed to tribes which were detached from the Kingdom of the Odrysae, or which had never been subjected by it.

The crisis which this kingdom experienced at the end of the fifth and in the early fourth century BC is very clearly revealed by these archaeological finds.

Another interesting fact revealed by these excavations is the widespread distribution of plaques for horse trappings made of bronze and silver. Although some archaeologists explain this fact by the presence of the Scythians, it should be noted that there were no Scythians in south-eastern Thrace, which bordered on Asia Minor, or to the north-east, in the region nearer to the Scythians. No matter how strange it may seem, the contrary is the case, for it is precisely in north-west Thrace that a large number of these plaques were found. On the other hand, phialai and vases made of silver were most widespread, and ornaments for shields appeared at the same time. These articles are ornamented with animal motifs, treated in a style close to that of the Scythians, but preserving a certain purely Achaemenid character. In contrast to the Geometric period, the animals most frequently depicted are lions, bears, wolves, griffins and lion-griffins, without counting the other imaginary animals with the bodies of snakes, which are quite strange and alien to old Thracian art. Human figures also appeared and we sometimes come across a whole composition in which the deity in the form of a horseman occupies the central place. Thus, although fights between animals and animal motifs are depicted (motifs whose complexity sometimes makes interpretation difficult), these works are close to Scythian art; however, certain particular features reveal the originality of Thracian art.

Animal ornamentation is not a special phenomenon in Thracian or in Scythian art alone. The Greeks who lived in the coastal cities of Thrace also introduced many oriental elements into their metalwork under the influence of the Achaemenids. The rhyton (a drinking vessel) appeared in Thrace at the same time, in the form of a human or an animal head, and also much jewellery, brought from Greek workshops, ornamented with animals: the head of a lion, a bull or a horned lion. The Greek craftsmen tried to achieve an even greater stylization, and so did the Thracian craftsmen: muscles and wrinkles around the mouth and eyes were treated quite conventionally.

In brief, the finds from this period indicate influences from the east, which was to increase and culminate with the campaigns of Alexander the Great in Asia.

205–207

The treasure of the Sredna Mogila (Middle Mound), near Mezek, Svilengrad region (modern Haskovo district)

TURN OF THE FIFTH AND FOURTH
CENTURIES BC

ARCHAEOLOGICAL MUSEUM, SOFIA

205 PHIALE
Silver, diam. 8·5 cm.
Inv.No.6755.
No ornamentation on the interior, on the outside the bottom is ornamented with concentric circles and beads forming a rosette. The phiale was cast.
Bibl. I. Velkov, *IAI*, XI, 134, No.1, Fig.122.

206 HEADSTALL
Silver, height 4 cm.
Inv.No.6800.
In the form of a lion's head between two goat heads, the beginning of the lion's mane being marked with semi-circles; there is a round opening behind the head through which the strap was passed.
Bibl. Iv. Venedikov, *IAI*, XI, 1937, 134, Figs. 123–125.

207 THREE PLAQUES
Silver, height 5·5 cm.
Inv.No.6799.
In the form of a cross with three branches, ornamented with lions' heads (the lower jaw is not depicted; there are wrinkles on the cheeks) in the centre, concentric circles, a ring on which they were hung at the back.

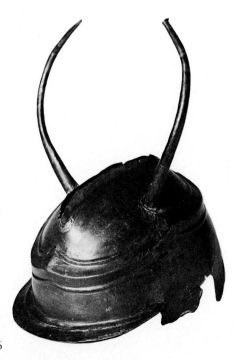

The Brezovo treasure
Plovdiv district

TURN OF THE FIFTH AND FOURTH
CENTURIES BC

ARCHAEOLOGICAL MUSEUM, SOFIA

These articles were found in a mound. The
most important of them are the plaques for
the trappings of a horse, but there were also
vases like those found in the Middle Mound
near Mezek.
Bibl.: B.Filov, *RM*, XXXII, 1917, 27–29,
Nos.2–6, Figs.2–8.

HORSE TRAPPINGS
208 HEADSTALL
Silver, height 4·7 cm.
Inv.No.1712.
Formed of two lions' heads, one above the
other. The upper head is round and protruding
(wrinkles on the cheeks behind which the name
is indicated by two semi-circles), the lower
head is in relief, seen from above; the lower
jaw is missing.

209 TWO PLAQUES
Bronze, silver plated, height 6·1 to 6·3 cm.
Inv.No.1712.
Open-work, in the form of a cross around a
boss (the branches of the cross are widened at
the ends, and joined together by circles and
spirals — elements of highly stylized animal
images).

210 TWO PLAQUES
Bronze, height 5 cm.
Inv.No.1712.
In the form of an animal its head turned back
and its legs folded, shoulder and thigh highly
stylized.

211 TWO PAIRS OF PLAQUES
Silver, height 4·5 to 4·8 cm.
Inv.No.1712.
In the form of a griffin's head with open beak.
The mane is depicted by a semi-circular border
of hatching.

212 TWO PLAQUES
Silver, height 7·2 cm.
Inv.No.1712.
In the form of lions' legs emerging from the
shoulder of an animal. The claws are curved
and sharp.

213 REIN
Silver, length 18 cm.
Inv.No.1709.
The sides in the form of the letter S finished at
one end by the head of a lion, at the other by a
little ball.

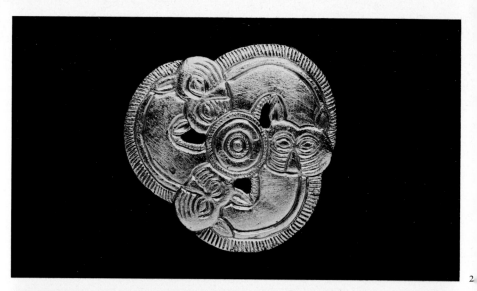

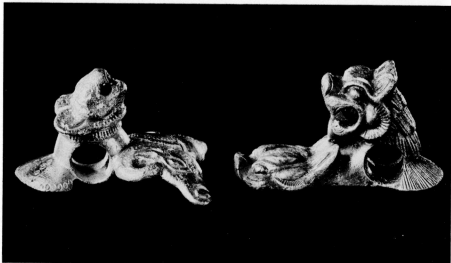

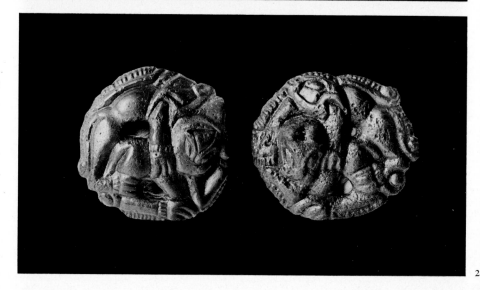

214 TWO PHIALAI
Silver, height 17 cm., diam. 10·4 and 10·1 cm., weight 110·5 gr. and 124·4 gr.
Inv.No.1709.

215 RING
Gold, diam. 2·5 cm., weight 14·75 gr.
Inv.No.1579.
There is a roughly made figure of a horseman on the obverse of the plaque on the ring. He is moving towards a woman who is holding a rhyton (drinking vessel) in her hand.

216–225

The treasure from Radyuvene, Lovech district

FIFTH TO FOURTH CENTURIES BC

ARCHAEOLOGICAL MUSEUM, SOFIA

This treasure was a chance find. In general the articles described below are dated according to their style.

216 TWO PLAQUES FROM THE TRAPPINGS OF A HORSE
Silver, length 4 cm., weight 24·5 gr.
Inv.Nos. 5201 and 5202.
The lower part of one plaque is missing. The motif is in the form of a lion's legs emerging from the shoulder of an animal (See No.212).
Bibl. B. Filov, *RM*, XXXII, 1917, *op. cit.*, 54, No.51, Fig.56.

217 ARYBALLOS
(bottle with a spherical body and short neck)
Silver, height 14·5 cm., diam. 7 cm., weight 340·7 gr.
Inv.No.5199.
No ornamentation. A small part of the mouth missing.
Bibl. B. Filov, *RM*, XXXII, 1917, 54, No.50, Fig.55.

218 PHIALE
Silver, diam. 13 cm.
With central boss but no ornamentation.
Inv.No.5195.
Bibl. B. Filov, *RM*, XXXII, 1917, 53–54, No.49, Fig.54.

219 PHIALE
Silver, diam. 10 cm.
Inv.No.5193.
With central boss. Part of bottom missing.
Bibl. See No.218.

220 PHIALE
Silver, diam. 12·4 cm.
Inv.No.5192.
With a central boss surrounded by beading and radially placed grooves.
Bibl. See No.218.

221 PHIALE
Silver, diam. 12·4 cm.
Inv.No.5196.
With a central boss, no ornamentation. A small hole at one side.
Bibl. See No.218.

222 PHIALE
Silver, diam. 19·5 cm.
Inv.No.5189.
Ornamented with indentation, beading and a rosette of grooves around the central boss.
Bibl. See No.218.

223 PHIALE
Silver, diam. 10·5 cm.
Inv.No.5190.
With a central boss surrounded by grooves. Pierced.
Bibl. See No.218.

224 PHIALE
Silver, diam. 10·5 cm.
Inv.No.5191.
With a central boss, the bottom grooved.
Bibl. See No.218.

225 PHIALE
Silver, diam. 11·9 cm.
Inv.No.5197.
With a central boss, no ornamentation.
Bibl. See No.218.

226 PHIALE
Bronze, diam. 17 cm.
Turn of the fifth and fourth centuries BC.
Inv.No.8015.
The bottom ornamented with two rows of lotus buds.

227 PHIALE
Silver, diam. 8·8 cm.
Gradnitsa, Lovech district.
Fourth century BC.
Collection of Sofia University No.1.
Ornamented with grooves around the central boss, and a design of olives on both sides of a flat band.

229–233

Horse Trappings

Boukyovtsi, near Oryahovo

TURN OF FIFTH AND FOURTH CENTURIES BC

ARCHAEOLOGICAL MUSEUM, SOFIA

Bibl. IAI, XII, 1938, 137, No.5 and 7–8, Fig.227–228.

229 HEADSTALL
Silver, height 3·8 cm.
Inv.No.6698.

In the form of a falcon's head with curved beak and protruding eye, ornamented with a palmette at the lower end. A round opening for passing the bridle through behind the falcon's head.

230 PLAQUE
Silver, height 2·8 cm.
Inv.No.6700.
Ornamented with two lotus blossoms joined together, a ring at the back.

231 THREE PLAQUES
Silver, height 5·8 cm.
Inv.No.6701, a, b, c.
Round, with rings at the back.

232,233 TWO PHIALAI
Silver, height: (a) 7 cm. (b) 5·5 cm.; diam.: (a) 17·7 cm. (b) 13 cm.
Inv.Nos.6697 and 6696.
(a) Grooved around the boss, with a band of engraved ovulae on the rounded part. Above them tongue-shaped ovulae.
(b) The tongue-grooving is finer. Three scallops between two grooves at the bottom, a tongue-shaped ornament at the top.
Bibl. I. Velkov and Hr. Danov, *IAI*, XII, 1938, 436, Nos.3–4, Figs.225–226.

234–236

Set of Plaques for Horse Trappings, Teteven

TURN OF THE FIFTH AND FOURTH CENTURIES BC

TETEVEN MUSEUM OF HISTORY

Bibl. T. Gerassimov, *IAI*, XVII, 1950, 254–255, Nos.1–3, Fig,191.

234 HEADSTALL
Bronze, height 5·5 cm.
Inv.No.A20.
In the form of a griffin's head, highly stylized and surrounded above and below by a mane. An opening through which a strap was passed behind the head.

235,236 TWO PLAQUES
Bronze, diam. 4 cm.
Inv.Nos.A21 and A22.
Irregular in shape, depicting a group of griffins attacking a lion, the images highly stylized, a ring at the back.

237 PLAQUE
Bronze, diam. 2·3 cm.
Inv.No.A23.
Round with a ring at the back.

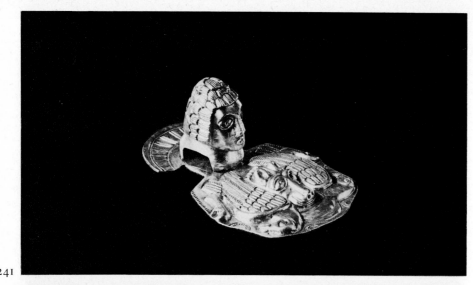

241

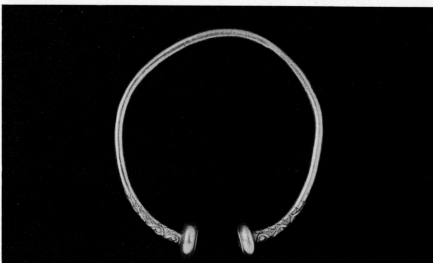

253

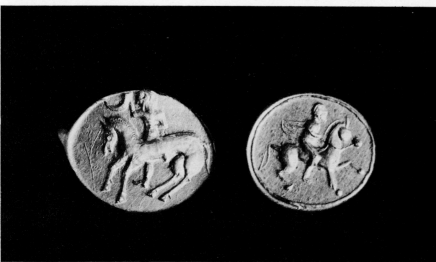

255
256

58

Horse Trappings
Orizovo, near Chirpan

TURN OF THE FIFTH AND FOURTH
CENTURIES BC

ARCHAEOLOGICAL MUSEUM, PLOVDIV

Bronze vessels were also found in this
mound.
Bibl. D. Tsonchev, *GPM*, I, 1948, 21–22,
Nos.4–6, Figs.8-10.

238 HEADSTALL
Bronze, height 3 cm.
Inv.No.2582.
Three-dimensional head of a griffin (with
curved beak, big round eyes and incised semi-
circles on the cheeks), a round opening through
which the bridle was passed below the head.

239 TWO PLAQUES
Bronze, height 5 cm.
Inv.No.2584.
Ornamented with a griffin and another in-
definite animal, the shoulder stylized in the
form of a horse's head. A ring at the back.

240 PLAQUE
Bronze, height 5 cm.
Inv.No.2585.
In the form of a griffin's protome. A ring at the
back.

241 HEADSTALL
Silver, height 7·4 cm.
Sveshtari, Shoumen district.
Turn of the fifth and fourth centuries BC.
Archaeological Museum, Sofia.
Inv.No.3159.
In the form of an ellipse, ornamented with a
three-dimensional human head. The hair in a
network of polygons, covered with incised
lines. A square hole for the strap behind the
head. Below it the head of a lion in relief, seen
from above, without a lower jaw. A band of
triangles above the forehead indicates the
beginning of the mane. Two folds along the
cheeks curve towards the nose. A bird on each
side of the head. On the upper part grooves
arranged in a fan-shape like a bird's tail.
Bibl. Iv. Venedikov, *Actes du Ier Congrès
international des études Balkaniques et Sud-Est
européennes*, II, 1970, 390, Figs.13–14.

242 PLAQUE
Element from a horse-trapping.
Bronze, height 6·4 cm.
Lazar Stanevo, Lovech district.
Turn of the fifth and fourth centuries BC.
Archaeological Museum, Sofia.
Inv.No.8401.
In the form of a dog, its legs folded under the
body.

244–245
Horse Trappings
Bednyakovo, near Chirpan

FOURTH CENTURY BC

ARCHAEOLOGICAL MUSEUM, SOFIA

Inv. No.4235.
A red-figured Attic vase was found in this mound with these objects.
Bibl. B. Filov, Denkmäler . . ., 49–50, Nos. 44–46, Figs.47–51.

244 HEADSTALL
Bronze, height 3 cm.
The upper part in the shape of a summarily worked animal's head, resembling a hare's. Behind it there is a round opening for the strap. Ornamented with a roughly worked palmette at the lower end.

245 THREE PLAQUES
Bronze, height 5·8 cm.
Shaped like the protome of a griffin, the eyes clearly drawn, the ears pricked up, the legs reminiscent of a lion's paws. Two of the images face left, the third faces right. A ring at the back.

246 HELMET
Bronze, height 14 cm.
Bryastovets (Karaagach), Bourgas district. Fourth century BC.
Archaeological Museum, Sofia.
Inv.No.3454.
This helmet is ornamented with two horns. The cheek-pieces, of iron, are missing.
Bibl. I. Velkov, *IAI*, v, 1928–29, 41, Fig.58.

247 HELMET
Bronze, height 23·7 cm.
Kovachevitsa, near Gotsé Delchev, fourth century BC.
Archaeological Museum, Sofia.
Inv.No.2676.
Torques were also found in Kovachevitsa. The helmet is of the Thracian type with movable cheek-pieces attached to a hinge on the helmet, and fastened in the middle of the chin, forming a vizor for the face with openings for the eyes, nose and mouth. A beard and moustache, stylized in large spirally curled tufts of hair are depicted in relief on the cheek-pieces.
Bibl. V. Mikov, *GHBM*, 1925, 181, Figs.1–2.

248 HELMET
Bronze, height 30 cm.
Assenovgrad. Fourth century BC.
Archaeological Museum, Sofia.
Inv.No.7308.
Of the Thracian type, with eyebrows marked on the forehead, and cheek-pieces which fastened in front, beard and moustache in relief around the mouth-opening.
Bibl. T. Ivanov, *RPr*, I, 1948, 102, No.1, Figs. 71–72.

249 PAIR OF GREAVES
Bronze, height 42 cm.
Assenovgrad. Fourth century BC.
Archaeological Museum, Sofia.
Inv.No.7309.
The shape of the leg is plastically moulded. There is a stamp on the outer side at the upper end.
Bibl. T. Ivanov, *RPr*, I, 1948, 105, Fig.79.

250 PECTORAL
Golyama Zhelezna, Sofia district.
Gold, length 9·8 cm.
Fourth century BC.
Archaeological Museum, Sofia.
Inv.No.3255.
In the shape of a diamond, ornamented with dots.
Bibl. V. Mikov, *IAI*, XVII, 1950, 147–48, Fig.85.

251 PECTORAL
Gold, Length 13·5 cm., weight 7·62 gr.
Voinitsité, near Chirpan. Fourth century BC.
Archaeological Museum, Sofia.
Inv.No.3110.
One end missing. In the form of an ellipse. Surrounded by a border of dots and pendants, earrings, alternating with a little circle with its centre marked. Beads in the centre surrounded by dots.

252 PECTORAL
Gold, length 12·7 cm., weight 11·50 gr.
Opulchenets, Plovdiv district.
Fourth century BC.
Archaeological Museum, Plovdiv.
Inv.No.1383.
In the form of an ellipse. Eleven motifs of double concentric circles on the border. Four figures of women dressed in long *chitons* and mantles which cover their heads are arranged in the middle in the form of a cross. There is a hole at each end by which the pectoral was attached.
Bibl. B. Dyakovich, *GPHB*, 1931, 187, Fig.1.

253 TORQUE
Gold, diam. 14·5 cm., weight 430 gr.
Tsibur Varosh, near Lom. Fourth century BC.
Archaeological Museum, Sofia.
Inv.No.3242.
The ends decorated with plant ornaments, which end in flattened balls. This is the only torque of this type found in Thrace.

254 END OF A TORQUE
Gold, length 3·7 cm., weight 9·47 gr.
Gerlovo, near Novi Pazar. Turn of fourth and third century BC.
Archaeological Museum, Sofia.
Inv.No.5753.
A small tube ornamented with palmettes and spirals ending in a small hollow ram's head.

255 RING
Gold, diam. 2·85 cm., weight 11·8 gr.
Glozhené near Teteven. Fourth century BC.
Archaeological Museum, Sofia,

Inv.No.7955.
A bearded man is depicted on the bezel of the ring. He is holding a horn in his hand, and a stallion is standing behind it.

256 RING
Gold, diam. 2·6 cm., weight 18 gr.
Origin unknown. Fourth century BC.
Archaeological Museum, Sofia.
Inv.No.8398.
The ring has an ellipse-shaped bezel on which a horseman is depicted, riding to the right. He has a pointed beard and is dressed in a *chlamys* (cloak), flowing out behind him. The muscles of the horse are stressed, the tail is curved at right angles, the head is stylized in the form of two spherical balls, and the hooves are like small balls.

257 EARRING
Gold, length 2·1 cm., weight 1·94 gr.
Rankovtsi near Gotsé Delchev. Fourth century BC.
Archaeological Museum, Sofia.
Inv.No.5742.
The lower part, shaped like an *askos* (goatskin bottle), is hollow. A row of beading in the middle, at each end and on the base of the ring.

258 PAIR OF EARRINGS
Gold, diam. 1·5 cm., weight 2·5 gr.
Madara, Shoumen district. Fourth century BC.
Archaeological Museum, Sofia.
Inv.Nos.6819 and 6820.
In the form of a ring of twisted wire ending in a lion's head, ornamented with granules.
Bibl. R. Popov, *Mogila No.1. Sbornik Madara I,.* 1934, 253, Fig.218.

259 TWO BRACELETS
Silver, width 4·5 cm.
Granitovo, near Vidin. Fourth century BC.
Archaeological Museum, Sofia.
Inv.No.4036 a and b.
With overlapping ends, three bands in relief with incised ornamentation along the length.

260 TWO BRACELETS
Silver, width 3·5 and 3·8 cm.
Lom region. Fourth century BC.
Lom Museum of History.
Inv.No.20199.
Ornamented with grooves and an incised design.

261 TWO FIBULAE
Silver, height 6·5 cm.
Lom region. Fourth century BC.
Lom Museum of History.
Inv.No.20200.
The bow ornamented with motifs in the form of a cross. One of the ends, shaped like a leaf, is ornamented with a bukranion (a decorative element in the form of an ox head), the other with a rosette.

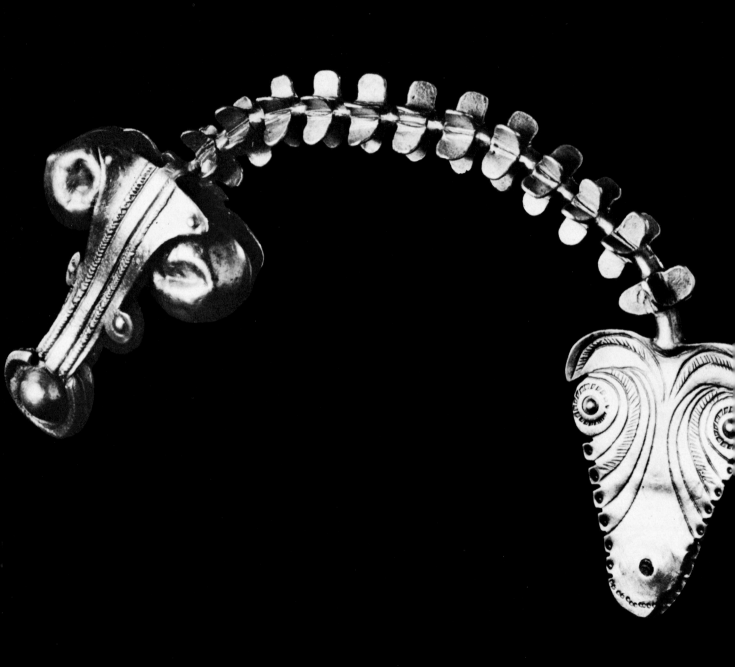

262–264

Finds from Vladinya

262 PHIALE
Silver, height 3·5 cm., diam. 10·5 cm.
Vladinya, Lovech district. Early fourth century
BC.
Archaeological Museum, Sofia.
Inv.No.8150.
A cross with a scaly ornament around the boss.
Bibl. A. Dimitrova, *IAI*, XXIX, 1966, 123, No.11.
Figs.15–16.

263 BRACELET
Silver, width 28·5 cm., length 4·5 cm.
Vladinya, Lovech district. Fourth century BC.
Archaeological Museum, Sofia.
Inv.No.8151.
Open, with tapered ends, ornamented with
grooves and an incised design.
Bibl. A. Dimitrova, *IAI*, XXIX, 1966, 118, No.5,
Figs.6–7.

264 TWO FIBULAE
Silver, width 4·7 and 8 cm., height 6·6 and 6 cm.
Vladinya, Lovech district. Fourth century BC.
Archaeological Museum, Sofia.
Inv.Nos.8148 and 8149.
Of the same type as the Boukyovtsi fibulae; the
pins are missing.
Bibl. A. Dimitrova, *IAI*, XXIX, 1966, 115,
Nos.1–2, Figs.2-A-B.

265–269

The second treasure from Boukyovtsi, near Oryahovo

FOURTH CENTURY BC

ARCHAEOLOGICAL MUSEUM, SOFIA

265 SET OF JEWELLERY
Silver.
Inv.No.2668-A.
Consists of five fibulae (the sixth is missing)
ornamented with palmettes and rosettes. They
are attached to a chain. The hook is attached
to the chain by a human head, rosettes and
poppies and acorns. There is a large rosette in
the middle of the ornament. The fibulae are
decorated with palmettes, rosettes and other
ornaments.
Bibl. R. Popov, *GNAM*, Sofia, 1922–25, I, Fig.2.

266 BEAKER (from the First Treasure from
Boukyovtsi)
Silver gilt, height 12·2 cm.
Inv.No.6694.
A band of engraved and gilt lotus blossoms
alternating with palmettes below the mouth.
The body is covered with horizontal grooves.
Only at the bottom there is an unornamented
band.
Bibl. I. Velkov and Hr. Danov. *IAI*, XII, 135,
No.1.

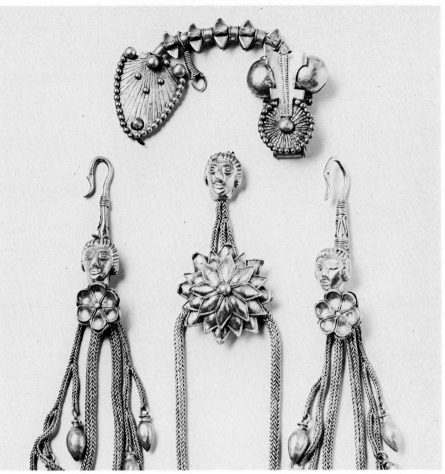

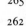
265

262

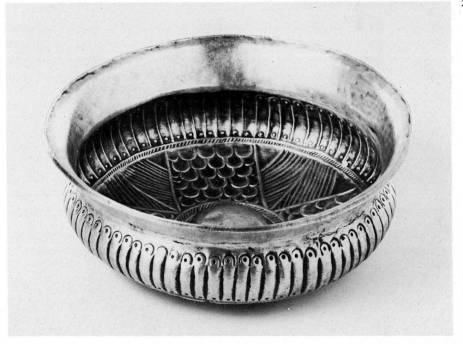

267 SMALL VASE
Silver, height 6·4 cm.
Inv.No.2558-B.
No ornamentation.
Bibl. R. Popov, *GNAM*, Sofia, 1922, 25, 8,
Figs.11–12.

268 ONE-HANDLED VASE
Silver, height 9 cm.
Inv.No.2558-C.
A large part of the mouth is missing. Below it
there is a band of astragali. The handle ends in
volutes at the upper end and in a palmette at
the lower end.
Bibl. See No.267.

269 ONE-HANDLED VASE
Silver, height 8·6 cm.
Inv.No.6695.
The body is covered with vertical grooves,
broken by a horizontal band without orna-
ments. On both sides of this band and at the
base of the neck there is a row of beading. The
handle is curved and is shaped like a palmette
at the lower end.
Bibl. I. Velkov and Hr. Danov, *IAI*, XII, 1938,
436, No.2, Fig.224.

270 VASE
Silver, height 11 cm.
Strelcha, near Panagyurishté, fourth century
BC.
Archaeological Museum, Plovdiv.
Inv.No.3356.
A row of ovules in the middle and at the base of
the neck.

Rich burials of the fourth century BC

The large finds of Letnitsa, Alexandrovo and Branichevo contain many similar articles which allow us to assign these treasures to one and the same period. The burial finds of the Mogilanska Mogila (Mound) in Vratsa can also be assigned to the same period. In them all, particularly in Vratsa and Branichevo, silver phialai are found with the names of Thracian kings, Kotys (382–359 BC) and Amatokos (359–351 BC), at whose orders they were made, to be offered to the persons buried in the tombs.

The names of the master craftsmen who made them are found on the phialai: Engeiston in Alexandrovo, Edteos in Vratsa and Teres in Branichevo.

271–288
The Letnitsa treasure, Lovech District

400–350 BC

DISTRICT MUSEUM OF HISTORY, LOVECH

This treasure was found accidentally contained in a bronze vessel. Besides the rein and the headstall it consists of small openwork silver plaques, which ornamented the harness of a horse. Each plaque has a ring on its back through which the straps fastening it passed. The openwork plaques are reminiscent of other similar finds. The new feature of this treasure is the large quantities of square and rectangular plaques, depicting scenes from daily life or fantastic monsters. They were the work of another craftsman. Besides their original realism a strong eastern influence is felt.
Bibl. I.Venedikov and P.Pavlov, *Izkoustvo*, III, 1963, 9, 20.

271 HEADSTALL
Silver gilt, height 5 cm.
Inv.No.593.
Depicts a lion attacking a bull. The bull has bent its forelegs, which are folded under it. There is a round hole under the lion through which a strap was passed.

272 TWO PLAQUES
Silver gilt, height 7 cm.
Inv.No.606.
A swastika whose arms end in a griffin's head, with sharply curved beak. A semi-circle behind the animal's eye indicates the beginning of the mane. A border of incised hatching.

273 PLAQUE
Silver gilt, diam. 7 cm.
Inv.No.591.
Round, depicting eight horses' heads with ears, mane and trappings indicated. All the heads in profile, the eye shown frontally.

274 PLAQUE
Silver gilt, height 5 cm.
Inv.No.505.
Rectangular, with a border of three rows of ovules, broken by the figures. Inside the frame there is a long-haired woman, dressed in a long robe, holding a patera (dish) in her hand. A three-headed snake stands before her.

275 PLAQUE
Silver gilt, height 5 cm.
Inv.No.604.
Two women and a man within a rectangular frame. The man is seated on a cushion and has raised the front of his garment. He has long hair gathered up at the top of his head, a beard and moustache. The kneeling woman has also raised the front of her garment. The picture illustrates a sacred marriage between two deities. The man and woman are embracing, while behind them another woman, wearing a long robe, holds a twig in her right hand and has placed her left hand on a vessel. The breasts of both women are indicated by small circles. The heads of all three figures are shown in profile with the eyes frontally.

276 PLAQUE
Silver gilt, height 4·5 cm.
Inv.No.582.
Square with a broken border of ovulae (see preceding numbers). It shows a wolf attacking a deer. The fur of the animals is indicated. The local craftsman has depicted the muscles in the smallest details.

277 PLAQUE
Silver gilt, height 6 cm.
Inv.No.581.
Rectangular, with a border of ovulae, broken in many places (see preceding numbers). It depicts a fight between two bears, standing on their hind legs. The heads of the animals are highly stylized, the tails in the form of spirals, and the fur indicated.

278 PLAQUE
Silver gilt, height 5 cm.
Inv.No.580.
Rectangular, surrounded by a row of ovulae, depicts a griffin with outspread wings attacking an elk, whose legs are folded under its body.

279 PLAQUE
Silver gilt, height 5 cm.
Inv.No.583.
Square, surrounded by ovulae on both sides. Depicting a Nereid (sea nymph) riding a hyppocamp with the body of a snake and the head of a horse. The Nereid is dressed in a long robe; her breasts are indicated by two small

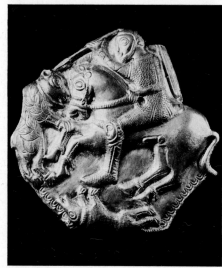

273

281

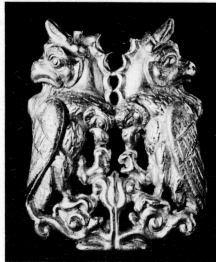

288

circles, the face is shown in profile with a frontal eye.

280 PLAQUE
Silver gilt, height 5 cm.
Inv.No.589.
Rectangular, depicting a horseman holding a phiale in his left hand. He has long hair and a short beard, is wearing a cuirass and riding a stallion, whose saddle and trappings are indicated.

281 PLAQUE
Silver gilt, height 5 cm.
Inv.No.590.
Irregular in shape, surrounded by a row of ovulae, broken by the figures. It shows a horseman attacked by a bear. The horseman is riding a stallion and brandishing a spear in his right hand, while holding the reins in his left. He is wearing a cuirass and greaves. There is a wolf under the horse.

282 PLAQUE
Silver, height 4·5 cm.
Inv.No.584.
Irregular in form. Depicts a horseman brandishing a spear, with a horse's head behind him.

283 TWO PLAQUES
Silver gilt, height 5 cm.
Inv.Nos.587 and 588.
Rectangular in form. Depicting a horseman with a short beard brandishing a spear in his left hand and wearing a cuirass. A human head behind him.

284 PLAQUE
Silver gilt, height 4·5 cm.
Inv.No.585.
Rectangular in form, it depicts a horseman with his hair tied in a knot at the top of his head. He wears a cuirass and rides a stallion. In his right hand he brandishes a spear, and holds the reins in his left. There is a bow at his back. This plaque has a border of ovules broken by the spear, the horse's hooves, the bow, the tail of the horse and the rider's head, all of which protrude from the frame.

285 PLAQUE
Silver gilt, height 4·2 cm.
Inv.No.586.
Like the preceding plaque. The spear and the horse's tail emerge from the frame and there is a horse's head filling in the empty space in the corner of the plaque at the horseman's back.

286 PLAQUE
Silver, height 4·5 cm.
Inv.No.583 A.
Like the preceding one but there is a woman's head at the horseman's back.

287 PLAQUE
Silver gilt, height 7 cm.
Inv.No.592.

Open-work and irregular in form, it depicts a fight between a lion and a griffin. Two snakes, erect behind them, take part in the fight. The tenseness of the fight is indicated with great skill, although the craftsman has not yet rid himself of conventionality and retains the local style, particularly in depicting the animals' heads.

288 FOUR PLAQUES
Silver gilt, height 2·8 cm.
Inv.No.594.
Irregular in form, openwork in technique, it depicts two eagles in front of two griffins.

289 PHIALE
Silver, diam. 13·5 cm., weight 133·7 gr.
Alexandrovo, Lovech district (early fourth century BC).
Archaeological Museum, Sofia.
Inv.No.2241.
Inscribed in Greek characters on the neck with the name of King Kotys and that of the craftsman who made it (Engeiston),

290 PHIALE
Silver, diam. 12·2 cm., weight 123·4 gr.
From Alexandrovo, Lovech district (early fourth century BC).
Archaeological Museum, Sofia.
Inv.No.2242.
Like the preceding one, but boss is gilt.
Inscribed: A Δ.

291 PHIALE
Silver, diam. 12·52 cm., weight 133·2 gr.
Alexandrovo, Lovech district (early fourth century BC).
Archaeological Museum, Sofia.
Inv.No.2243.
Without ornamentation.

292–310

The Vratsa treasure (Mogilanska Mound) 380–350 BC

DISTRICT MUSEUM OF HISTORY, VRATSA

Three tombs were found in this mound. One of them had been robbed in antiquity; another contained only two small vases of gold and silver. The richest tomb contained the skeleton of a man; the skeleton of a woman with earrings (No.295) and a gold wreath (No.299); and three horses (one of them with very rich trappings, the other two harnessed to a chariot). Two small vases and four beakers were found in the same grave, but the greave, of very fine craftsmanship (No.292) was the most important of all finds.
Bibl. Hoddinott, 76.

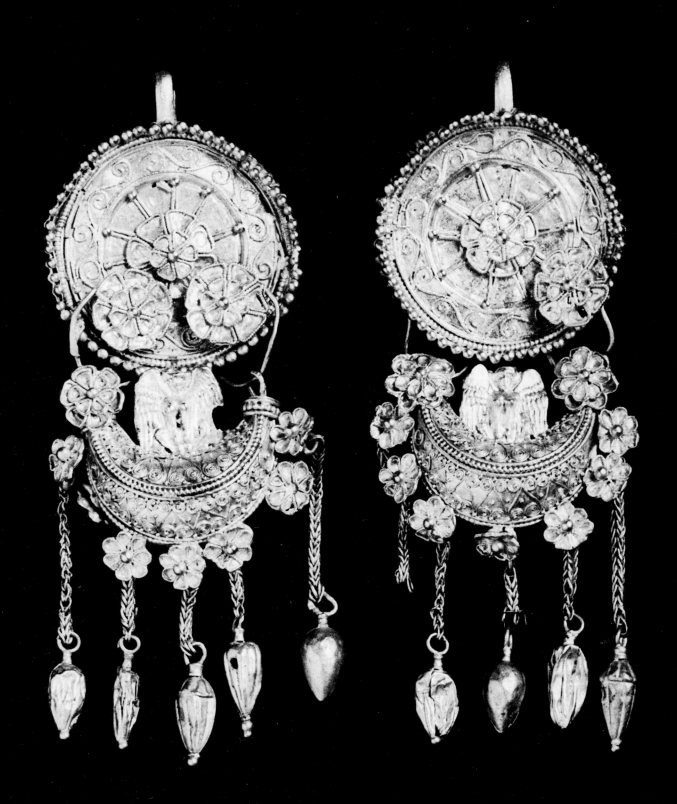

292 GREAVE
Silver and gold, height 46 cm.
Inv.No.B-231.
The upper part is in the form of a woman's
head with hair worn in spirally wound curls,
gathered above the forehead in a plait. Below
it there is a wreath of ivy leaves; the ears are
placed high and the right side of the face is
ornamented with parallel gilt stripes. On both
sides of the face at the level of the neck the
hair is formed into the figure of a lion, under
which two snakes with lions' heads emerge
from snails' shells. Below them there are two
more snakes with griffins' heads. One of them
is attacked by an eagle with huge claws. The
lower part of the greave is ornamented with
spirals which turn into the wings of a bird.
Bibl. I. Venedikov, *Archaeologia*, 1966, No.2,
12, Fig.34.

293 ONE-HANDLED VASE
Silver gilt, height 8 cm., diam. 7 cm.
Inv.No.B-392.
The body fluted, the neck without ornamenta-
tion.
Bibl. V. Nikolov, *Archaeologia*, 1967, No.1.

294 ONE-HANDLED VASE
Gold, height 9 cm., weight 240 gr.
Inv.No.391.
Beading and ovules on the edge of the lip, a
wreath of palmettes on the shoulder. Below it
two chariots face each other. There is a low
base, ornamented with ovules. The handle is in
open-work in the form of a Hercules knot. The
bridles of the four horses are ornamented with
round plaques. Folds on the necks and at the
ends of the manes are indicated by parallel
incised lines. The breast-straps have an inter-
twined ornament. The chariots have four-spoke
wheels. The seats are winged, and in them is a
beardless Apollo, dressed in a short-sleeved
tunic. The god is shown in profile, but the eye
frontally. Between the groups of four horses
is a large palmette.
Bibl. V. Nikolov, *Archaeologia*, 1967, No.1, 14,
Figs.5–6.

295 EARRINGS
Gold, length 7·5 cm., weight 37 gr.
Inv.No.B-60.
The upper part is a disc ornamented with
rosettes, spirals and beading in relief. The
boat-shaped lower part is surmounted by a
figure of a siren, and is ornamented with
spirals, beading and rosettes from which small
chains are hung, ending in acorns.
Bibl. I. Venedikov, *Archaeologia*, 1966, 1,
10, Fig.2.

296 PHIALE
Silver, height 4·5 cm., diam. 10 cm.
Inv.No.B-68.
A head of Aphrodite in profile (gilt) on the
boss.

297 PHIALE
Silver, height 4·5 cm., diam. 12·5 cm.
Inv.No.B-69.
Without ornamentation, but it bears an
inscription formed by dots: Thracian names in
Greek letters, ΚΟΤΥΟΣ ΕΤΒΕΟΥ
(cf. Nos.543–47).

298 PHIALE
Silver, height 4·5 cm., diam. 12·5 cm.
Inv.No.B-468.
Without ornamentation. The same inscription
as on No.297.

299 WREATH
Gold, diam. 24 cm., weight 205 gr.
District Museum of History, Vratsa.
Inv.No.B-59.
Made of laurel twigs, the veining on the leaves
clearly showing as well as the growth rings
where the twigs have been cut. Ball-shaped
fruit on long stems.
Bibl. I. Venedikov, *Archaeologia*, 1966, 8, No.1,
Fig.1.

**300 THIRTY-SEVEN SMALL ROUND
PLAQUES**
Gold, diam. 2 cm.
Inv.No.B-63.
In the form of rosettes.

301 ONE-HANDLED VASE
Silver, partly gilt, height 16·5 cm., diam. 9 cm.
Inv.No.B-67.
Ornamented with ovules around the mouth
and at the base of the neck, and a cord-like
ornament on the upper part of the body.

302 VASE
Silver, height 14 cm., diam. 6 cm.
Inv.No.B-66.
Form and ornamentation of a pine cone.

303–310
Set of Plaques: Horse Trappings
DISTRICT MUSEUM OF HISTORY, VRATSA

303 HEADSTALL
Silver, height 6·5 cm.
Inv.No.B-41.
A lion's head with a fan-shaped mane. There
is a round opening for the strap under the
animal's head.
Bibl. I. Venedikov. *Novootkrito trakiysko
Mogilno pogrebenié vuv Vratsa*, *Archaeologia*,
1966, 1, No.1, Fig.5–6.

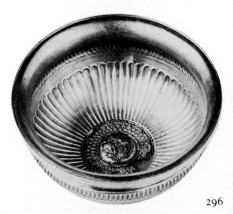

292

296

304 TWO PLAQUES
Silver, height 10 cm.
Inv.Nos.B-30 and 31.
Irregular in form, depicting a lion attacking a
bull. The animals, whose heads are highly
stylized, have open mouths (the teeth are
indicated); the lion's mane is indicated by a
scaly ornament with spirals and incised stripes;
the bull's horns are like those of a goat. A ring
at the back.

305 TWO PLAQUES
Silver, diam. 7 cm.
Inv.Nos.B-36 and 37.
Round, open-work, with a border of incised
lines broken by the figures here and there. A
boss in the centre in a border of incised lines,
towards which the heads of three open-
mouthed monsters are turned; above them
along the edge of the plaque three four-legged
monsters like lizards.

306 TWO PLAQUES
Silver, height 8·5 cm.
Inv.Nos.B-38 and 39.
Open-work, irregular in form with a border of
incised lines, parallel and in relief. A lizard-
like monster in the centre and three animal
heads. A ring at the back.

307 FOUR PLAQUES
Silver, height 7 cm.
Inv.Nos.B-32, 33, 34, 35.
In the form of a swastika whose three branches
end in the head of a griffin (curved beak and a
large round eye).

308 REIN
Silver, length 18 cm.
Inv.No.B-29.
The central part is an iron chain.

309 EIGHTY CYLINDRICAL BEADS
Silver, height 1 cm.
Inv.No.B-44.

310 THIRTEEN SMALL BEADS
Silver.
Inv.No.B-42.

311 PHIALE
Silver, height 6·7 cm., diam. 10 cm., weight
164 gr.
Branichevo, Shoumen district (second half of
fourth century BC).
District Museum of History, Shoumen.
Inv.No.408.
With a boss, the lower part ornamented with
motifs of scales. The neck, without ornament,
has two inscriptions in Greek letters giving the
name of King Amatokos and that of the
craftsman Teres.
The weight is also indicated: 50·5 drachmas
and 2 obols; 101 drachmae.
Bibl. Tsv. Dremsizova, *Nadgrobna Mogila pri s.
Branichevo*, Sofia, 1960, 451, Fig.6.

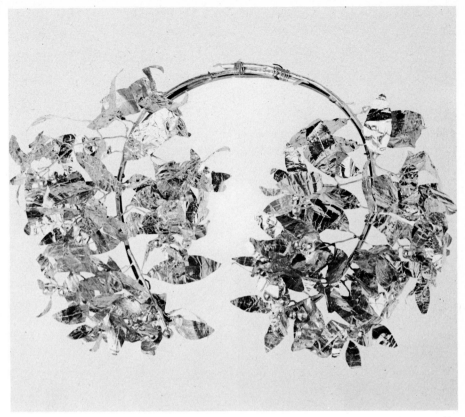

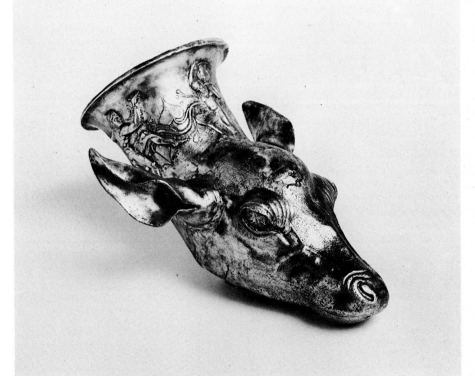

312–315

Treasure from Rozovets, Plovdiv District

EARLY FOURTH CENTURY BC

ARCHAEOLOGICAL MUSEUM, SOFIA

This treasure was found in a beehive tomb under a mound.

312 VASE
Silver, height 15·3 cm., diam. 8·8 cm., weight 214 gr.
Inv.No.B-39.
The body is ornamented with broad leaves and there is a row of ovules round the bottom of the neck.
Bibl. Strong, 87.

313 RHYTON (drinking vessel)
Silver, height 11·2 cm., diam. 9 cm., weight 49·5 gr.
Inv.No.49.
In the form of a deer's head, the neck ornamented with a wreath of ivy leaves, a silenus in the centre holding a cantharus (drinking vessel) on his shoulder, surrounded by two Satyrs.

314 PLAQUE FOR A SHIELD
Silver, height 21·8 cm.
Inv.No.B-36.
Oblong in shape.
Bibl.Duvanlij, 169–70, Figs.184–5.

315 EIGHT PLAQUES FOR SHIELDS
Silver, diam. 8 cm.
Inv.No.B-37.
Round, with a central boss.
Bibl. See No.314.

316–317

The treasure from Vurbitsa, Shoumen District

SECOND HALF OF FOURTH CENTURY BC

ARCHAEOLOGICAL MUSEUM, SOFIA

Besides a phiale and pitcher, there was a rich find in a tomb at Vurbitsa, including an iron silver-plated pectoral, very like the pectoral found at Mezek (No.318).

316 PHIALE
Silver, height 8·7 cm., diam. 9·7 cm., weight 168·5 gr.
Inv.No.51.
Narrow and deep, with a wreath of incised and gilt ivy leaves round the neck. The bottom is hexagonal covered with tongue-shaped grooves. There is a rosette underneath.
Bibl.Duvanlij, 173, No.3. Figs.188–89. Strong, 101, Fig.23b.

317 VASE WITH ONE HANDLE
Silver, height 17·8 cm., diam. 9·6 cm., weight 390 gr.
Inv.No.51.
Ornamented with a frieze of laurel leaves and a row of ovules. The handle in the form of a Hercules knot, finished at the upper end with volutes, and at the lower with spirals.
Bibl. Duvanlij, Plate XI, 2.

318–324

The treasure from the Maltepe Mound near Mezek, Haskovo District

350–300 BC

ARCHAEOLOGICAL MUSEUM, SOFIA

This treasure comes from a beehive tomb in which the remains of a man and two women were found, together with the fittings of a chariot.

With a total length of 32 m., the tomb consists of a long passage (*dromos*), two antechambers and a burial chamber. The latter is circular and covered with a dome; it contained the tomb of a man, in whose honour this monument was erected. Near him an iron silver-plated pectoral was found (No.318). The burnt bones of two women were found in a layer of soil, separating the double floor of the antechambers. Wonderful gold jewellery was found in the interior of the tomb and a tetradrachm of Alexander the Great (336–323 BC) was found beside each woman, enabling us to date these tombs somewhat later than the man's.
Bibl. Hoddinott, 69.

318 PECTORAL
Iron, silver-plated, 21 cm. long.
Inv.No.6401.
Crescent shaped, its ends ornamented with spirals and scales. The central part has two rows of women's heads, alternating with other bands ornamented with geometrical and plant designs. This pectoral was part of an iron cuirass.
Bibl. B. Filov. *IAI*, XI, 1937, 67, 43, Figs.75–77.

319 TWO PLAQUES
Gold, height 3·4 cm., weight 6·55 and 6·90 gr.
Inv.No.6452.
Irregular in form. Decorated with highly stylized plant ornaments. A ring at the back.
Bibl. B. Filov, *IAI*, XI, 1937, 30, 34, Figs.27–28.

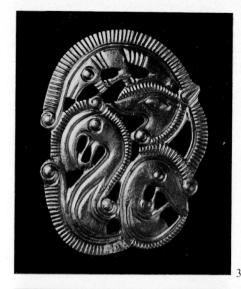

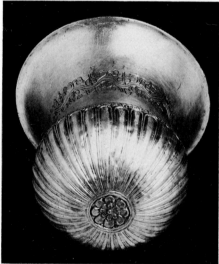

3〇

3▮

320 FOUR PLAQUES

Gold, diam. 2·2, 2·7 and 2·8 cm., weight 935 to
995 gr.
Inv.No.6453.
Round, ornamented with a rosette. A ring at
the back.
Bibl. See No.319.

321 NECKLACE

Gold, length 38 cm., weight 6·50 gr.
Inv.No.6249.
In the form of a chain with the head of a
horned lion at each end.
Bibl. B. Filov. *IAI*, XI, 1937, 77, Fig.84, 4.

322 NECKLACE

Gold, weight 27·15 gr.
Inv.Nos.6426 to 6428.
Composed of twelve hollow spherical beads and
two oblong ones at each end; in the centre a
pendant in the form of a vase. All elements
decorated with filigree.
Bibl. B. Filov, *IAI*, XI, 1936, 76–77, Fig.84, 1–2.

323 FIVE EARRINGS

Gold, diam. 2·2 and 2 cm., weight 6·4 and
6·55 gr., 4·10 and 4·19 gr.
Inv.Nos.6442 and 6441.
In the form of a ring of twisted wire, one end
wider and ornamented with spirals, ending in a
lion's head.
Bibl. B. Filov, *IAI*, XI, 1937, 77, Fig.30, 1–4.

324 TWENTY-EIGHT BUTTONS

Gold, width 1·1 cm., weight 22·90 gr.
Inv.No.6433.
In the form of a knot, with a small ring for
attachment to the garment.
Bibl. See No.321.

325–347
The Loukovit Treasure

END OF THE FOURTH CENTURY BC

ARCHAEOLOGICAL MUSEUM, SOFIA

This treasure was buried in the period of
Macedonian rule in Thrace, possibly during
the reign of Alexander the Great, when he
was crossing the lands of the Triballi, or
perhaps several decades later. The treasure
consists of three small pitchers, nine phialai
and a large number of silver plaques, orna-
mented with animal motifs and figures of
horsemen. It all probably belonged to a
prince of the Triballi in North Bulgaria and
can be dated to the end of the fourth cen-
tury BC.
Bibl. D. Dimitrov, *Archeologicheski
otrkitiya v Bulgaria*, Sofia, 1957, Nos.61 to
62.

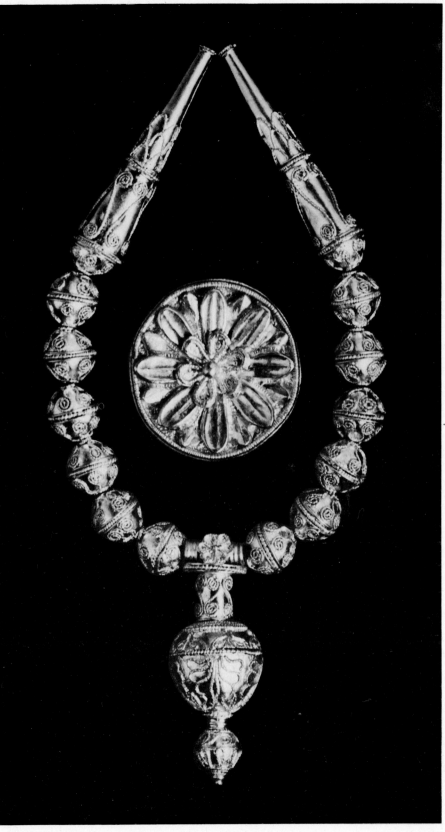

320
321

319

328

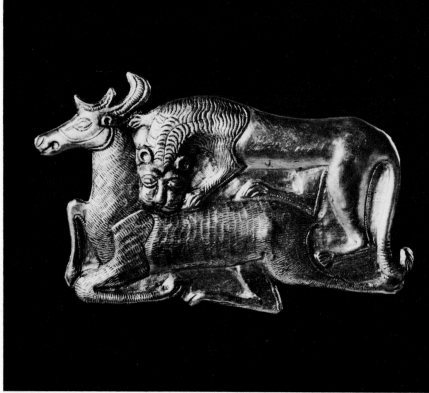

325 HEADSTALL
Silver, height 10 cm., weight 67 gr.
Inv.No.8212.
In the form of an ellipse, the ornamentation partly gilt. Recalls a lion's mane. In the centre, the head of a griffin.

326 HEADSTALL
Silver, gilt, length 5·2 cm., weight 41·5 gr.
Inv.No.8203.
A three-dimensional lion's head. Below and above it decoration in the form of a palmette.

327 TWO PLAQUES
Silver, length 7·5 and 6·6 cm., weight 38 and 39·7 gr.
Inv.Nos.8213 and 8214.
Irregular in form, depicting a horseman armed with a spear attacking a lion. Some parts are gilt.

328 TWO PLAQUES
Silver, length 8·7 cm., width 4·9 cm., weight 102 gr.
Inv.Nos.8215 and 8216.
A lion with a gilded mane attacking a deer, whose legs are folded beneath its body.

329 TWO PLAQUES
Silver, length 10·3 cm., weight 37·5 gr.
Inv.Nos.8197 and 8198.
Two griffins, one opposite the other, their legs folded under their bodies. The animals are joined in the lower part by the tail of a bird.

330 TWO PLAQUES
Silver gilt, length 8·7 cm., width 4·9 cm., weight 32 gr.
Inv.Nos.8204 and 8205.
Animal ornaments framed by rosettes and spirals. The ornaments are difficult to define.

331 FOUR PLAQUES
Silver, length 10·3 cm., width 9·8 cm., weight 34·6 gr.
Inv.Nos.8193 and 8196.
In the form of a swastika, the arms of which emerge from a boss and end in the heads of griffins.

332 TWO ROUND PLAQUES
Silver, diam. 9·3 and 9·4 cm., weight 59·1 and 49 gr.
Inv.Nos.8209 and 8208.
No ornamentation.

333 A ROUND PLAQUE
Silver gilt, diam. 3·9 cm., weight 19·2 gr.
Inv.No.820.
In the form of a rosette.

334 TWO ROUND PLAQUES
Silver, diam. 4·7 cm., weight 24·2 gr.
Inv.Nos.8211 and 8210.
A gilt rosette in the centre.

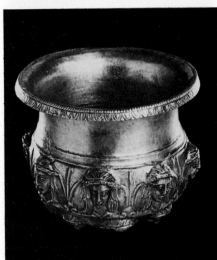

29

41

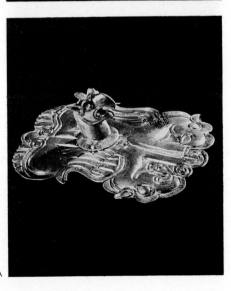

7-A

335 PHIALE
Silver, height 6·8 cm., diam. 7·8 cm., weight
68·8 gr.
Inv.No.8219.
No ornamentation.

336 PHIALE
Silver, height 5·6 cm., diam. 5·4 cm., weight
35·1 gr.
Inv.No.8220.
Like No.335.

337 PHIALE
Silver, height 4·2 cm., diam. 12·5 cm., weight
122·3 gr.
Inv.No.7990.
Like No.335.

338 PHIALE
Silver, height 6 cm., diam. 7·7 cm., weight
94·5 gr.
Inv.No.8006.
Like No.335.

339 PHIALE
Silver, height 4·5 cm., diam. 10·7 cm., weight
70·2 gr.
Inv.No.8223.
The bottom grooved.

340 PHIALE
Silver, height 5·1 cm., diam. 10·6 cm., weight
70·7 gr.
Inv.No.8222.
Like No.339.

341 PHIALE
Silver, height 7 cm., diam. 8·6 cm., weight
99·7 gr.
Inv.No.8226.
Ornamented with the heads of women alter-
nating with palmettes.

342 PHIALE
Silver, height 4·5 cm., diam. 14·4 cm., weight
176·2 gr.
Inv.No.8225.
Ornamented with 'almonds' alternating with
palmettes.

343 PHIALE
Silver, height 2·8 cm., diam. 13 cm., weight
71·8 gr.
Inv.No.8224.
Ornamented with almonds and palmettes.

344 SMALL PITCHER
Silver, height 13·9 cm.
Inv.No.8212.
Ornamented with beading round the mouth
and on the body. The upper part of the handle
has volutes and there is a palmette on the
lower part.

345 SMALL PITCHER
Silver, height 15·3 cm., diam. 6 cm., weight
157·7 gr.
Like No.344.

346 LITTLE PITCHER
Silver, height 14·1 cm., diam. 5·3 cm.
Inv.No.7937.
Like No.344, but ornamented with ovules.

347-A to 347-L

Horse trappings from the Loukovit treasure

347-A HEADSTALL
Silver, height 10·3 cm.
Inv.No.8005.
Ornamented with two opposed griffins, the
manes indicated by incised lines. At the top a
griffin's head, and at the back a ring.

347-B THREE ROUND PLAQUES
Silver, diam. 9·4 cm.
Inv.Nos.8207, 8206 and 8205.
No ornamentation, rings at the back.

347-C TWO PLAQUES
Silver gilt, diam. 3·5 cm.
Inv.Nos.8199 and 8200.
In the form of rosettes with an incised orna-
ment in the centre.

347-D PLAQUE
Silver gilt, diam. 2·2 cm.
Inv.No.8202.
In the form of a rosette.

347-E TWO PLAQUES
Silver gilt, height 2·4 cm.
Inv.No.8232.
In the form of a sphinx.

347-F TWO PLAQUES
Silver gilt, height 2·4 cm.
Inv.No.8232.
In the form of a griffin.

347-G ORNAMENT
Silver, diam. 2 cm.
Inv.No.8229.
Semi-circular, no ornament.

347-H SIXTEEN ORNAMENTS
Silver, height 1·3 cm.
Inv.No.8230.
In the form of a lion's head.

347-I SEVEN ORNAMENTS
Silver, height 2·6 cm.
Inv.No.8231.
In the form of a human head.

347-J TIP OF A WHIP
Silver gilt, height 5·3 cm.
Inv.No.8227.
In the form of a dog's head, biting a ring.

347-K ORNAMENT
Silver, diam. 2·6 cm.
Inv.No.8240.
In the form of a rosette; in the centre a small open cylindrical tube.

347-L TWENTY-FIVE CYLINDRICAL ELEMENTS
Silver, length 1·9 to 3 cm.
Inv. No.8237.

348 EARRING
Gold, height 10·1 cm., weight 27·37 gr.
Boyana, Sofia region (end of the fourth century BC).
Archaeological Museum, Sofia.
Inv.No.2887.
In the form of an open ring, ending in a three-sided pyramid, ornamented with geometrical granulated motifs, two little balls, ornamented with three beads at the top.

349 PECTORAL
Gold, length 16·1 cm., weight 6·79 gr.
Skalitsa, near Yambol (second half of the fourth century BC).
Archaeological Museum, Sofia.
Inv.No.7946.
Oblong in form. The ornamentation consists of two highly stylized Trees of Life. The surface is covered with dots forming various motifs (zig-zags, herring-bone pattern), a hole by which it was attached at each end.
Bibl. T. Ivanov, *Archaeologia*, 1960, 2, 41.

350 SMALL PITCHER
Silver, height 8 cm., diam. (at mouth) 6 cm.
Gornyané, near Gotsé Delchev, 330–300 BC.
Archaeological Museum, Sofia.
Inv.No.6764.
Pear-shaped, no ornamentation.
Bibl. V. Mikov, *IAI*, 1937, 209, No.2, Fig.189.

351 SMALL PITCHER
Bronze, diam. 8 cm.
Tuzha, near Kazanluk. Turn of the fourth and third century BC.
Kazanluk Museum of History.
Inv.No.479.
Badly damaged. A large part of the ornamentation missing. Bands of bulls' heads, birds and fish.
Bibl. G. Tabakova-Tsanova and L. Getov. *Kazanluk Museum*, Sofia, 1967, 147, No.61.

352 SMALL PITCHER
Silver, height 10 cm.
Kazanluk (turn of the fourth and third century BC).
Kazanluk Museum of History.
Inv.No.118.
Found in the soil of the mound which covered the famous Kazanluk tomb. Pear-shaped, the neck ornamented with gilt incised leaves.
Bibl. V. Mikov, *Antichnata grobnitsa pri Kazanluk*, Sofia, 1954, 26, No.5, Fig.28.
Hoddinott 98.

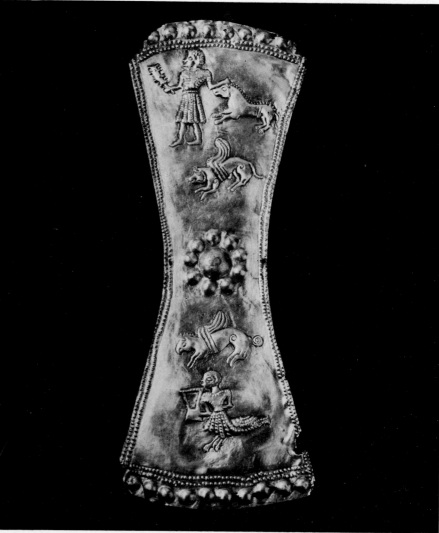

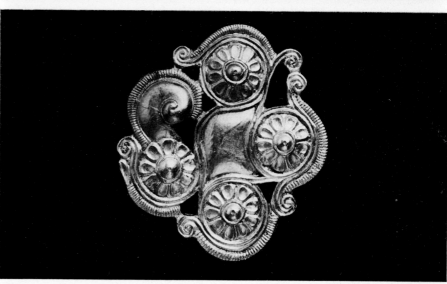

356

380

353–359
Tomb group from Panagyurishté

350–300 BC

ARCHAEOLOGICAL MUSEUM, SOFIA

353 TWO PLAQUES FOR HORSE TRAPPINGS
Bronze, height 6·5 cm.
Inv.No.3569.
The two legs and shoulder of a lion ornamented with the heads of griffins.
Bibl. B. Filov, *IAI*, VI, 1916–18, 23, Plate L.6.

354 TWO PLAQUES FOR HORSE TRAPPINGS
Silver, diam. 8·6 cm.
Inv.No.3559.
Round, depicting Heracles fighting the Nemean lion. The hero is squeezing the animal's neck in his hands, and the lion is trying to escape him. The craftsman has expressed the animal's distress, the movements and strain of the muscles. There are traces of gilding.
Bibl. B. Filov, *RM*, XXXII, 1917, 38–39, Nos.21–22, Plate I, 1–7.

355 FOUR PLAQUES FOR HORSE TRAPPINGS
Silver, height 5·5 cm.
Inv.No.3553.
Square in form. The head of Apollo with a wreath. There are traces of gilding.

356 CENTRAL PLAQUE OF A SHIELD
Silver, height 32 cm.
Inv.No.3555.
Oblong, with a border of two rows of beading, ornamented with a central rosette on both sides of which there is a griffin. At the upper end Herakles with the Nemean lion; a siren at the lower end. The bodies of both figures are shown full face, but the legs and heads are in profile.
Bibl. L. Ognenova, *IAI*, XVIII, 1925, 63–64, Nos.1–4, Figs.19–22, A and B.

357 TWO PLAQUES FROM A SHIELD
Silver, diam. 9·2 and 9·5 cm.
Inv.No.3561.
Round, bordered by two rows of beading, four leaves round a central boss.
Bibl. See No.356.

358 TWO PLAQUES FROM A SHIELD
Silver, diam. 8 cm.
Inv.No.3561.
Round, bordered by two rows of beading. Two animals, a bird and a palmette round the central boss.
Bibl. See No.356.

359 PLAQUE FROM A SHIELD
Silver, diam. 8·6 cm.
Round, bordered by a double row of beading. Five lotus blossoms round the central boss.
Bibl. See No.356.

360–368
The Panagyurishté treasure

TURN OF THE FOURTH AND THIRD
CENTURY BC

ARCHAEOLOGICAL MUSEUM, PLOVDIV

Its weight in gold (6,100 gr.) is not the only impressive feature of this treasure; the original form and ornamentation of the vessels which compose it are also impressive. It consists of a phiale and eight rhyta, one of which is in the form of an amphora, while the others are shaped like the heads of women and animals. These vessels have an opening in the lower part through which the liquid flowed. This opening had to be stopped when liquid was poured into the vessel. The amphora has two openings, which made it possible for two persons to drink from it at the same time, and it was perhaps intended for blood brotherhood or treaty ceremonies; the articles seem to have been made by several craftsmen at Lampsacus, on the Asiatic shores of the Dardanelles. The inscriptions show the actual weight of some of the vessels in staters of Lampsacus.

The subjects and ornamentation (An attack on a palace, the Judgement of Paris, Bacchantes) belong to the Hellenistic repertoire. The artist gives the figures swollen muscles and places them in tense attitudes, while their faces express strong feelings.
Bibl. Iv.Venedikov, *Panagyurskoto sukrovishté*, 1961. Strong, 97, 102. Hoddinott, 85. *JHS*, XCIV, 1974, 38.

360 AMPHORA-RHYTON
Gold, height 28 cm., weight 1695·25 gr.
Inv.No.3203.
There are two figures on the bottom; a bearded Silenus carrying a cantharus, and Herakles as a child, strangling the snakes. The figures are separated by a rosette. Two negroes' heads on either side, their open mouths forming the hole through which the liquid flowed out. Handles in the form of Centaurs with raised arms, rest their front legs on the mouth, whose edge is ornamented with ovules and beading. There is a row of ovules at the base of the smooth neck.
A scene is depicted on the body at its broadest

53

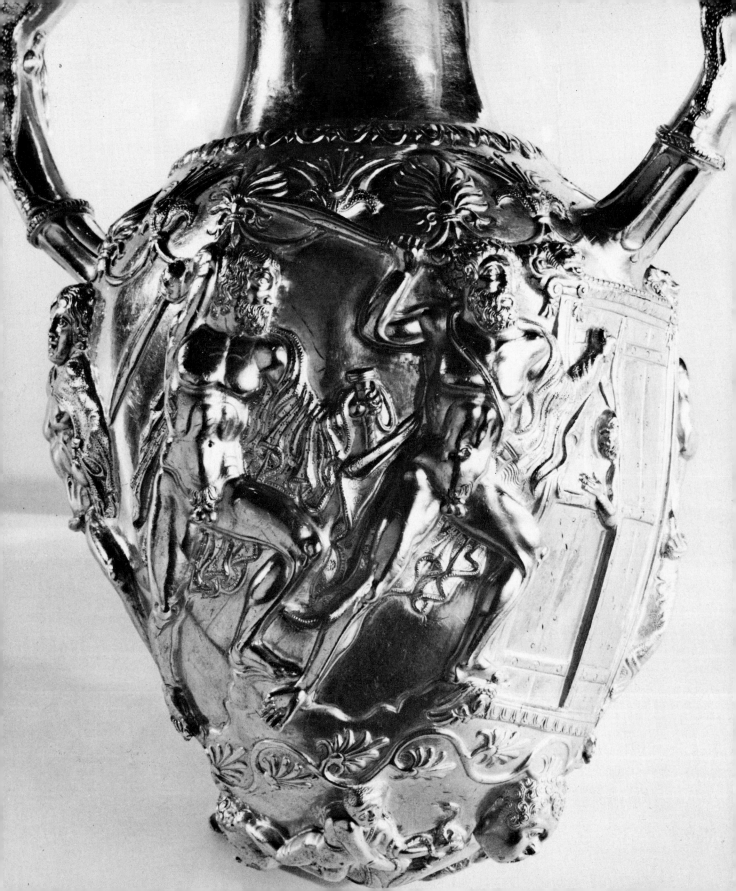

part: five warriors attacking the entrance of a palace, where an old man is hiding.

Some of the warriors are swinging curved swords (*machaira*) and one of them is blowing a trumpet. They are all naked under their open, flowing cloaks. The details of the weapons and the garments are finely engraved. On the other side of the door a young man is talking with an old man. There is a band of palmettes above and below the figures.

An inscription on the neck indicates the weight of the vessel in Greek figures, calculated in staters of Lampsacus (= 200 staters, ½ a drachma and 1 obol).

361 PHIALE
Gold, diam. 25 cm., weight 845·7 gr.
Inv.No.3204.
Individually worked ornaments, soldered together with silver, are disposed in four bands around the boss: one band of acorns and three bands of negroes' heads. The spaces between these motifs are ornamented with palmettes. On the inner side there is an inscription indicating the weight according to two currency systems: in staters of Lampsacus, and in drachmae.

362 RHYTON (drinking vessel)
Gold, height 14 cm., weight 349·05 gr.
Inv.No.3196.
The rhyton has no handle, its lower part ending in the protome of a he-goat, very realistically worked. The opening through which the liquid flowed is between the animal's fore-legs. A design of ovules and beading round the edge of the mouth. On the neck: Hera, Artemis, Apollo and Nike (the name of each goddess is engraved at her head).

363 RHYTON (drinking vessel)
Gold, height 13·5 cm., weight 674·6 gr.
Inv.No.3197.
In the form of a stag's head. The opening through which the liquid flowed is on the animal's lower lip. The rhyton has a handle in the form of a lion; the animal has placed its fore-legs on the edge of the mouth, which is ornamented with ovules and beading. Athena, Artemis and Aphrodite are depicted on the neck, their names being inscribed beside their heads.

364 RHYTON (drinking vessel)
Gold, height 12·5 cm., weight 505·5 gr.
Inv.No.3198.
Like No.363, with the exception of the ornamentation on the neck, which depicts on one side Herakles fighting the Hind of Cyreneia, and on the other Theseus fighting the Bull of Marathon.

365 RHYTON (drinking vessel)
Gold, height 12·5 cm., weight 505·05 gr.
Inv.No.3199.
In the form of a ram's head, the handle and mouth similar to No.364. The animal's head is worked with great skill, the muzzle being

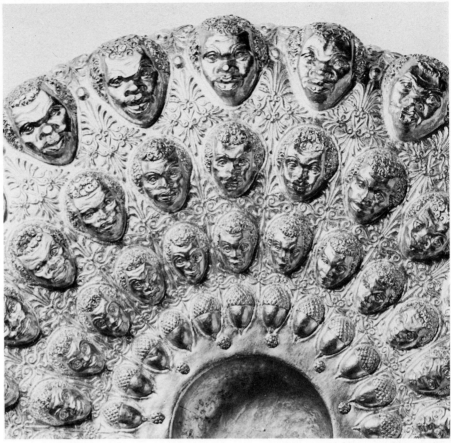

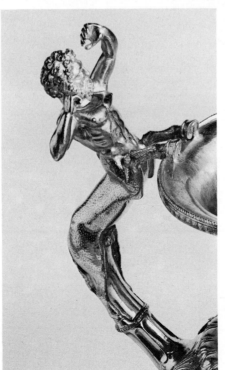

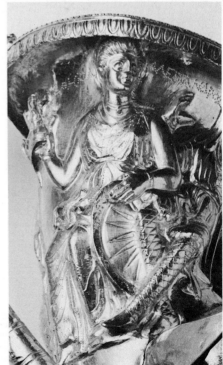

361

360

363

smooth, while the wool is decoratively treated, shown by double concentric circles. On the neck: Dionysus and the nymph Eriope are seated; on both sides are dancing Bacchantes with one breast uncovered.

366 RHYTON (drinking vessel)
Gold, height 20·5 cm., weight 387·3 gr.
Inv.No.3202.
In the form of an Amazon's head with a necklace round the neck ornamented with a medallion in the form of a lion's head, the pour-hole being in the animal's open mouth. The handle is square, grooved and ending in a winged sphinx, whose fore-legs rest on the edge of the mouth. The Amazon wears a helmet decorated with two figures of griffins and plant ornaments.

367 RHYTON (drinking vessel)
Gold, height 14 cm., weight 460·75 gr.
Inv.No.3200.
The handle, mouth and pour-hole the same as in No.366, but the neck is not ornamented, and the Amazon is not wearing a helmet. The back of the head is covered with a veil which continues over the temples and has a border fastened by a buckle above the forehead.

368 RHYTON (drinking vessel)
Gold, height 22·5 cm., weight 466·75 gr.
Inv.No.3201.
Like No.367, but the wings of the sphinx are missing.

369–370

Jewellery from Seuthopolis Kazanluk Region

EARLY THIRD CENTURY BC

ARCHAEOLOGICAL MUSEUM, SOFIA

Bibl. K.Zhouglev, *Godishnik na Sof.-Universitet, fac.Istoria i philosophia*, XLVII, 1952. M.Chichikova, *Sevtopolis*, 1970, No.92. Hoddinott, 97.

369 TWO EARRINGS
Gold, diam. 1·7 and 1·8 cm., weight 3·95 and 3·97 gr.
Inv.No.7852.
Made of twisted wire ending in a lion's head.

370 TWO FIBULAE
Gold, width 1·5 cm., weight 1·03 gr.
Inv.No.7856.

371 BEADS FROM A NECKLACE AND PENDANT
Gold, height 3·6 cm., weight 12·5 gr.
Varna, early third century BC.
Archaeological Museum, Sofia.
Inv.No.2382.
The pendant in the form of a pyramid has plant

ornaments encrusted in blue enamel.
Bibl. T. Ivanov, *IVAD*, X, 1956, 93, No.2, Plate III, 2.

372 TWO EARRINGS
Gold, diam. 4·8 cm., weight 4·55 gr.
Assenovgrad, third century BC.
Archaeological Museum, Sofia.
Inv.No.4232.
In the form of an open ring ending in a small hook at one end, and a bull's head at the other. Unpublished.

373 NECKLACE
Gold, length 32 cm.
Nessebur, third century BC.
District Museum of History, Bourgas.
Inv.No.1334.
In the form of a small chain; the fastening ornamented with an amethyst and ending in the head of a lion, to which a hook is fastened on one side and a ring on the other.
Bibl. I. Lazarov and V. Chimbouleva. *District Museum of History, Bourgas*, Sofia, 1967, 159, No.45.

374 EARRINGS
Gold, diam. 2·7 cm., weight 29 gr.
Nessebur, third century BC.
District Museum of History, Bourgas.
Inv.Nos.1332 and 1333.
An open ring ending at one end with a figure of Pegasus. A pendant in the form of a small amphora with a lid; some of the details of the Pegasus and the pendant are worked in filigree.
Bibl. I. Gulubov, *IAI*, XIX, 1955, 141, Fig.15 A–B.

375 EARRINGS
Gold, height 2·6 cm.
Nessebur, third century BC.
Nessebur Museum.
Inv.Nos.369 and 370.
An open ring of twisted wire ending at one end with the head of a Maenad crowned with a laurel wreath, covered with multi-coloured enamel, the hair bound with a ribbon.
Bibl. V. Chimbouleva, *Archaeologia*, 1964, 4, 58, No.3, Fig.3.

376 ORNAMENTAL PLAQUE
Gold, length 8·7 cm.
Nessebur, third century BC.
District Museum of History, Bourgas.
Inv.No.1303.
In the shape of an ellipse with a fine border in relief. A mythological scene depicted in the middle. In the centre Cepheus and Cassiopeia; at the ends Perseus cutting off the Gorgon's head, and Andromeda trying to escape from the monster. On Andromeda's left a little Eros. This plaque was attached to a bronze fibula.
Andromeda was the daughter of Cepheus, King of Ethiopia and of Cassiopeia. Her mother pretended that she was the loveliest of all the Nereids (sea nymphs). The latter, being jealous, turned to Poseidon, god of the sea,

who, to please them, sent a sea monster to devastate Cepheus's land. To appease the wrath of the god, Andromeda was bound to a rock and exposed as an offering. Perseus saw her there, killed the monster, set Andromeda free and married her.
Bibl. I. Gulubov, *IAI*, XIX, 1955, 144, Fig.11.

377 ORNAMENTAL PLAQUE
Gold, length 6·9 cm.
Nessebur, third century BC.
District Museum of History, Bourgas.
Inv.No.1343.
In the form of an ellipse, ornamented with a Gorgoneion (head of Medusa). This plaque was attached to the garment by a fibula and served as a pectoral, although it had no holes at the ends by which it could be attached.
Bibl. See No.376, Figs.7 and 8.

378 ORNAMENTAL PLAQUE
Gold, length 8·1 cm.
Nessebur, mid-third century BC.
District Museum of History, Bourgas.
Inv.No.1335.
In the shape of an ellipse. Like the two preceding ones attached to a bronze fibula. Plant ornaments surround a frame which held a stone (now missing). The stone was probably engraved in the centre to represent a Gorgoneion (head of a Medusa), as indicated by the two wings, depicted at the sides.
Bibl. See No.376.

379 TWO ORNAMENTS
Gold, height 9 cm.
Nessebur, mid-third century BC.
District Museum of History, Bourgas.
Inv.Nos.1302, 1303.
It is not possible to establish exactly what the function of these two articles was; their upper part ends in a woman's head, with hair encircled by a diadem. The entire surface is covered with dots.
Bibl. I. Gulubov, *IAI*, XIX, 1955, 144, Fig.10 C–D.

380 RING
Gold, length 6·1 cm.
Nessebur, mid-third century BC.
District Museum of History, Bourgas.
Inv.No.1336.
In the form of a spiral representing a dragon. Was ornamented with stones, but only one amethyst has been left.
Bibl. M. Lazarov and B. Chimbouleva, *District Museum of History, Bourgas*, Sofia, 1967, 160, No.49.

381 RING
Gold, length 4 cm.
Nessebur, mid-third century BC.
Nessebur Museum.
Inv.No.3681.
In the form of a snake winding around the finger in a spiral.
Bibl. Op. cit. 1967, 160, No.50.

382–386

Plaques from chariot from Malkata Mogila (The Little Mound) near Mezek

ARCHAEOLOGICAL MUSEUM, SOFIA

Although this mound is dated to the second half of the fourth century BC, similar articles are usually dated to the third century BC in Western Europe. See Introduction to No.318.

382 FIVE RINGS FOR REINS
Bronze, length 7·3 to 8·4 cm.
Inv.Nos.6411 and 6412.
The lower part ornamented with a highly stylized human head.

383 RECTANGULAR BUCKLE
Bronze, height 12 cm.
Inv.No.6418.

384 TWO ORNAMENTS
Bronze, height 12·1 cm.
Inv.No.6413.
In the form of flowers with a human face on both sides. The back is flat, the stem of one of the two ornaments is broken.

385 ROSETTE
Bronze, traces of silver, height 12·2 cm.
Inv.No.6413.
A handle emerges from the rosette ending in the stylized head of an animal.

386 ORNAMENT
Bronze, height 11·3 cm.
Inv.No.6413.
The fork-like ends are ornamented with an animal's head.

387 FIRE-DOG
Stone, height 29 cm.
From Belitsa, near Razlog, third century BC.
Archaeological Museum, Sofia.
Inv.No.7044.
In the form of an animal's protome, with incised geometrical ornaments.

388 FIRE-DOG
Stone, height 30 cm.
Provenance unknown, third century BC.
Archaeological Museum, Sofia.
Inv.No.8105.
Like No.387.

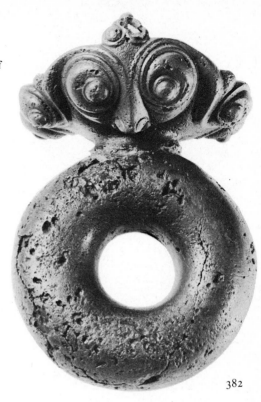

382

387

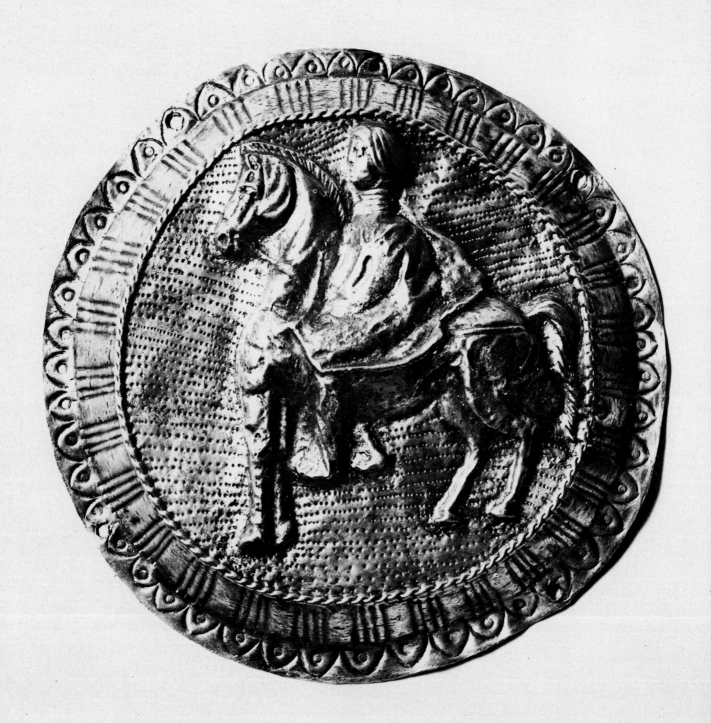

The decline of Thracian culture

(THIRD TO FIRST CENTURIES BC)

On the death in 280 of Lysimachus, the last great king of Thrace, Thracian culture began to decline. The conflicts between this ambitious general of Alexander the Great and the Thracian kings, and the wars against the other Successors had exhausted the economic and military resources of Thrace. This opened up the way for a new conqueror to enter the country; the Celts of Western Europe ravaged the Thracian regions and the Greek cities of the coast. In 216 BC their rule was overthrown. In that same year the Romans reached the Adriatic coast of the Balkan Peninsula. After engaging the Macedonians (who had tried to restore their rule over Thrace in three prolonged and consecutive wars), and occupying Macedonia in 164 BC, the Romans invaded Thrace, first aiding the Odrysae, and then other Thracian tribes. That is how in the second half of the first century BC, when other Thracian tribes in the north-west had been subjected, the Odrysaean Kingdom became a Roman protectorate, which preserved its independence until the year AD 49.

This period can be called the epoch of great invasions from the West. There are few monuments connected with it. The campaigns of the Macedonians, the Celts and the Romans devastated the region and the mounds of the third to first centuries BC offer only ordinary articles. The fibulae, swords and shield plaques are identical with those found in Central Europe and Italy. As in southern Russia, so too north of the Balkan Range we find the so-called Sarmatian monuments, the treasures of Galiché and Yakimovo. The coins found are imitations of Macedonian coins and of those struck in Thasos.

389–400
Phalerae from Galiché, near Oryahovo

SECOND TO FIRST CENTURIES BC

ARCHAEOLOGICAL MUSEUM, SOFIA

389 PHALERA
Silver gilt, diam. 18·3 cm.
Inv.No.5876.
Ornamented with the bust of a woman in relief; long hair surrounds her face. She is dressed in a richly ornamented low-cut garment. Eight folds around her neck resemble torques place one above the other. There is a bird on each side of the bust at shoulder level. Four holes served to attach the phalera.

390 PHALERA
Silver gilt, diam. 15·8 cm.
Inv.No.5877.
The bottom covered with dots against which the figure of a horseman stands out. He is wearing several torques placed one above the other. The horse has short hind legs and is roughly worked. The border, decorated with ovules, has four holes by which it was attached.

391 PHALERA
Silver gilt, diam. 12 cm.
Inv.No.5878.
Ornamented with an eight-leaf rosette with veining, and a small rosette in the centre. The border, ornamented with ovules, has four holes by which it was attached.

392 PHALERA
Silver gilt, diam. 4·8 cm.
Inv.No.5879.
Ornamented with a four-leaf rosette with veining, the border ornamented with ovules has four holes by which it was attached.

393 PHALERA
Silver gilt, diam. 14·9 cm.
Inv.No.5879.
Similar to No. 392.

394 PHALERA
Silver gilt, diam. 15 cm.
Inv.No.5879.
Similar to No. 392, part missing.

395 PHALERA
Silver gilt, diam. 14·8 cm.
Inv.No.5879.
Similar to No. 392, cracked.

396 PHALERA
Silver gilt, diam. 15·1 cm.
Inv.No.5879.
Similar to No.395, but damaged.

398 PHALERA
Silver gilt, diam. 9·7 cm.
Inv.No.5880.
Similar to No.396.

399 PHALERA
Silver gilt, diam. 9·5 cm.
Inv.No.5880.
Similar to No.396.

400 PHALERA
Silver gilt, diam. 8·9 cm.
Inv.No.5880.
Similar to No.396.

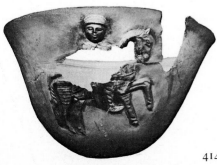

90

414

The treasure from Bohot, Pleven District

FIRST CENTURY BC

DISTRICT MUSEUM OF HISTORY, PLEVEN

Inv.No.57.
Bibl. Strong, 122.

401 HEMISPHERICAL BOWL
Silver, diam. 14·5 cm., weight 236 gr.

402 HEMISPHERICAL BOWL
Silver, diam. 14·3 cm., weight 124 gr.
Similar to No. 401; part of the mouth
missing.

403 HEMISPHERICAL BOWL
Silver, diam. 13·4 cm., weight 232 gr.
Similar to No. 401.

404 HEMISPHERICAL BOWL
Silver, diam. 12·3 cm., weight 188 gr.
Similar to No. 401.

405 HEMISPHERICAL BOWL
Silver, diam. 14 cm., weight 196·5 gr.
Similar to No. 401; an incised line
around the mouth.

406 HEMISPHERICAL BOWL
Silver, diam. 13·8 cm., weight 218 gr.
Similar to No. 401.

407 HEMISPHERICAL BOWL
Silver, diam. 15 cm., weight 230 gr.
Similar to No. 401.

408 HEMISPHERICAL BOWL
Silver, diam. 13·6 cm., weight 235 gr.
Similar to No. 401.

409 HEMISPHERICAL BOWL
Silver, diam. 13·8 cm., weight 220 gr.
Similar to No. 401.

410 SITULA (pail)
Bronze, height 23 cm., diam. 22 cm.
Inv.No.58
The lower part missing.

411
417

419

411–419

The treasure from Yakimovo, Mihailovgrad District

FIRST CENTURY BC

MIHAILOVGRAD MUSEUM

411 BOWL
Silver, height 7·5 cm., diam. 14·7 cm.
Inv.No.38.
Incised ovules ornament the mouth on the
outside.

412 BOWL
Silver, height 6·8 cm., diam. 12 cm.
Inv.No.39
A gilt strip beside the mouth.

413 BOWL
Silver, height 10·2 cm., diam. 16·5 cm.
Inv.No.37.
Similar to the above.

414 BOWL
Silver, height 10·3 cm., diam. 16 cm.
Inv.No.46.
Incised ornamentation on the inside around
the mouth. On the outside a gilt figure in
relief: a horseman, garbed and shod.
Part of the horse and the horseman missing.

415 CANTHARUS
Silver, height 8·6 cm., diam. 11 cm.
Inv.No.41.
Hemispherical on a high foot; an incised
ornament on the outside of the body. The
handles have horizontal protuberances (one
missing).

416 CUP
Copper, height 7·8 cm., diam. 11·3 cm.
Inv.No.47.
Cylindrical, a thin silver strip around the
mouth.

417 PHALERA
Silver, traces of gilding, diam. 8 cm.
Inv.No.40.
A dotted ornament on the border. The bust of a
bearded man in high relief. Around his neck
there are three folds recalling torques placed
one above the other. An owl on his shoulder.

418 PHALERA
Silver gilt on the outside, diam. 8 cm.
Inv.No.45.
Bust of a winged woman in low relief. The hair
parted in the middle and falling to the
shoulders on both sides. The arms are not in
the right place.

419 TWO BRACELETS
Silver, diam. 8 cm.
Inv.Nos.43 and 44.
Made of a narrow band in triple spirals;
snake's heads at the ends.
Bibl. Athanas Milchev, *Archaeologia*, 1973,
1–14, No.1.

The Roman period

429

After the Roman Conquest, Thrace was
divided into three provinces: Macedonia,
Moesia and Thrace. Urbanization devel-
oped and the Thracian cities possessed
almost all the usual features of Roman
cities: architecture on a large scale, sculp-
ture, paintings and the applied arts, the
latter always influenced by Hellenistic art.
The religion of the conqueror was also
established in the urban centres, while the
Thracian deities, displaced and isolated in
solitary areas, were only honoured in the
inaccessible mountains. Rich cemeteries
with tombstones, marble statues and paint-
ed tombs appeared round the cities. But in
general the Thracians remained true to the
old burial customs and preserved their
burial mounds right down to the Christian
era.

It is in the mounds of the Roman period
that helmet masks and plaques of the types
found in Stara Zagora (the second half of
the first century BC) came to light, objects
which had always been Eastern in character.
However, the most characteristic monu-
ments of this period are the Thracian cha-
riots (also discovered in the mounds) to
which horses in rich trappings were har-
nessed. The articles found at Shishkovtsi
(Nos.497 to 505) give us an idea of the
ornamentation of these chariots, over fifty
of which have been found.

Most of the monuments originating in
Roman Thrace are very similar to those
found in all the Roman provinces of Europe:
many portraits on gravestones, reliefs and
statues, bronze vessels, glass and silver vases,
weapons, silver and gold jewellery. How-
ever, there is a group of articles found only
in Thrace: votive tablets depicting Zeus
(Jupiter) and Hera (Juno), Asclepius
(Aesculapius, god of medicine) and Hy-
gieia (goddess of health), Sylvanus, Diony-
sus (Bacchus), Pan, Satyrs and Maenads,
Herakles (Hercules) and other Greek and
Roman deities.

The most interesting of them are the
reliefs which depict a horseman or the
Thracian Hero, a strange local deity who
combines the characteristics of many gods
(Asclepius, Zeus, Dionysus, Sylvanus,
Apollo, Pluto and Mithras). This Hero is
also depicted in bronze and there is no
doubt that these figurines, which are to be
found only in Thrace, were locally made.

Another frequently treated theme is that

of the three nymphs, depicted as goddesses of humility and fertility. Their images are similar to those of the Three Graces.

The Roman period is represented in the Exhibition by typically Thracian monuments. Gold and silver jewellery was also very plentiful in Thrace and the pieces exhibited were taken from the Nikolayevo Treasure (Nos.437 to 456).

420 HELMET
Bronze, height 19·7 cm.
From Bryastovets (Karaagach), Bourgas district. First century AD.
Archaeological Museum, Sofia.
Inv.No.6176.
Cone-shaped. The deities Mercury, Apollo and Minerva, Victoria and Mars are depicted on the upper part. Each god is shown under an arch. Neptune is shown on the cheek-pieces.
Bibl. I. Velkov, *IAI*, V, 1918, 1919, 15–20, Plates III–V, Figs.7–9.

421 HELMET MASK
Bronze, iron, height 22 cm.
Plovdiv, first century AD.
Archaeological Museum, Plovdiv.
Inv.No.19.
The back of the helmet is made of iron and made to look like hair. A silver band forms a laurel wreath. The mask is of bronze with openings for the eyes and the face is beardless.
Bibl. B. Filov, *GNBP*, 1923, 123, Fig.1–3.

422 HELMET MASK
Bronze, iron, height 23 cm.
Stara Zagora, second half of the first century AD.
District Museum of History, Stara Zagora.
Inv.No.2 C 1116.
Like No.421 but without a wreath.

423 HELMET MASK
Bronze, height 21 cm.
Silistra, first century AD.
District Museum of History, Silistra.
Inv.Nos.509 and 607.
The helmet is ornamented with sphinxes and garlands and an eagle with outspread wings. The hair highly stylized. The mask shows a young face.

424 HELMET
Bronze, height 21 cm.
Sofia, second, third century AD.
Archaeological Museum, Sofia.
Inv.No.5754.
Scylla, the sea monster, depicted over the forehead.
Bibl. Hr. Danov, *IBAI*, XI, 1937, 196, Figs. 173–75.

425 PLAQUE
Silver, diam. 17·8 cm.
Stara Zagora, first century AD.
District Museum of History, Stara Zagora.
Inv.No.II-132-7.
Herakles fighting the Nemean Lion. Six animal figures around him: two lions, two lion-griffins and two winged lions.
Bibl. D. Nikolov. *District Museum, Stara Zagora*, Sofia, 1965. 134, Nos.28–29.

426 PLAQUE
Silver, diam. 17·5 cm.
Stara Zagora, first century AD.
District Museum of History, Stara Zagora.
Inv.No.II-132-9.
Similar to No.425, but with different animals depicted on it. Much damaged.
Bibl. See No.425.

420

82

4

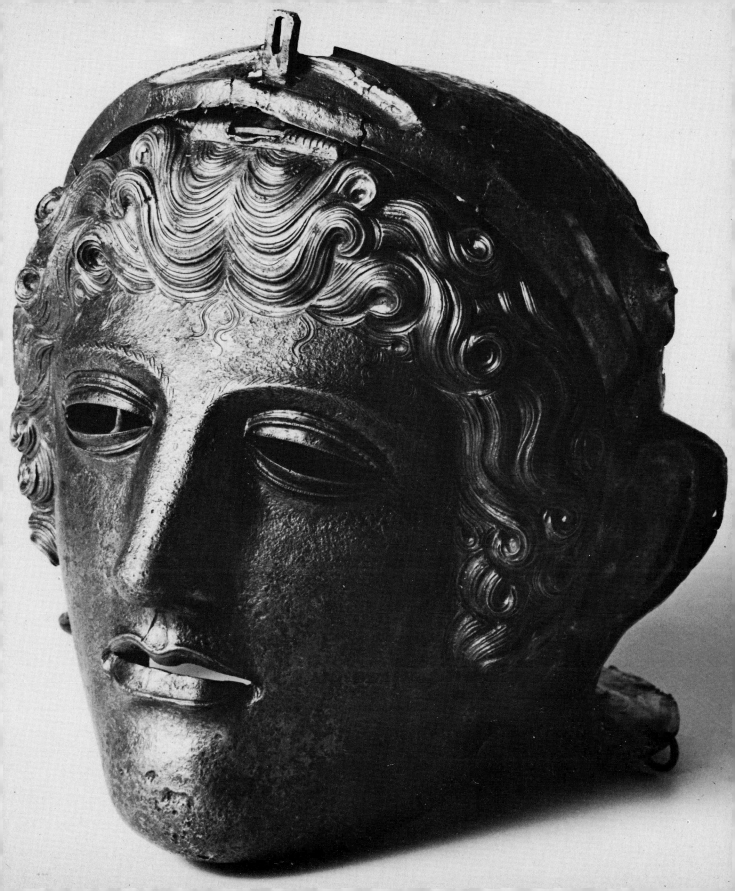

427–430

Plaques from Kroumovgrad

SECOND CENTURY AD

ARCHAEOLOGICAL MUSEUM, SOFIA

427 PLAQUE
Silver, diam. 7 cm.
Inv.No.3747.
Round, ornamented with the bust of a bearded
giant in a round frame, the head slightly
turned to the left.
Bibl. B. Filov, *Drevnoto iskustvo v Bulgaria*,
Sofia, 1925, 33, Fig.24.

428 PLAQUE
Silver, diam. 7 cm.
Inv.No.3747.
Similar to No.427.
Bibl. See No.427.

429 PLAQUE
Silver, diam. 7·3 cm.
Inv.No.3748.
Ornamentation on the border like No.427.
Bust of Hercules.
Bibl. See No.427.

430 PLAQUE
Silver, diam. 7·5 cm.
Inv.No.3749.
Similar to No.427, etc. with a bust of Athena.
Bibl. See No.427.

431–436

Treasure from Golyama Brestnitsa, near Teteven

SECOND CENTURY AD

DISTRICT MUSEUM, PLEVEN

Bibl. Hr.Petkov, *Archaeologia*, 1960, No.1,
26–8, Nos.1–4, Figs.22 and 24–26.

431 VESSEL
Silver, height 9 cm., diam. 22 cm.
Inv.No.713.
Cylindrical, the mouth turned inward. An
inscription in Greek below the mouth:
'Flavius Mestrianus offers this treasure as a
gift to the hero Pyrmerula'.

432 CASSEROLE
Silver, height 6 cm., diam. of mouth 7·4 cm.
Inv.No.113–2.
Slightly convex, the handle wider at each end.

433 CASSEROLE
Silver, height 6 cm., diam. (at mouth) 7·6 cm.
Inv.No.113–1.
Similar to the above.

434 CASSEROLE
Silver, height 6 cm., diam. (at mouth) 7·6 cm.
Inv.No.113–3.
Similar to the above.

435 CASSEROLE
Silver, height 4 cm., diam. 9 cm.
Inv.No.113–5.
Concentric circles incised on the bottom. The
handle slightly wider at each end and orna-
mented with plant designs in relief.

436 CASSEROLE
Silver, height 4 cm., diam. 9·5 cm.
Inv.No.113–4.
Greek inscription. A Romanized Thracian
offers this treasure as a gift to the Thracian
Horseman (see No.431).

437–456

The treasure from Nikolayevo, Pleven District

AD 249

ARCHAEOLOGICAL MUSEUM, SOFIA

Bibl. B. Filov, *IAI*, IV, 1914.

437 RING
Gold, diam. 2·7 cm., weight 22·10 gr.
Inv.No.4796.
A smooth ring with a small blue stone around
which there are plant ornaments.

438 RING
Gold, diam. 2·8 cm., weight 20·57 gr.
Inv.No.4793.
Similar, but the ring grooved along its length.
Incised spirals around the stone.

439 RING
Gold, diam. 2·3 cm., weight 14·98 gr.
Inv.No.4895.
Similar to the above.

440 RING
Gold, diam. 2·7 cm., weight 26·30 gr.
Inv.No.4754.
Similar to the above.

441 RING
Gold, diam. 2·9 cm., weight 23·96 gr.
Inv.No.4792.
Similar to the above, but the ring itself is
double and there are two pale blue stones.

441

442 RING
Gold, diam. 2 cm., weight 11·23 gr.
Inv.No.4791.
Open-work with a Latin inscription
(Dedication from Aurelius Bitus to Hercules).

443 BRACELET
Gold, diam. 7·5 cm., weight 85·29 gr and
73·38 gr.
Inv.No.4783.
Made of twisted wire with fastenings at the
ends.

444 BRACELET
Gold, diam. 5 cm., weight 33·7 gr.
Inv.No.4784.
Open, the ends ornamented with a motif in the
form of a spiral ending in a ring.

445 TWO BRACELETS
Gold, diam. 10 cm., weight 113 gr.
Inv.Nos.4784 and 4785.
Hollow (filled with resin) with a polygonal cross-
section. The bracelets were made of two parts
joined by a hinge.

446 TORQUE
Gold, diam. 12·5 cm., weight 42·9 gr.
Inv.No.4781.
Made of twisted wire with a ring at each end.

447 LUNULA
Gold, weight 2·58 gr.
Inv.No.4804.
In the form of a crescent with a ring from which
it hung, ornamented with granules.

448 PAIR OF EARRINGS
Gold, length 3·5 cm., weight 3·65 and 3·90 gr.
Inv.No.4798.
In the form of a ring to which a disc, encrusted
with blue enamel is hung; ends in a pendant
covered with granules.

449 PART OF A NECKLACE
Gold, length 17 cm., weight 7·20 gr.
Inv.No.4779.
Composed of links in the form of Hercules
knots, joined by rings and emeralds; fastened
at the ends.

450 NECKLACE
Gold, length 41 cm., weight 20·15 gr.
Inv.No.4776.
A small chain ornamented with a green stone
and a pendant in the form of a crescent.

451 NECKLACE
Gold, length 43 cm., weight 40·4 gr.
Inv.No.4778.
Composed of twelve-sided links joined together
with figures of eight. The fastening in the form
of small tubes.

452 NECKLACE
Gold, length 37·5 cm., weight 30·83 gr.
Inv.No.4775.
Composed of semi-cylindrical grooved links.

A triangular plaque at each end. The fastening is a hook on one side and a ring on the other.

453 NECKLACE
Gold, length 46·6 cm., weight 91·99 gr.
Inv.No.4774.
Composed of a triple chain of twisted gold wire; the ends in the form of birds' heads, fastened to the chains by small nails. A medallion in the middle composed of a gold coin struck in Caracalla's reign (AD 198–217), surrounded by eight precious stones.

454 NECKLACE
Gold, length 41 cm., weight 29·15 gr.
Inv.No.4777.
The chain composed of fifty-eight links with a crystal medallion in the middle. The ends in the form of leaves, and with a small hook on one side and a ring on the other.

455 SMALL SALT-CELLAR
Silver, height 10·4 cm., weight 106·44 gr.
Inv.No.4766.
In the form of a statuette: a seated child holding a dog in its arms.

456 PHIALE
Silver, height 29 cm., diam. 9 cm.
Inv.No.4767.
With a ring-like stand. No ornamentation.

457 FIGURINE OF TELESPHORUS
Terracotta, height 17 cm.
Stara Zagora, second century AD.
District Museum of History, Stara Zagora.
Inv.No.C3-612.
The statuette depicts a Thracian god of health, Telesphorus, wearing a typical Thracian outer garment with a hood. The face is summarily treated. The statuette is hollow and has a round base. There is an inscription in Greek on the back.
Bibl. Hr. Bouyukliev, M. Dimitrov, D. Nikolov, *Archaeological Museum – Stara Zagora*, Sofia, 1966, No.66.

458 APOLLO ON HORSEBACK
Bronze, height 7 cm.
Provenance unknown.
Archaeological Museum, Sofia.
Inv.No.412.
The head slightly turned to the left, holding an object which is missing in his left hand.
Bibl. S. Reinach, *RA*, XXXI, 1897, 228, No.11, Fig.11.

459 APOLLO ON HORSEBACK
Bronze with a dark green patina. Height 10 cm.
Zlatovruh, near Assenovgrad.
Archaeological Museum, Sofia.
Inv.No.1227.
Wearing a chlamys, with a quiver at his back.
Bibl. S. Reinach, *RA*, XXXIV, 1899, 121, No.7, Fig.7.

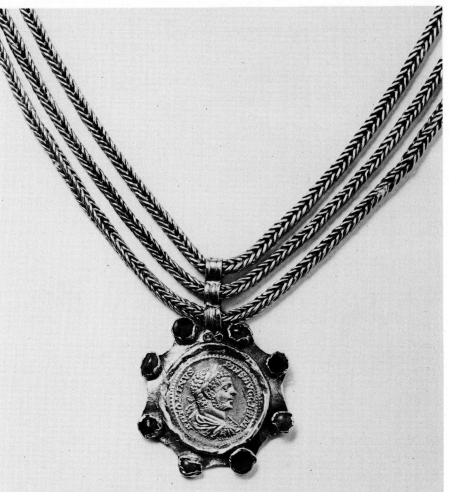

453

461

473

455

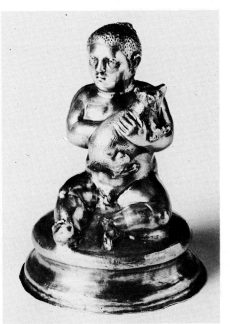

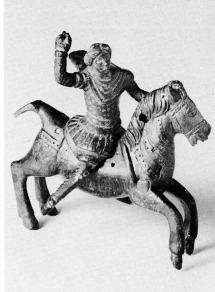

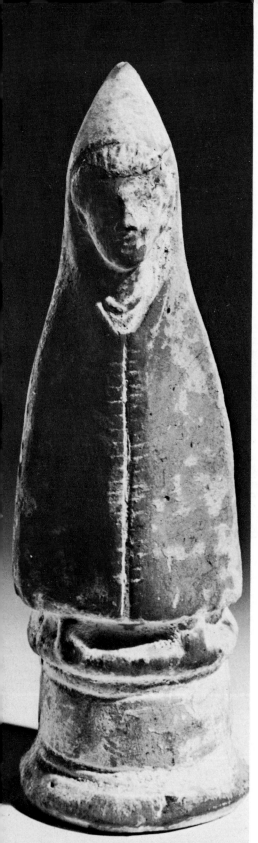

460 THRACIAN HORSEMAN
Bronze, green patina, height 5·5 cm.
Izvorovo, near Svilengrad.
Archaeological Museum, Sofia.
Inv.No.6802.
The horse is missing, but the man's attitude
indicates that he is a horseman.

461 THRACIAN HORSEMAN
Bronze, height 7·5 cm.
Droumhor, Kyustendil district.
Archaeological Museum, Sofia.
Inv.No.7046.
A beardless horseman, his hair in a knot,
waving a raised arm, and holding the reins in
his other hand.
Bibl. T. Gerassimov, *IAI*, XIII, 1939, 327, No.1,
Fig.360.

462 THRACIAN HORSEMAN
Bronze, height 9·5 cm.
Deultum, Bourgas district.
Archaeological Museum, Sofia.
Inv.Nos.5965 and 5966.
A youth, his hair in a knot; eyes protruding,
with engraved pupils; wearing a chiton and a
cuirass. He has a mantle and shoes, and is
holding a patera in his hand. The horse's head
is slightly turned to the left, the mane is cut
short, the trappings indicated by small incised
lines and dots. A crescent on the animal's
breast, and ivy leaves on its flanks.
Bibl. T. Gerassimov, *IAI*, XIII, 1939, 329, No.3,
Figs.361–62.

463 THRACIAN HORSEMAN
Silver, height 6·7 cm.
Lozen, near Svilengrad.
Archaeological Museum, Sofia.
Inv.Nos.4103 and 4104.
He wears a chlamys, blowing out at his back,
and makes the sign of the *benedictio latina* with
his right hand. The horseman's head is round
and flat. The eyes and mouth are summarily
worked.

464 THRACIAN HORSEMAN
Bronze, greenish patina, height 5·5 cm.
Lozen, near Svilengrad, second to third
centuries AD.
Archaeological Museum, Sofia.
Inv.Nos.4102 and 3696.
The horse standing on its two hind legs and
left foreleg. The head turns to the right. The
upper part of the mane is plaited. There is a
strap ornamented with dots round its neck.

465 THRACIAN HORSEMAN
Bronze, shiny greenish patina, height 5 cm.
Vidbol, Vidin district.
Archaeological Museum, Sofia.
Inv.No.6732.
The arms broken to the elbows. The right leg
missing.

466 THRACIAN HORSEMAN
Bronze, height 5·6 cm.
Razboina, near Aitos.
Archaeological Museum, Sofia.
Inv.No.6222-A and B.
The horseman's left arm broken. The right arm
is stretched out, the left shoulder lowered.

467 SMALL HORSE
Bronze, light green patina, height 4·8 cm.
Haskovo district.
Archaeological Museum, Sofia.
Inv.No.5670.
The body and legs lengthened, the head and
neck flattened, the tail falling vertically. The
eyes shown by small circles, also the details of
the trappings.

468 SMALL HORSE
Bronze, green patina, height 5·3 cm.
Maritsa, Pazardzhik district.
Archaeological Museum, Sofia.
Inv.No.4678.
Similar to the preceding one.
Unpublished.

469 SMALL HORSE
Bronze, dark green patina, height 5·3 cm.
Lozen, near Svilengrad, second to third
centuries AD.
Archaeological Museum, Sofia.
Inv.No.3144.
Mounted on a modern stand. The reins shown
around the neck in relief have incised ornamen-
tation.
Unpublished.

470 SMALL HORSE
Bronze, height 6 cm.
Lozen, near Svilengrad.
Archaeological Museum, Sofia.
Inv.No.4102.
A stallion, the right leg raised high, the head
turned to the right, the mane gathered in a
bunch, the tail long and thick.

471 GALLOPING HORSE
Bronze, height 5 cm.
Deultum, Bourgas district, second to third
centuries AD.
Archaeological Museum, Sofia.
Inv.No.2294.
The legs and tail broken, incised ornament of
small circles and lines around the neck.

472 TWO SMALL HORSES
Bronze, shiny greenish patina, height 4·6 and
3·6 cm.
Chirpan, second to third centuries AD.
Archaeological Museum, Sofia.
Inv.No.1749, A and B.
The mane indicated by small short lines, the
reins marked around the neck.

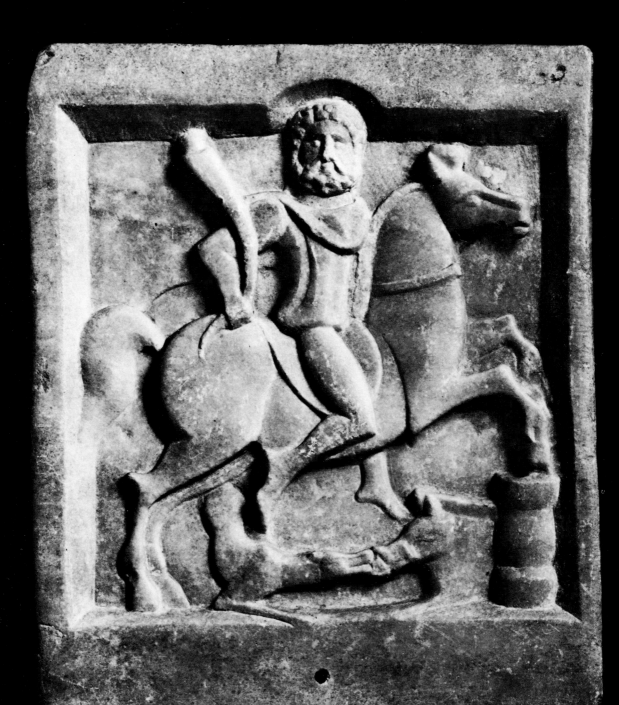

473 GALLOPING HORSE

Bronze, greenish patina, height 7·8 cm.
Chavka, near Momchilgrad.
Archaeological Museum, Sofia.
Inv.No.6231.
The tail raised, the head turned to the left,
lines and three rows of dots along the neck.
Leaf ornamentation on the flanks, the saddle
decorated with a fringe.

474 VOTIVE RELIEF

Marble, height 18 cm., width 21 cm.
Glava Panega, Lovech district.
Archaeological Museum, Sofia.
Inv.No.3412.
Square. The horseman is calmly making for an
altar on the right. The goddess Diana is seated
behind it holding a patera and a torch.
Latin inscriptions: above: *S. Saldocaputeno;*
below: *L. Naevius Probus vet. posuit Silvano et
Dianae v.s.t.m.p.*
Bibl. G. Kazarow, *Die Denkmäler des thrak-
ischen Reitergottes in Bulgarien*, Budapest, 1938,
69, No.318, Fig.174.

475 VOTIVE RELIEF

Marble, height 21 cm., width 23 cm.
Lilyaché, Vratsa district.
Archaeological Museum, Sofia.
Inv.No.7524.
Square. A horseman wearing boots and a
chlamys, blown out behind him, holding a
short curved vine-cutter in his left hand; there
are two dogs and an altar beneath the horseman;
on the right a tree with many branches; below
it a veiled woman. Below, a Latin inscription:
Aur. Jovinus miles leg. XI Claudia V.P. (A
soldier of the XI Legion presents this relief.)
Bibl. I. Venedikov, *IAI*, XVIII, 1952, 197, No.I,
Fig.179.

476 VOTIVE RELIEF

Marble, height 38·3 cm., width 31 cm.
Plovdiv.
Archaeological Museum, Plovdiv.
Inv.No.2103.
In an arched frame a three-headed bearded
horseman, a chlamys blown out by the wind
behind him. He holds a double axe in his right
hand. The horseman is moving to the right. The
horse has placed one hoof on an altar. Beneath
him are a dog and a boar; in front of him, two
women; behind him a servant, who is holding
the horse's tail. The busts of Sol (the Sun) and
Luna (the Moon) to the right and left of the
horseman. A Greek inscription below: 'The
family dedicates this relief for health and
salvation'.

477 VOTIVE RELIEF (fragment)

Marble, height 25 cm., width 29 cm.
Batkoun, Pazardzhik district.
Archaeological Museum, Plovdiv.
Inv.No.2320-A.
The upper part arched; the horseman is waving
his spear and galloping to the right. He is
holding a cithara (lyre) behind the horse's head.
There is a mussel-shaped nimbus above his
head.

478 VOTIVE RELIEF

Marble, height 21 cm., width 19 cm.
Izvor, Plovdiv district.
Archaeological Museum, Plovdiv.
Inv.No.139.
An arched quadrangular frame; a three-headed
horseman wearing a chlamys blown out behind
him, holding a patera in his right hand and
riding to the right. In front of him a woman and
a tree; behind him a servant holding the horse's
tail. A Greek inscription: Offering from a
certain Auluxeni to the Great God.
Bibl. G. Kazarow, *op. cit.*, Budapest, 1938, 88,
No.427, Fig.237.

479 VOTIVE RELIEF

Marble, height 18 cm., width 13 cm.
Cherven Bryag.
Archaeological Museum, Sofia.
Inv.No.762.
An arched quadrangular frame. A three-headed
horseman with a chlamys blown out behind
him rides to the right. One of the heads is
shown separately.
Bibl. G. Kazarow, *op. cit.*, 41, No.148, Fig.64.

480 VOTIVE RELIEF

Marble, height 30 cm., width 25 cm.
Kaspichan.
Archaeological Museum, Sofia.
Inv.No.1322.
Square. A bearded horseman, holding the horn
of plenty in his hand, rides to the right. The
horse has raised its forelegs and placed a hoof
on the altar. Under the horse, a dog and a boar.
Bibl. G. Kazarow, *op. cit.*, 101, No.518, Fig.265.

481 FRAGMENT OF A VOTIVE RELIEF

Marble, height 12 cm., width 16 cm.,
provenance unknown.
Archaeological Museum, Sofia.
Inv.No.2667.
Square. A Thracian horseman riding to the
right and holding a hare in his right hand. His
chlamys blows out behind him.

482 VOTIVE RELIEF

Marble, height 26 cm., width 23 cm.
Bessarabovo, Roussé district.
Archaeological Museum, Sofia.
Inv.No.7043.
Arched quadrangular frame. Jupiter (part
missing) and Juno holding sceptres. Jupiter is
riding a stag, below him a ram. Juno appears
as an Amazon on a doe; a boar at her feet. A
bull in front of the deities. Above, Latin
inscription: *Jovi Optimo Maximo et Junoni
Reginae;* below; *Iul. Julianus mil.leg I Ital. ex
v.p.* (offering of a soldier of the First Legion
Italica to the Great Jupiter and Queen Juno).

483 FRAGMENT OF A VOTIVE RELIEF

Marble, height 26 cm., width 21 cm.
Glava Panega, Pleven district.
Archaeological Museum, Sofia.
Inv.No.3867.

Aesculapius (God of Medicine) with a wand
around which a snake has wound itself, and
Hygieia (Goddess of Health), whose bust is
preserved; there is a tree between the deities
around which a snake has wound itself. Next to
Aesculapius stands Telesphorus, leaning on a
staff. In the upper corners, busts of Sol (the
Sun) and Luna (the Moon). A Latin instription
above them: *Sancto Sylvano de et Dianae*
(Dedicated to Sylvanus and Diana).
Bibl. V. Dobruski, *Trakiysko svetilishté na
Asclepiya do Glava Panega. Archaeologicheski
izvestia na naroden muzei*, Sofia, I, 1907, 56,
No.35, Fig.27.

484 VOTIVE RELIEF

Marble, height 20 cm., width 17 cm.
Glava Panega, Pleven district.
Archaeological Museum, Sofia.
Inv.No.3441.
Arched quadrangular frame. Sylvanus (God of
the Woods) standing, with long hair and wear-
ing a short tunic, holds a sceptre in his hand.
In his other hand he holds a tree. He has dogs
on both sides.
Bibl. V. Dobruski, *op. cit.*, 81, No.116, Fig.58.

485 VOTIVE RELIEF

Marble, height 29 cm., width 20 cm.
Souhatché, near Byala Slatina.
Archaeological Museum, Sofia.
Inv.No.3933
Square frame, slightly arched. Jupiter, nude,
brandishing a thunderbolt, and Juno holding a
sceptre in one hand, and an indeterminate
object in the other, in a four-wheeled chariot
drawn by two horses.
Bibl. B. Filov, *IAI*, III, 1912, 42, No.35, Fig.35.

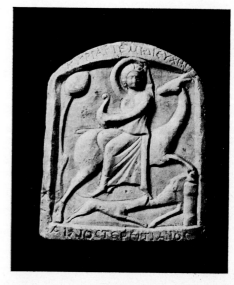

486 VOTIVE RELIEF
Marble, height 24 cm., width 23 cm.
Panagyurishté.
Archaeological Museum, Sofia.
Inv.No.2906.
An arched square frame. Bacchus and Hercules
in a chariot drawn by two panthers, Silenus
riding one of them. In front of them an altar
from which flames rise in the air, behind them a
vine.

487 VOTIVE RELIEF
Marble, height 18·5 cm., width 18 cm.
Saladinovo, Pazardzhik district.
Archaeological Museum, Sofia.
Inv.No.969.
Arched square frame. Three nude nymphs
dancing and waving a veil above their heads.
Fallen urns on both sides of the nymph in the
middle, with water flowing from them.
Bibl. V. Dobrouski, *MSb*, XII, 1896, 412, Plate
IV, Fig.8.

488 VOTIVE RELIEF
Marble, height 28·5 cm., width 23 cm.
Saladinovo, Pazardzhik district.
Archaeological Museum, Sofia.
Inv.No.961.
Arched square frame. Three nymphs wearing
long tunics, the two end nymphs rest their
hands on the middle nymph who is holding a
mussel shell.
Bibl. V.Dobrouski, *MSb*, XII, 1896, 412, Plate II,
Fig.4.

489 VOTIVE RELIEF
Marble, height 23 cm., width 18 cm.
Saladinovo, Pazardzhik district.
Archaeological Museum, Sofia.
Inv.No.960.
Square arched frame. Three nude nymphs, one
of whom is carrying a flower. The middle
nymph is shown back view. In the lower corners,
urns from which water is flowing.
Bibl. V. Dobrouski, *MSb*, XII, 1896, 408, I,
Plate I, Fig.2.

490 VOTIVE RELIEF
Marble, height 18·5 cm., width 18 cm.
Saladinovo, Pazardzhik district.
Archaeological Museum, Sofia.
Inv.No.968.
Arched trapezoid frame. Three nude nymphs,
the middle one shown back view, the one on
the left holding a flower. In the lower corners,
two small figures leaning on sticks, the one on
the left seated, the one on the right standing. A
Greek inscription, dedication to the Three
Nymphs.
Bibl. V. Dobrouski, *MSb*, XII, 1896, 410, X,
Plate I, Fig.3.

491 VOTIVE RELIEF
Marble, height 26 cm., width 22 cm.
Saladinovo, Pazardzhik district.
Archaeological Museum, Sofia.
Inv.No.959.
Square arched frame. Three nymphs, the

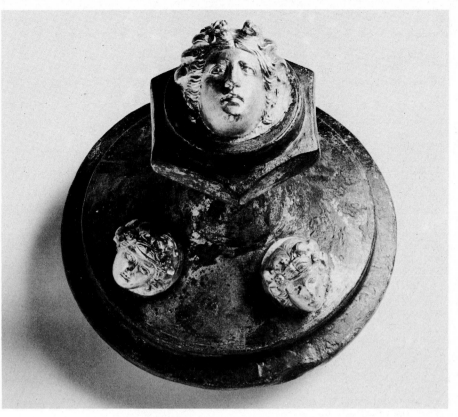

497

503

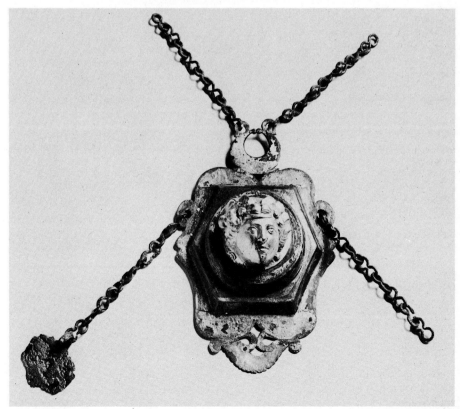

middle one shown back view holding the other two by the hand. On both sides of the middle nymph in the lower corners, fallen urns with water flowing from them.

492 VOTIVE RELIEF
Marble, height 20 cm., width 20 cm.
Sadina, near Popovo.
Archaeological Museum, Sofia.
Inv.No.80.
A square arched frame. Diana with a quiver on her shoulder, riding a doe. A Greek inscription: Artemisia presents this relief to the goddess Artemis.
Bibl. V. Dobrouski, *MSb*, XI, 1894, 93, No.1.

493 VOTIVE RELIEF
Marble, height 47 cm., width 40·5 cm.
Madara, Shoumen district.
Archaeological Museum, Sofia.
Inv.No.4710.
A square arched frame. Hercules nude lying beside a tree, holds a club in one hand, and a cantharus (drinking vessel) in the other. There are three figures above him, one of which holds a wineskin. On the left opposite the hero is a small votive tablet on which three nymphs are depicted. There is a frieze at the base of the relief, illustrating the deeds of Hercules.
Bibl. B. Filov, *IAI*, II, 1911, 85, Fig.1.

494 VOTIVE RELIEF
Marble, height 33 cm., width 39 cm.
Pazardzhik, second century AD.
Archaeological Museum, Sofia.
Inv.No.1635.
Square. Jupiter and Juno with a sceptre, an altar next to the deities above which they are holding a patera. On the right three nymphs, draped, holding one another by the hand.
Bibl. V. Dobrouski, *MSb*, XVI–XVII, 1900, 59, No.24, Fig.31.

495 VOTIVE RELIEF
Marble, height 20 cm., width 17 cm.
Romantsi, near Pernik, second to third centuries AD.
Archaeological Museum, Sofia.
Inv.No.5755.
A square arched frame. Diana with bow and quiver riding a doe which has placed her fore-legs on an altar; beneath the doe a boar and a dog. Greek inscription: dedication to Artemis.

496 STATUETTE
Marble, height 15 cm.
Mlamolovo, Kyustendil district. Second to third centuries AD.
Archaeological Museum, Sofia.
Inv.No.2293 a.
Hermes riding a ram with a caduceus in his hand; the legs of animal and deity are missing.
Bibl. V. Dobrouski, *MSb*, XVIII, 1901, 785, No.97, Fig.56.

497–505
Ornaments of a chariot from Shishkovtsi, Kyustendil District

SECOND TO THIRD CENTURIES AD

ARCHAEOLOGICAL MUSEUM, SOFIA

Inv.No.7992
Bibl. I.Venedikov, *Trakiyska kolesnitsa*, Sofia, 1959, 27, Plates 16–19.

497 PART OF A CHARIOT
Bronze, silver, height 21 cm., diam. 15 cm.
Cone-shaped. At the top a hexagon inscribed in a circle, ornamented with the head of a Maenad in silver. The wreath, eyes and lips gilt. The lower part was ornamented with four plaques of which two heads of a Maenad have been preserved, which are smaller.

498 TWO ORNAMENTS FROM A CHARIOT
Bronze, height 13 cm., diam. 8·4 cm.
There was a plaque with the head of a Maenad on the original, missing. See No.497.

499 THREE ORNAMENTS FROM A CHARIOT
Bronze, height 10 to 14 cm., diam. 8·1 to 8·9 cm.
Similar to No.498.

500 TWO ORNAMENTS
Bronze, height 12 cm., diam. 8·6 cm.
Ornamented with a silver head of a maenad. The wreath, eyes and lips gilt.

501 ELEMENT OF A CHARIOT
Bronze, height 12·5 cm., diam. 7·3 cm.
Similar to No.500.

502 TWO BUCKLES
Bronze, height (with the ring) 9·5 cm., width 13 cm.
Oblong, ornamented with plaques of heads of a Maenad (two on each ornament); only one is left. At the back a metal bar with a little round plate at each end, riveted to the article. There is a ring above it.

503 TWO PECTORALS FROM A HORSE'S TRAPPINGS
Bronze, height 19 cm.
Ornamented with plaques of silver gilt, the head of a Maenad. On the upper and lower part there is a pattern of holes. Rings at the top and on both sides through which little chains are drawn.

504 TWO ORNAMENTS FOR A CHARIOT
Bronze, height 21 cm., width 15 cm.
Hexagonal in form, the sides representing hemispherical sections. The upper parts in the form of a hexagon ornamented with plaques, heads of a Maenad (See No.497).

505 ORNAMENT FROM A CHARIOT
Bronze, height 22 cm., diam. 12·2 cm.
Ornamented with a silver bust of Hercules. He has a lion's skin thrown over his shoulder and a wreath on his head. The skin, mouth, eyes and wreath are gilt.

506 THREE VESSELS STUCK TOGETHER
Pottery, height 20 cm., diam. 10 cm.
Pavlikeni, Turnovo district, Second to third centuries AD.
District Museum of History, Turnovo.
Field No.534.
The vessels mis-shapen beakers thrust into one another. Each has a handle and leaf-shaped black ornamentation. They were found like this in an abandoned potter's kiln in a big Roman pottery centre in the province of Lower Moesia.
Unpublished.

507 VESSEL WITH ORNAMENTATION IN RELIEF
Pottery, height 16·5 cm., diam. of mouth 21 cm.
Pavlikeni, Turnovo district. Second to third centuries AD.
District Museum of History, Turnovo.
Field No.492.
The vessel is cone-shaped in its lower part and cylindrical in its upper part, ornamented with spiral and leaf-shaped ornaments in relief. It has two profiled handles and is covered with black varnish.
Unpublished.

508 SMALL VESSEL
Pottery, height 10·5 cm., diam. of body 12 cm.
Boutovo, Turnovo district. Third century AD.
District Museum of History, Turnovo.
Inv.No.1026, Vol. A.
A biconically shaped vessel, with a broadened profiled mouth and two handles. It is ornamented in relief with a pine cone design and covered with red glaze. Part of the mouth restored.
Unpublished.

Coins

Thracian Tribes

509 DERRONI TRIBE
Silver decadrachm, diam. 35 mm.
Sixth to fifth centuries BC.
Archaeological Museum, Sofia.
Inv.No.8739.
Obverse: A man with a pointed beard and Macedonian broad-brimmed hat (*kausia*) in a two-wheeled chariot drawn by an ox. He holds a whip in his left hand. A symbol of the sun above the animal.
Reverse: A triskelion (three legs).
Bibl. T. Gerassimov. 'Nahodka ot Decadrachmi na trako-makedonskoto plemé Derroni,' *IAI*, XI, 1937, 240.

510 ORESCI TRIBE
Silver stater, diam. 20 mm.
Fifth century BC.
Archaeological Museum, Sofia
Inv.No.6962.
Obverse: Centaur with a nymph.
Reverse: Incised swastika.

511 UNKNOWN THRACIAN TRIBE
Silver stater, diam. 1·9 cm., weight 5 gr.
Fifth century BC.
Archaeological Museum, Sofia.
Inv.No.10473-54.
Obverse: Silenus kneeling on the ground and holding a Maenad in his arms.
Reverse: Incised swastika.

512 UNKNOWN THRACIAN TRIBE
Silver drachm, diam. 16 mm.
Fifth century BC.
Archaeological Museum, Sofia.
Inv.No.2799.
Similar to the preceding one.

Thracian Kings

513 SPARATOKOS (*c.*424 BC).
Silver, diam. 10 mm., weight 1·35 gr.
Archaeological Museum, Sofia.
Inv.No.4545.
Obverse: Forepart of a horse facing left.
Reverse: An eagle with outspread wings.

514 SPARATOKOS (*c.*424 BC)
Silver, diam. 15 mm.
Archaeological Museum, Sofia.
Inv.No.9565-50.
Obverse: A horse moving to the left.
Reverse: An eagle flying to the left, holding a snake inscribed in a circle in its beak.

515 SPARATOKOS (*c.*424 BC)
Silver, diam. 15 mm.
Archaeological Museum, Sofia.
Inv.No.7219.
Obverse: A horse moving to the left.
Reverse: An eagle with outspread wings.

516 KOTYS I (382–359 BC)
Silver, diam. 12 mm.

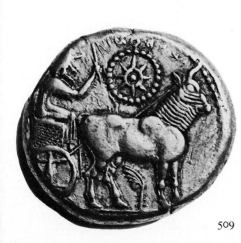

509

Archaeological Museum, Sofia.
Inv.No.121.
Obverse: Head of a bearded man facing left.
Reverse: Two-handled vessel.

517 AMATOKOS (359–371 BC)
Bronze, diam. 21 mm.
Archaeological Museum, Sofia.
Inv.No.8761.
Obverse: A double axe.
Reverse: A bunch of grapes.

518 TERES II (348 BC)
Bronze, diam. 21 mm.
Archaeological Museum, Sofia.
Inv.No.10940-64.
Obverse: A double axe.
Reverse: A vine with bunches of grapes in an incised square.

519 KERSOBLEPTES (359–348 BC)
Bronze, diam. 12 mm.
Archaeological Museum, Sofia.
Inv.No.10724.
Obverse: Head of a woman facing right.
Reverse: Vase with two handles and a grain of wheat.

520 KETRIPORIS (356 BC)
Bronze, diam. 17 mm.
Archaeological Museum, Sofia.
Inv.No.7220.
Obverse: Head of a bearded Dionysus wearing a wreath and facing right.
Reverse: A cantharus and a thyrsus.

521 HEBRIZELMOS (386–385 BC).
Bronze, diam. 18 mm.
Archaeological Museum, Sofia.
Inv.No.10430–54.
Obverse: A man's head facing left.
Reverse: Forepart of a lion facing right.

522 LYSIMACHUS (306–280 BC)
Gold stater, diam. 20 mm.
Archaeological Museum, Sofia.
Inv.No.6810.
Obverse: Head of Alexander the Great facing right.
Reverse: Athena seated on a throne, armed with a spear. She is holding Nike by her left hand; a shield behind her.

523 LYSIMACHUS (306–280 BC)
Silver tetradrachm, diam. 17 mm., weight 15·72 gr.
Archaeological Museum, Sofia.
Inv.No.8063.
Obverse: Head of Alexander the Great with the horns of a ram, facing right.
Reverse: Athena holding Nike in her left hand; Nike is leaning on a shield.

524 LYSIMACHUS (306–280 BC)
Silver tetradrachm, diam. 18 mm.
Archaeological Museum, Sofia.
Inv.No.8096.
Similar to No.523.

525 LYSIMACHUS (306–280 BC)
Bronze, diam. 20 mm.
Archaeological Museum, Sofia.
Inv.No.6238.
Obverse: Athena facing right.
Reverse: A doe.

526 SEUTHES III (324–311 BC)
Bronze, diam. 22 mm.
Archaeological Museum, Plovdiv.
Inv.No.6435.
Obverse: King's head within a circle, facing right.
Reverse: The king on a galloping horse facing right; a laurel wreath under the horse.

527 SEUTHES III (324–311 BC)
Bronze, diam. 17 mm.
Archaeological Museum, Plovdiv.
Inv.No.1370.
Similar to No.526.

528 ADAIOS (255–235 BC)
Bronze, diam. 20 mm.
Archaeological Museum, Sofia.
Inv.No.8365.
Obverse: Head of Apollo facing right.
Reverse: Triskelion.

529 MOSTIDES (c.200 BC)
Bronze, 20 mm.
Archaeological Museum, Sofia.
Inv.No.6919.
Obverse: Head of Apollo facing right.
Reverse: Horse moving to the left.

530 MOSTIDES (c.200 BC)
Silver, tetradrachm, diam. 17 mm., weight 16·04 gr.
Archaeological Museum, Sofia.
Inv.No.6471.
Obverse: Bust of the king wearing a diadem and facing right.
Reverse: Athena seated on a throne on the left, holding Nike, leaning on a shield.

531 SADALAS II (first century BC)
Bronze, diam. 16 mm.
Archaeological Museum, Sofia.
Inv.No.6559.
Obverse: Woman's head with a diadem facing right.
Reverse: Eagle standing facing left.

532 RHOIMETALKES I (2 BC–AD 12)
Bronze, diam. 28 mm.
Archaeological Museum, Sofia.
Inv.No.4546.
Obverse: Heads of the king and his queen facing right.
Reverse: Heads of Augustus and Livia facing right.

92

533 RHOIMETALKES I (2 BC–AD 12).
Bronze, diam. 27 mm.
Archaeological Museum, Sofia.
Inv.No.3539.
Obverse: Heads of the king and his queen.
Reverse: Head of Augustus.

534 KOTYS AND RHESKUPORIS
(first century BC)
Bronze, diam. 20 mm.
Archaeological Museum, Sofia.
Inv.No.47.
Obverse: Head of the king with a diadem facing right.
Reverse: Nike facing left.

Thracian imitations of Greek coins

THIRD TO FIRST CENTURIES BC

535 PHILIP II (382–336 BC)
Silver tetradrachm, diam. 23 mm., weight 13·67 gr.
Archaeological Museum, Sofia.
Inv.No.2730.
Obverse: Head of Zeus facing right.
Reverse: Horseman galloping to right.

536 ALEXANDER THE GREAT
(356–323 BC)
Silver, diam. 20 mm., weight 2·92 gr.
Archaeological Museum, Sofia.
Inv.No.5164.
Obverse: Head of the young Herakles facing right.
Reverse: Zeus on a throne holding a sceptre and an eagle.

537 PHILIP III (317 BC)
Silver, diam. 16 mm., weight 2·92 gr.
Archaeological Museum, Sofia.
Inv.No.1437.
Obverse: Head of Herakles facing right.
Reverse: Like the preceding coin.

538 THASOS
Silver tetradrachm, diam. 30 mm.
Archaeological Museum, Sofia.
Inv.No.8233.
Obverse: Head of Dionysos wearing a wreath.
Reverse: Heracles standing, nude.

539 THASOS
Silver tetradrachm, diam. 33 mm., weight 17·40 gr.
Archaeological Museum, Sofia.
Inv.No.11157.
Like No.538.

540 THASOS
Silver tetradrachm, diam. 33 mm., weight 17·40 gr.
Archaeological Museum, Sofia.
Inv.No.99900.
Like No.538.

541 THASOS
Silver, diam. 35 mm., weight 16·30 gr.
Archaeological Museum, Sofia.
Inv.No.10838–59.
Like No.538.

542 THASOS
Silver, diam. 33 mm., weight 16·20 gr.
Archaeological Museum, Sofia.
Inv.No.10875–60.
Like No.538.

526

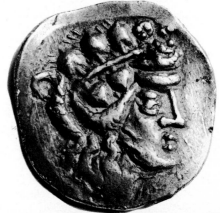

540

Addenda

Treasure found at the village of Borovo, Roussé District

FIRST HALF OF THE FOURTH CENTURY BC

ROUSSE, DISTRICT MUSEUM OF HISTORY

Found in December, 1974. This is a luxury drinking set consisting of five vessels. Three of them (Nos.543–5) are *rhyta* in the form of horns ending in the foreparts of animals. The fourth (No.546) is a large dish, at the bottom of which is depicted a doe attacked by a griffin. The last vessel (No. 547) is a small pitcher ornamented with a composition of many figures with Dionysus in the centre.

The design of ivy twigs on two of the *rhyta*, the procession headed by Dionysus on the small pitcher, and the handles of the dish in the form of the heads of satyrs, unite the whole find in a single theme and connect it with the cult of Dionysus.

For the inscriptions, cf. No.297.

543 RHYTON
Silver, height 20·2 cm.
Inv.No.II 357.
The body of the vessel is vertically fluted. Along the upper edge is a border of ovules and beading. Below them small incised lines indicate the place where a previously cut out ivy twig with leaves was to be placed. The vessel ends at the bottom in the forepart of a galloping horse. There is a pour-hole between its forelegs. The mane and hooves are gilt. On the animal's belly is an inscription in Greek, reading: ΚΟΤΥΟΣ ΕΤΒΕΟΥ

544 RHYTON
Silver, height 20·2 cm.
Inv.No.II 358.
The body of the vessel is vertically fluted. Along the upper edge is a border of ovules and beading. Below it is a gilded ornament in relief consisting of two ivy twigs with leaves and fruit. The lower part of the vessel ends in the forepart of a sphinx. The pour-hole between its forepaws is finished by a lion's head. The sphinx's hair, breast and feathers are gilt. There is an inscription in Greek on the animal's belly: ΚΟΤΥΟΣ ΕΤΒΕΟΥ

545 RHYTON
Silver, height 16·5 cm.
Inv.No.II 359.
The body is ornamented with horizontal fluting; at the lower end is a palmette between the fluting. The vase ends in the forepart of a bull. The hairy parts of the animal and its nostrils are gilded. Between its forelegs there is a pour-hole.

546 DISH
Silver. diam. 29 cm.
Inv.No.II 360.
On the outside the vessel is ornamented with a gilded ovoid design, broken in two places for the handles, which end in the gilded heads of satyrs. A doe attacked by a griffin is depicted at the bottom of the vessel.

547 SMALL PITCHER
Silver, height 18·2 cm.
The surface of the pitcher is occupied by two richly ornamented bands in relief; the upper one is narrow, and the lower, main band is wider. A scene representing the celebration of the cult of Dionysus is depicted on it. Dionysus and Ariadne are shown in the centre of the procession with sileni, maenads and satyrs round them. There is an inscription in Greek, ΚΟΤΥΟΣ ΕΤΒΕΟΥ on the neck of the pitcher.
Bibl. Ivanov, *Izkoustvo*, 1975, 14, No.3–4.

Treasure from Dalboki, Stara Zagora District

425–400 BC

ASHMOLEAN MUSEUM, OXFORD

This treasure was found in 1879 in a stone tomb in a burial mound near the village of Dalboki. It comprises the possessions of a rich Thracian warrior: objects of gold, silver, bronze, iron and pottery, some imported from Greece, some locally made. At some date before 1908 the greater part of the Treasure passed into the collection of Sir Frederick Cook at Doughty House, Richmond. Nos.548–558 and 560–561 were acquired from the Cook Collection for the Ashmolean Museum in 1948, by the Seven Pillars of Wisdom Trust. No.559, also from the Cook Collection, was given to the Ashmolean Museum in 1947 by Sir John Beazley. These objects are lent by the Ashmolean Museum to supplement this Exhibition.
Bibl. B.Filov, *IBAI*, VI–VII, 1930–33, 45.
I.Venedikov and T.Gerasimov,
Trakiysko Izkoustvo, Sofia, 1973, 370.

548 PECTORAL
Gold, width 35 cm.
Inv.No.1948.96.
Semi-circular in form, cut out in the centre. Ornamented with a border of ovules followed by a row of roundels and one of almonds; then alternate rows of lions' heads and roundels or rosettes. Three rows of lions' heads, flanked by two rows of rosettes, divide the pectoral radially into four segments. Made by a Thracian craftsman.

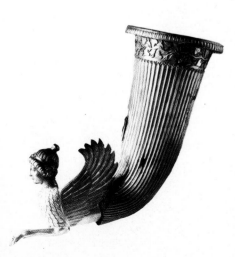

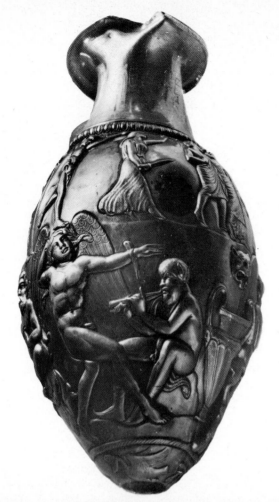

547

546

549 BEAKER
Silver, height 11·3 cm.
Inv.No.1948.102.
The beaker is ornamented with incised designs.
There are three bands at the top. The upper
band consists of touching lotus blossoms
alternating with palmettes. Below it there is a
band of scale ornament, while the lowest band
is formed by a guilloche pattern. At the bottom
there is another band formed by three rows of
scale ornament. Greek work for a Thracian
customer(?).
Bibl. Strong, 85, Plate 18.

550 BEAKER
Silver, height 12·5 cm.
Inv.No.1948.103.
Like No.549 but ornamented at the top with a
band of larger and more roughly worked palm-
ettes, separated by lotus blossoms, and a band
of three rows of scale ornament at the bottom.
Local work, imitating No.549(?).
Bibl. See No.549.

551 MUG
Silver, height 9 cm.
Inv.No.1948.104.
A copy of a type of mug common in Athenian
pottery of the late fifth century BC. Local
work(?).
Bibl. See No.549.

552 CUIRASS
Bronze. Height 39·2 cm.
Inv.No.1948.97 and 98.
The cuirass is in two parts, back and front. The
pectoral muscles and the abdomen on the front,
and the shoulder-blades on the back are indi-
cated by a border in relief. The cuirass is of the
bell type.
Bibl. BCH, lxxxv, 1961, 516.

553 BOWL
Bronze, diam. 26 cm.
Inv.No.1948.100.
A footbath? There were originally two handles,
one of which is now missing. Greek work.

554 WATER PITCHER (HYDRIA)
Bronze, height 41.3 cm.
Inv.No.1948.101.
The usual form of Greek hydria, with one
horizontal and two vertical handles. The shape,
in Greece, is even more common in pottery than
in bronze.

555 BEAKER
Bronze, height 27·7 cm.
Inv.No.1948.99.
Like the silver beakers, Nos.549 and 550. This
outsize version, evidently local work, may have
been passed round as a loving-cup at Thracian
drinking-bouts.

556 AMPHORA
Pottery, height 39·6 cm.
Inv.No.1948.108.
Damaged. A common variety of Athenian

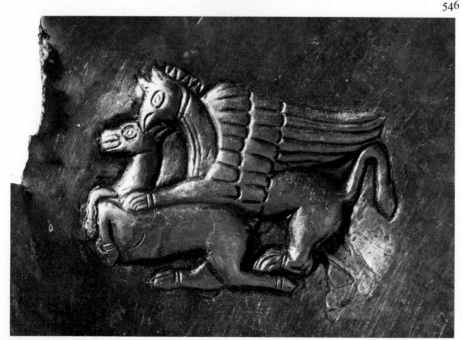

'black glaze' amphora of the fifth century BC.
Surface misfired to brown.

557 STEMLESS CUP
Pottery, diam. 18·2 cm.
Inv.No.1947.333.
Given by Sir John Beazley, 1947.
A common variety of Athenian 'black-glaze'
pottery of the later fifth century BC. The interior
bears elaborate impressed designs.
*Bibl. Ashmolean Museum, Beazley Gifts, 1912–
1966, 414, Plate 58.*

558 STEMLESS CUP
Pottery, diam. 18·6 cm.
Inv.No.1948.105.
Like No.557.

559 ONE-HANDLED CUP
Pottery, height 9 cm.
Inv.No.1948.107.
Local ware, made under Greek influence.

549–551

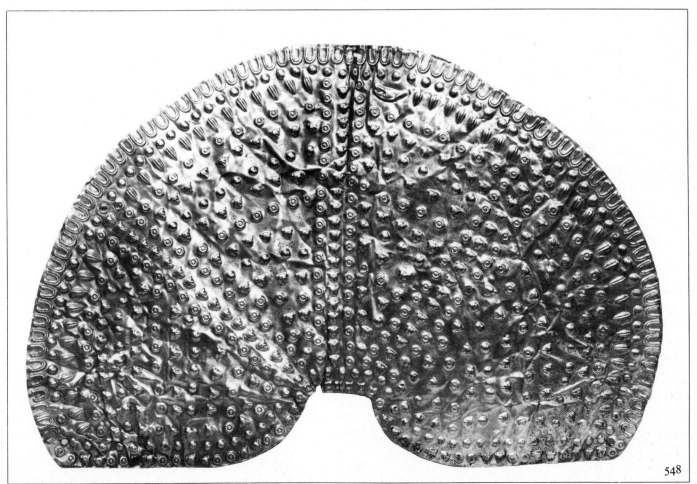

548

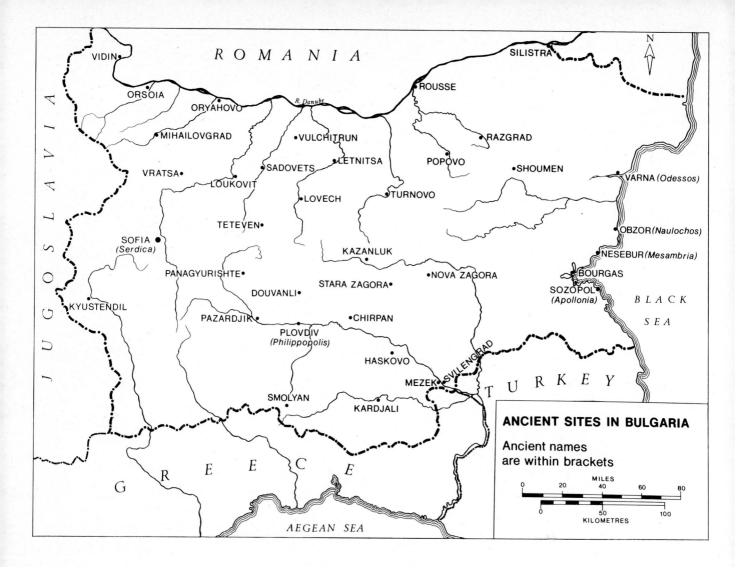

ANCIENT SITES IN BULGARIA

Ancient names
are within brackets

MILES
0 20 40 60 80

KILOMETRES
0 50 100

Abbreviations

BCH	*Bulletin de Correspondance hellénique.*
Duvanlij	B.D.Filov, *Die Grabhügelnekropole bei Duvanlij in Südbulgarien*, Sofia, 1934.
GPM	*Godishnik na Plovdivskiya Muzei.*
GNAM	*Godishnik na Narodniya Arheologichesko Muzei* (Sofia).
GNAMP	*Godishnik na Narodniya Arheologichesko Muzei v Plovdiv.*
GNBP	*Godishnik na Narodnata biblioteca v Plovdiv.*
Hoddinott	R.F.Hoddinott, *Bulgaria in Antiquity*, London, 1975.
IAI	*Izvestiya na Arheologicheski Institut.*
IBAI	*Izvestiya na Bulgarskiya Arheologicheski Institut.*
IVAD	*Izvestiya na Varnenskoto Arheologichesko Drujetsvo.*
MPK	*Muzei i Pametnitsi na Kultura.*
MSb	*Sbornik na Ministerstroto na Narodnoto Prosveshtenie.*
RA	*Revue archéologique.*
RM	*Mitteilungen des Deutschen archäologischen Instituts, Römische Abteilung.*
RPr	*Razkopki i Pronchvaniya.*
Strong	D.E.Strong, *Greek and Roman Gold and Silver Plate*, London, 1966.